PHOTOGRAPHY
PAST *FORWARD*
APERTURE
AT 50

EDWARD WESTON: PHOTOGRAPHER

PHOTOGRAPHY

ANNIVERSARY

PAST FORWARD

APERTURE AT 50

**WITH A HISTORY BY
R. H. CRAVENS
AND EXCERPTS FROM
APERTURE ISSUES
1952–2002**

APERTURE

CONTENTS

Gianni Berengo Gardin, Flor Garduño, Anna Gaskell, Mario Giacomelli, Ralph Gibson, Allen Ginsberg, David Goldblatt, Nan Goldin, Emmet Gowin, David Graham, Timothy Greenfield-Sanders, Philip Jones Griffiths, Jan Groover, Lewis Hine, David Hockney, Horst P. Horst, Eikoh Hosoe, Peter Hujar, Graciela Iturbide, Mimmo Jodice, Nicholas K. Kahn and Richard S. Selesnick, Robert Glenn Ketchum, Chris Killip, Mark Klett, Josef Koudelka, Barbara Kruger, Dorothea Lange, Jacques Henri Lartigue, Clarence John Laughlin, Jan Van Leeuwen, Annie Leibovitz, Jerome Liebling, Charles Lindsay, O. Winston Link, Danny Lyon, Alen MacWeeney, Pascal Maitre, Sally Mann, Robert Mapplethorpe, Mary Ellen Mark, Lee Marmon, Dona Ann McAdams, Don McCullin, David McDermott and Peter McGough, Ralph Eugene Meatyard, Susan Meiselas, Ray K. Metzker, Pedro Meyer, Duane Michals, Lee Miller, Arno Rafael Minkkinen, Richard Misrach, Lisette Model, Tina Modotti, Tracey Moffatt, Inge Morath, László Moholy-Nagy, Barbara Morgan, Ugo Mulas, Martin Munkacsi, Charles Nègre, Shirin Neshat, Michael Nichols, Nam June Paik, Pavel Pecha, John Pfahl, Pierre et Gilles, Keri Pickett, Adrian Piper, Sylvia Plachy, Sigmar Polke, Raghu Rai, Robert Rauschenberg, Man Ray, Elaine Reichek, Marc Riboud, Matthieu Ricard, Eugene Richards, Gerhard Richter, Miguel Rio Branco, Sebastião Salgado, Lucas Samaras, August Sander, Lise Sarfati, Ferdinando Scianna, Andres Serrano, Charles Sheeler, Cindy Sherman, Stephen Shore, Lorna Simpson, Raghubir Singh, Sandy Skoglund, Clarissa Sligh, W. Eugene Smith, Frederick Sommer, Doug and Mike Starn, Maggie Steber, Chris Steele-Perkins, Joel Sternfeld, Paul Strand, Thomas Struth, Josef Sudek, Hiroshi Sugimoto, Paul Thorel, Shomei Tomatsu, Larry Towell, Javier Vallhonrat, Max Waldman, Nick Waplington, Andy Warhol, Alex Webb, Carrie Mae Weems, William Wegman, Brian Weil, Brett Weston, Edward Weston, Minor White, Garry Winogrand, Joel-Peter Witkin, David Wojnarowicz, Franco Zecchin, and more . . .

PREFACE

THIS BOOK IS DEDICATED TO MINOR WHITE (1908–1976) AND MICHAEL E. HOFFMAN (1942–2001)

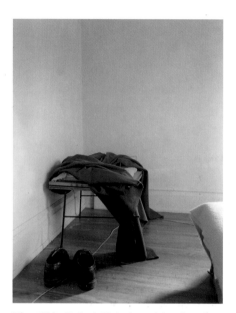

In 1952, Minor White, Beaumont and Nancy Newhall, Ansel Adams, Dorothea Lange, Barbara Morgan, and others joined forces to create a journal whose impact and longevity they could never have anticipated. Like a force of nature, *Aperture* magazine—having weathered everything from financial difficulties, censorious assaults, attacks from the left and right, every imaginable photographic style, a myriad of spiritual impulses, a group of editors with strong and eclectic sensibilities, three formats, a broad range of themes, ethnic and national focuses, an extraordinary roster of writers, and most recently a complete redesign—is fifty years old. Through sheer will, dedication, and most importantly vision—first Minor White's and then Michael E. Hoffman's—*Aperture* not only survived, it flourished and metamorphosed into a worldwide book-publishing and exhibitions program as well.

So, how to celebrate Aperture at fifty? A "*pastforward*" perspective seemed like an inclusive approach. And so here, we cast a look back over our own history—which in many ways has both mirrored and helped to determine the evolution of the medium—in order to understand our present, all the while maintaining an eye toward the future. This is not so much a retrospective as it is a kind of timeless, experiential reunion of photographers and writers, as reflected in the non-chronological sequencing of images and words. Rather than working in a linear mode, we have chosen to offer many entry points, contexts, and, we hope, new ways of looking. You will find excerpts and page spreads from fifty years of issues and books, which reveal how Aperture, in all of its projects, has continuously rethought and reinterpreted the varied aesthetic and social paths set forth by the Founders.

We are celebrating the photographers of Aperture's community in some instances through

Minor White (below), his bedroom (above), and interior of his apartment (bottom) in Rochester, New York, 1962. Photographs by Stevan A. Baron.

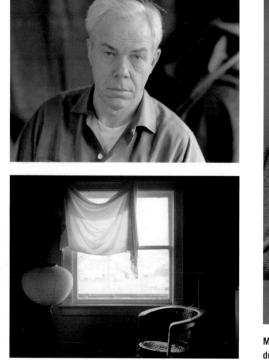

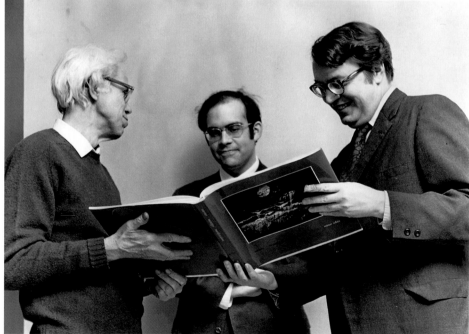

Minor White, Michael E. Hoffman, and Evan Turner, Director of the Philadelphia Museum of Art, during the hanging of "The Circle, Square, and Triangle" at the museum, 1970.

iconic images, and in others with new work that has not been previously published. In all cases, this project has been a collaborative one; many of the photographers themselves selected the work they wished us to feature, others responded enthusiastically to our suggested images. So many have expressed to us their appreciation of Aperture's influence and uniqueness, sharing their "I saw it in *Aperture* first" stories.

The untimely death of Michael E. Hoffman in November 2001, while our work on "the fiftieth" was in process, put a tragic cast on this milestone, as we expected to celebrate together with him. This publication is dedicated to Michael and to Minor, with love, respect, admiration, and gratitude for the phenomenal devotion, energy, and years they gave to Aperture.

For their extraordinary and ongoing grace under pressure, and strength during a most difficult period, I thank Wendy Byrne, Diana C. Stoll, and Richard H. Cravens—exceptional friends and collaborators—as well as all of the remarkable photographers who have worked so closely with us on this and so many other projects. The staff at Aperture has been wonderful and supportive, as always, and then there is the community at large: past editors, curators, agencies, galleries, estates . . . we have truly harassed everyone with requests for images, fact-checking, picture research and more—thank you all.

Finally, all of us wish to thank our subscribers and readers, our larger "community of interests"—a concept so important to Michael—for your encouragement, good humor, intelligence, tolerance, open-mindedness, and generosity of spirit. Without you and your support, this birthday would have been inconceivable.

—MELISSA HARRIS

ABOVE: New York's Mayor David Dinkins joins Michael E. Hoffman at Aperture's Annual Appeal dinner, 1990.
BELOW: Michael E. Hoffman with His Holiness the Dalai Lama and Matthieu Ricard in Dharamsala, India, ca. 1995.

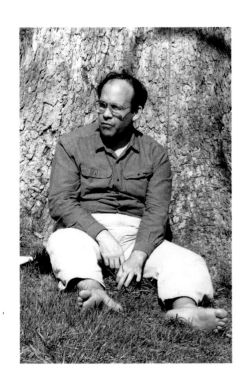

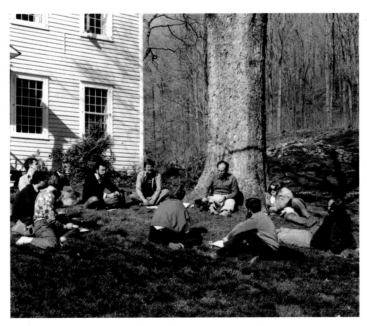

Aperture's senior staff, led by Michael E. Hoffman, meets in Shekomeko, New York, 1985, to work on plans for the future.

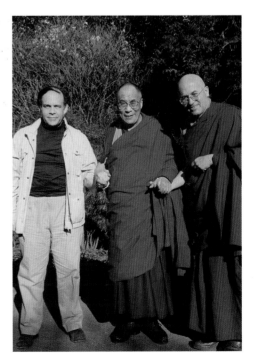

A RATIONALE FOR THE MINIATURE CAMERA

This rationale or working method for the miniature camera is one of discovery. One of using the accidental intelligently; one of treating the camera as an investigating tool to uncover the emotional blind spots of the prejudiced human eye.

To clear the way for discussion two main points need to be made. 1 If photography is to be an extension of vision each type of camera needs to be fully exploited for its unique possibilities, consequently thruout this paper an exaggerated distinction between view and miniature camera technique is kept. 2 The growth of any rationale can be outlined thus:

First, a rationale is firmly grounded in a specific camera, specific film, developers, paper, and so on.

Second, it grows out of technique. "Technique" will be considered a welding of tools and processes and the man into a working unit. During this welding process several things happen to man, tools, and processes. At first the tools temporarily block his expressiveness — just as the conscious phases of any learning process does. Any photographer working out an esthetic for himself is, to start, under the influence, if not the control of the specific instruments and procedures. Such influence is beneficial for during this time the tools, by force of their inanimate limits, powerfully channel or focus the man's ordinarily diffuse seeing. Then, as he masters the equipment and processes, as he absorbs their influence, the channeling is reversed — he gives direction to the medium. Out of this interaction of tools, processes, and man which becomes a technique or working unit, the rationale, or working method, also develops. The rationale is the man's own central and long term direction.

The exploratory rationale presented here is the working method one man developed for the miniature camera. It treats the camera as a research tool for the creative photographer. There are several places in the photographic cycle (or spiral) where tools, processes, and analysis of prints can affect the total rationale, or where the exploratory role of the miniature camera can be put into effect. These are: The *Exposure-Development* phase which is terminated in the negative. The *Printing* phase which ends with a set of fine photographs or reproductions. The *Display* phase which

LISETTE MODEL / Sammy's Bar, New York

Visions & Voices
A CELEBRATION OF GENIUS IN PHOTOGRAPHY
By R. H. CRAVENS

Romancing Edward
Love letters to Edward Weston

Weston was wonderfully engaged with his work, his love life, and the world at large. In the Weston archive at Tuscon's Center for Creative Photography, however, a more easily alluring Edward Weston surfaces. Along with the Center's vast holdings of his negatives and original prints, there is a carefully preserved collection of Weston's letters, each cataloged along with its own whimsical enclosures: all the romantic ephemera—pressed wisteria blossoms, bamboo leaves, paper wisps of Chinese fortune-cookie predictions—that were once tucked into precious billets-doux are now annotated and painstakingly preserved in museum-quality, acid-free envelopes.

Weston's own writing is rapturous and uninhibited. "Moskowski's Bolero!" he swoons in one of the letters. "I found it just now—I was swept away from the present—carried back in a surge of desire to those moments when you danced to its impassioned rhythms—I heard again the swish of your white kimono—and saw again the gleam of its brilliant textures—gliding—shifting—swirling against the golden gloom of my half lit walls—" Weston was acclaimed as a fabulous dance partner; his words, redolent of ambrosial nights and sensual pleasures, perform a seductive tango all their own. The letters selected here were all written during the years between the World Wars, a time when Los Angeles was considered the newest city in the world; their authors were part of Southern California's first avant-garde. The women observed in Weston's charismatic photographs—the crouching torqued knees, a dreamy profile lost in reverie—were bohemian modernists who openly expressed their political views, artistic and spiritual doubts, and individual freedom. They were variously Weston's studio partners and colleagues, paramours and models: the photographers Margarethe Mather and Tina Modotti, the artists Xenia Kashevaroff and Beatrice Wood, and the dancer Bertha Bruton Wardell. Mather, an ethereal beauty, was a

Edward Weston's public self-portrait has nearly always been based on his *Daybooks*—the diaries he kept from 1922 until 1934, writing at 5 A.M. each morning, fueled by a pot of strong coffee. Before the *Daybooks* were published (in two volumes, the first in 1961 and the second in 1966), the originals were brusquely censored by their author's own razorblade; Weston removed entire sections, or sliced out passages leaving window-like holes in the pages. In these edited journals, a curious, not altogether endearing picture of the artist emerges, one that is sometimes deeply compassionate and other times strident and hyper-declarative. What also becomes clear, though, is that

Introduction by Susan Morgan

BERTHA BRUTON WARDELL

My very dear Edward
It makes me so happy to hear from you. And I am not ashamed of my emotions. I quite glory in them as you—pagan yourself, well know. Not seeing you, I must have forgotten how completely trustworthy you are. So keep the letters or not as you think best—anyway they are yours. If women are changeable perhaps sometimes they can change for the better.

Olga Stack has a book on George Moore which she wishes sent you—to settle an argument which you and she once had in regard to GM's appearance.... Peter Krasnow's exhibit is very moving. The portrait of you has wistfulness which is like you though you also have a slightly Russian Jewish aspect in it which is unfamiliar. The wood carving I would enjoy licking and rubbing my cheek against as well as tucking under my arm to have as my own. How interesting to look from Peter's portraits so elongated to Rivera's painting just out the door so rotund.

Frame's watercolors are quite astonishing. She is in violent rebellion against the dictates of the art school which she is attending once a week. But as she says—I am learning to use a brush!

July 26, 1923
To Edward Weston.
On his way to new lands.
Dear, I cannot get it thru my head that you are really going away to another country. My feeling for you has not been a transient whimsy.

MARGARETHE MATHER
Monday, July 30, ca. 1923
The studio misses you—
And I do
[pressed geranium, stem and blossoms, enclosed]

✦

February 29, ca. 1920
your letter—you do not know me—you were my only valentine—
I would be yours
I long for you—
I want to kiss you—over and and over—to make up for all
that I never gave you—
in all these years
I mean this
I pray the gods are smiling upon you—

✦

February 26, ca. 1920
You were in a dream last night—and now the day brings only ghosts and I sicken with fear—and doubt—this—when in my heart—a drift of jonquils that I long to leave at your door—

TINA MODOTTI
December 26, 1921
Edward—Of all the different emotions which I feel tonight for you not one can be put into words—I have formulated in my mind & then

Prescient Beginnings

Susceptibility to the highest forces is the highest genius.
— *The Education of Henry Adams*

PROLOGUE

Aperture began with a few profoundly gifted individuals possessed of lofty ideals, high ambition, and no money, who created a humble photography journal with the life expectancy of a hamster—and not a particularly healthy one.

That its golden anniversary is herewith celebrated is little short of a miracle.

The fifty years accounts for the publication of a quarterly periodical. But it also embraces the subsequent publication of books—nearly five hundred of them; an archive of thousands of original, some near-priceless prints; exquisite reproductions of masterpieces for collectors; an educational program for interns; and Aperture's Burden Gallery in Manhattan, at the 23rd Street headquarters. But thinking merely in terms of a half-century is misleading.

In the pages of Aperture publications appear glimpses of the entire history of the medium, reaching back to its beginnings—the French and English inventors of photography in the late 1830s. From there the image makers represented move through the great Victorians and the twentieth-century masters and innovators right up to photographers at work in the twenty-first century, just before this monograph went to press. The succession of what might be called critical phases advances from Pictorialism, Photo-Secession, "Group 64," Modernism, Postmodernism, and so on, and ranges over descriptive labels such as "purist," "landscape," "surreal," "abstract," "documentary," "mystical," and so on and so on more. Technically, it is a span of imagery from daguerreotype to digital.

Chronologies are mostly irrelevant, however, because photography is the medium that poses conundrums of time. Images as sequenced in the ensuing pages reveal time past and time present, intersecting with hints of time future in chartless rhythms of non-Euclidean history. There is a deeper impulse among these photographs. Each was brought forth by an artist who captured a moment reflective of both inner and outer realities. These are visionary moments that have entered into and altered the psyche

of viewers, becoming part of that portfolio of the mind each of us carries about. And each image, through time, contains a history, some essence of its maker.

While thousands of artists, writers, skilled craftsmen, and supporters have sustained Aperture over the years, the improbable fact of its survival is due primarily to one man: Michael E. Hoffman. He kept it going through most of the last four decades: through official closure, the brink of bankruptcy, personal tragedy, and an endless search for the means to continue. In other words, through capacious ability and sheer willpower. And if this not-for-profit foundation has never prospered in a financial sense, Aperture thrives. No one would be more surprised than the people who created it, who are now referred to in rather stately fashion as "The Founders."

Time present and time past
Are both perhaps present in time future
And time future contained in time past
— T. S. Eliot, *Four Quartets*

After an uproarious spring evening in 1952 of talk, music, and drink, nine people gathered in the living room of a frame house with a view of the San Francisco Bay. Their goal was to bring to life an idea—long simmering among several of those present—for a journal devoted to a particular vision of photography. One

The Aspen Conference at which *Aperture* was first conceived; pictured are the Founders, including Minor White, Ansel Adams, Barbara Morgan, Nancy Newhall, Beaumont Newhall, and others, 1951. Photograph by Ferenc Berko.

OPPOSITE TOP: *Aperture* vol. 1, no. 1, 1952, pages 4–5: photograph by Lisette Model.
OPPOSITE BOTTOM: *Aperture* 159, 2000, pages 20–21: photographs by Edward Weston.
NOTE TO READERS: *Aperture*'s system of numbering issues underwent a change in 1975, when *Aperture* vol. 19, no. 4 was followed by Aperture 77; all subsequent issues are numbered consecutively, from 77 on.

wishes the scene might have been recorded, because despite a shared affinity for the subject, those present seldom agreed on much. Chief among them:

ANSEL ADAMS: The host, with his wife, Virginia. Born 1902 in Carson City, Nevada, Adams was America's best-known landscape photographer, an acknowledged master of camera and darkroom technique, and a foremost applied theoretician, whose Zone System of meticulous light-measurement and printing would become a cornerstone of photography education. The son of an avowed Emersonian transcendentalist, Adams had intended to be a concert pianist—a dream he never quite gave up. He subsequently was one of the country's foremost environmentalists and a founder of the Sierra Club.

DOROTHEA LANGE: Her name had become a virtual glyph for the term "documentary photographer." Born 1895 in Hoboken, New Jersey, and struck in childhood by polio that left her with a lifelong limp, Lange had become a fashionable San Francisco portrait photographer by the time she was twenty-five. The Depression called forth her genius. With her second husband, the social scientist Paul Taylor, she traveled tens of thousands of miles for the Farm Security Administration (FSA), recording the plight of farmers, migrants, and breadline unemployed. Her portrait *Migrant Mother*, of a destitute woman with two small children, became one of the most reproduced photographs of the twentieth century. Passionately engaged, Lange was to battle to the end of her life for a photography committed to documenting the enormous changes in the American social landscape.

BARBARA MORGAN: Born 1900 in Buffalo, Kansas, she was raised in Southern California and early in her studies fell under the spell of the concept of "rhythmic vitality" enshrined in the Chinese Six Canons of Painting. Unquestionably the greatest dance photographer in the medium's history—her collaboration with Martha Graham extended over sixty years—Morgan possessed a breadth of philosophical and intellectual interest, as well as being the most protean of photographers. She was self-described as a "kinetic light-sculptor," and her light drawings, double exposures, and photomontages ranged from emotionally charged insight to deft satire— all devoted to her ultimate intent of an "authentic response to life."

BEAUMONT NEWHALL: Scholar and historian, born 1908 in the seacoast village of Lynn, Massachusetts, he was a Harvard-trained art historian and Medievalist. Hired as a librarian by Alfred Barr, director of New York's Museum of Modern Art, Newhall went on to create there the first photography department of any American museum, and curated groundbreaking exhibitions in the latter half of the 1930s. Ever anxious about his overly dry, academic approach to the subject, Newhall nonetheless experienced in the most dramatic fashion the power of photography—the selection of human targets and images of the aftermath—when he was assigned to aerial reconnaissance in Europe during World War II. He later created the first American museum of photography at the George Eastman House in Rochester, New York, and among his prolific writings are the classic *History of Photography* and *Focus: Memoirs of a Life in Photography*.

NANCY NEWHALL: Born the same year as Beaumont in Swampscott, a town adjacent to Lynn, she was a painter who later was to say of their marriage in 1936, "When I married Beaumont I married photography." Nancy was among the most gifted writers and undeniably the finest literary editor in the medium in the twentieth century, with accomplishments notably including her landmark edition of the *Daybooks of Edward Weston*. During Beaumont's overseas duty, 1942–45, she was the acting curator of photography at the Museum of Modern Art. Despite tepid support from the museum's trustees, she organized three major shows, including "Art in Progress," spanning the history of photography, as well as monumental retrospectives of Paul Strand and Edward Weston.

MINOR WHITE: Born 1908 in Minneapolis, he received his first camera at age seven, and dated his decision to become a photographer to his twelfth year. After studying botany at the University of Minnesota, he found work in the 1930s with the Works Progress Administration (WPA), photographing civic theater groups and teaching photography workshops. The first national exhibition of White images occurred during the "Image of Freedom" show at the Museum of Modern Art, a patriotic endeavor curated by Beaumont Newhall and Ansel Adams. His World War II service on a destroyer in the Pacific included combat during the Leyte invasion, where, according to his letters, he killed at least one enemy soldier, was wounded, and witnessed the deaths of close friends. These experiences left him too shattered to photograph in the early aftermath of the war. His remarkable story emerges in some detail in the following pages.

Also present at the Aperture Founders' meeting were three individuals who made early and vital contributions: Ernest Louie, Melton Ferris, and Dody Warren. At the outset, the group constituted the Aperture family and as such set the tone for what would become an ever-widening community.

The relationships among the Founders were intense and complex: at times aesthetically and metaphysically exalted, and at others downright melodramatic. Ansel, for example, was rumored to have remarked that he never agreed with anything Minor ever said. Minor, throughout his editing career, was hesitant to publish Ansel's pictures. Dorothea Lange, with her deep social commitment, often felt some of the others—particularly those making "abstractions"— were either wasting their time or betraying the integrity of photography. Ansel and Nancy in due time fell in love, but both remained devoted to their respective spouses. Barbara Morgan healthily bal-

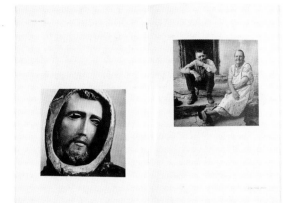

In the pages of Aperture publications appear glimpses of the entire history of the medium . . . Pictorialism, Photo-Secession, "Group 64," Modernism, Postmodernism . . . "purist," "landscape," "surreal," abstract," "documentary," "mystical," and so on and so on more.

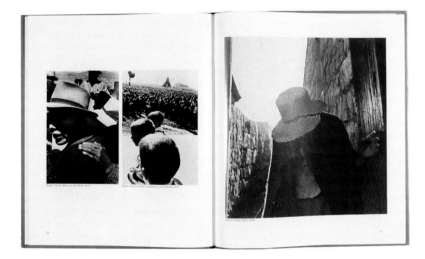

TOP: *Aperture* vol. 2, no. 4, 1953, pages 30–31: (left) photograph by Ansel Adams; (right) photograph by Dorothea Lange. MIDDLE: *Aperture* 81, 1978, pages 72–73: photographs by Robert Frank. BOTTOM: *Aperture* 145, 1996, pages 18–19: (left) photograph by Kiki Smith; (right) photograph by Constantin Brancusi.

anced family and working life, and carried on a prodigious schedule of photographing, painting, teaching, and designing. Over the years, the only person who seemed able to remain uninterruptedly on speaking terms with everyone else was Nancy Newhall.

Also as in a family, they were fiercely loyal to one another—photographing together, finding jobs for each other, always protective against threats or attacks from outsiders. All the criticisms, carpings, and outright bitchiness to be found in their letters and reminiscences were meant strictly for private consumption: family gossip.

There were other presences at that remarkable meeting in 1952. The need for a serious quarterly devoted to photography had been bruited the previous autumn during a seminar at the first Aspen Photographic Conference. The Newhalls had both attended, as had Ansel, Minor, Lange, Berenice Abbott, Laura Gilpin, Frederick Sommer, and Eliot Porter, among others, and there were representatives from advertising, magazines, and the Library of Congress. Those not present at Ansel and Virginia's house the following year were nonetheless keenly interested in the outcome of the meeting, and several were to become early Aperture contributors and supporters.

Another deeply felt influence was 125 miles down the coast at Carmel: Edward Weston, unable to attend because he was in a long, painful slip from life due to Parkinson's disease. Several of the San Francisco participants were close friends of Weston's and had photographed with him. Each was distressed at the illness that had deprived him of the capacity to use his camera four years earlier. He was now under the care of his sons, including Brett, whose international reputation as a photographer had begun at age seventeen, and Cole, keeper of the Weston legacy and later one of the medium's foremost colorists. Edward represented an ideal for those contemplating the new publication, a singleness of purpose that had underpinned his once-legendary vitality and his incomparable mastery.

And there was a ghost present in San Francisco—no less haunting simply because one does not believe in ghosts. This was the unquenchable spirit of Alfred Stieglitz, dead six years earlier, but deeply imbued in the lives and work of most serious American photographers. Born in 1864, like Lange in Hoboken, and supported by an unusually enlightened, affluent father, Stieglitz traveled extensively in Europe in his youth and had achieved an international reputation in photography salons by his early twenties. He had also begun writing extensively about photography and editing journals devoted to the medium. At the turn of the century, Stieglitz—despite recurring bouts of ill health—unleashed enormous energy on behalf of a new generation of creative photographers breaking free of what he felt were the limp, painterly conventions of the past. He named this movement the Photo-

Secession, and opened a series of galleries to exhibit the work of its proponents, as well as of other groundbreaking artists. The first gallery, called simply "291," and his publication *Camera Work* gave many Americans their initial view of imagery by Edward Steichen and Paul Strand, and also introduced to this audience works by Rodin, Matisse, Picasso, Brancusi, Picabia, and Toulouse-Lautrec, to name only a few. Subsequently, Stieglitz was to devote most of his curatorial efforts to American artists, including Marsden Hartley, John Marin, and Arthur Dove.

Stieglitz's most notable collaboration was with his second wife, the painter Georgia O'Keeffe. He mounted her first one-person show, launching one of the most remarkable careers in twentieth-century art. And she provided him with his perfect model, inspiring hundreds of photographs—nudes, portraits, and hands—which constitute an enormous block of Stieglitz's finest achievements.

The specter of Stieglitz present among the Aperture Founders that day in 1952 was largely the matter of an indelible personality and an elusive ideal. He was old when he came directly into the lives of Adams, White, and the Newhalls, but no American photographer of the time was untouched by Stieglitz's influence. In appearance, he had become a simulacrum of a black-and-white photograph: white hair and thick, well-trimmed moustache; almost unlined, near-albino skin; dark, penetrating eyes; he dressed in the whitest of linen and the blackest of tie, suit, and cape. Stieglitz was an at-once man: at once kaleidoscopically complex and evangelically simple, at once humble in the best sense and arrogant in the worst, at once remarkably patient and unnecessarily abrupt, at once a kind man and cruel.

His final gallery was An American Place, located in an office building on Madison Avenue, just a block from the Museum of Modern Art. Here, he would accept no money for himself but required the purchaser of an artwork to make a "contribution" to the artist. If, however, Stieglitz judged a buyer to be unworthy, he might refuse to sell him a photograph, drawing, or painting at any price. He had a general dislike of museums and the world of art galleries. Beaumont Newhall became his whipping boy for years after a visit in 1935. Representing the Museum of Modern Art, Newhall sought prints for an exhibition (Stieglitz wouldn't consider it), and asked innocently if a certain photograph was taken with panchromatic film. "Young man," Stieglitz snapped, "that has nothing at all to do with the picture"; and he walked off.

Two years earlier, Ansel Adams had made his pilgrimage to An American Place to show his work. After an unfriendly greeting, Stieglitz did go over the portfolio, and then looked at the images again, and described them as "some of the most beautiful photographs I've ever seen." To Ansel he granted the supreme accolade of a solo show—something Stieglitz had not done since his Strand exhibition nearly twenty years earlier. When Minor went to

An American Place in 1946, shortly before Stieglitz's death, the old man was kind, encouraging. Looking at Minor's prewar photographs, he asked, "Have you ever been in love?" Minor said yes, and Stieglitz told him, "Then you can photograph." It was the moment, Minor later said, that released him from his wartime traumas and reawakened his desire to photograph. To Nancy Newhall, Stieglitz was affectionate—almost fatherly; he was supportive of her writing and provided her with extensive recollections about his own life.

Stieglitz's deepest relations were with women—O'Keeffe, Nancy Newhall, and for many years the multitalented Dorothy Norman, who became his primary biographer. To his famous remark "Photography is my passion. The search for Truth my obsession," should be added a comment he once made to Nancy: "My medium is Woman." His relationships with the male artists he championed always began hopefully, and were always disappointing. At the turn of the century, Stieglitz had looked to Edward Steichen as the disciple who would carry on his ideals and work. By the late 1930s he had shifted his hopes to Ansel Adams. The problem was, neither Steichen nor Adams—both with families—had any affection for the poverty that Stieglitz ascetically embraced. Both went on to public success and considerable wealth—apostasy to Stieglitz.

And what of the ideals? Stieglitz is usually associated with the struggle to have photography recognized as an art form in itself, carrying on a struggle started in the late nineteenth century by the English polymath P. J. Emerson. This is a somewhat misleading simplification. As Michael Hoffman was to suggest years later, Stieglitz in his photography and writings was trying "to come in contact with a cosmic order, or a harmony." It was an effort manifested in the making of his series of photographs called "Equivalents."

The concept arose from a series of cloud photographs Stieglitz made in 1922, returning to a subject that he felt had defeated him years earlier. In looking at the cloud series, Stieglitz said, his aim was "increasingly to make my photographs look so much like photographs that unless one has eyes and sees, they won't be seen—and still everyone will never forget them having once looked at them . . . of greatest importance is to hold a moment, to record something so completely that those who see it will relive an equivalent of what has been expressed." Later, Stieglitz would come to believe that all art in the truest sense is an equivalent.

For all of his own writings and subsequent commentaries, Stieglitz's "equivalents" remains a slippery idea, and therein lies its enduring power. Once an ideal is nailed down it becomes mere ideology. As an ideal that informs intuition, the feeling for "equivalents" entered into the Aperture ethos from the beginning.

Ansel provided the name *Aperture* for the new journal, which was scheduled to be a quarterly. With Minor White volunteering as editor, the first issue appeared in April 1952. It was a modest affair compared with its inspiration, Stieglitz's *Camera Work*, which he had published from 1902 to 1917. One of the most beautiful journals in any medium of any time, *Camera Work* had been printed on Japanese tissue paper with Stieglitz's own photogravures of the artists represented. Stieglitz had enlisted writers as diverse as Gertrude Stein, John Galsworthy, Lewis Mumford, Hart Crane, and Waldo Frank. That first issue of *Aperture*, sized 6¼ by 9⅜ inches, boasted twenty-seven pages, and featured three photographs—by Lange, Adams, and the Viennese-born Lisette Model. Minor and Nancy did all the writing: two extended essays. A few additional photographs illustrated Minor's "The Exploratory Camera: A Rationale for the Miniature Camera." Nancy's piece was titled "The Caption: The Mutual Relation of Words/Photographs," and it remains one of the definitive essays on the subject.

Perhaps the most compelling aspect of the new publication was the statement of *Aperture*'s raison d'être in its first editorial. There, the Founders laid out their intentions for a "mature" journal that would communicate with "serious photographers and creative people everywhere, whether professional, amateur, or student":

> Every photographer who is a master of his medium has evolved a philosophy from such experiences; and whether we agree or not, his thoughts act like a catalyst on our own—he has contributed to dynamic ideas of our time. Only rarely do such concepts get written down clearly and in a form where photographers scattered all over the earth may see them and look at the photographs that are their ultimate expression.

Aperture, they concluded, was an open invitation to "a common ground for the advancement of photography."

Minor was a logical choice for editor; he already edited the periodical *Image* (and besides, he was the only candidate). Like Stieglitz, he had a rather unworldly attitude toward money; during the next fifteen years of his editorship, he never received a penny for his often prodigious efforts on behalf of *Aperture*. Nor did any of the contributors of photographs, essays, or reprints. Nor did Ernest Louie, the designer for the first few issues, nor Melton Ferris, who volunteered as production manager for several years. Minor did get something in return because he, in fact, *was Aperture*. Informally organized, it was copyrighted in his name. And the periodical was headquartered wherever Minor lived: first in San Francisco, where Ansel had found him a teaching post; subsequently in Rochester, New York.

Editors can be either despots or puppets; Minor was definitely, if on most occasions civilly, the former. It was up to him to interpret and realize the Founders' intentions. As with most complex individuals, time has yielded commentators who reduce the extraordinary to the banal in their labeling. In Minor's case, the sticking commonplaces are "mystic"—usually as a pejorative—and homosexual, in either the pejorative or the celebratory sense. His editing reveals a man of originality, practicality (as far as photography was concerned), and near-limitless curiosity.

During the next few years, the quarterly reflected the taste, sweep, and quirks of Minor's view of photography. There were, of course, those artists now revered as masters of the medium, though little exposed to public view at the time. Among them: Weston's last photographs of the endlessly evocative cove so associated with his name, Point Lobos; a portfolio from Mexico by Manuel Alvarez Bravo—a selection later recognized as among his masterpieces; and indelible images including Wynn Bullock's pastoral nudes, Pirkle Jones's poetic land- and seascapes, and Paul Caponigro's supernal rocks and stones. An issue in 1953 concentrated on Chinatown in San Francisco with a photoessay by Charles Wong, "The Year of the Dragon," a mysterious contemplation of a kind of metaphorical kidnapping; and "Chinese New Year," a selection of works by members of the California School of Fine Arts, where Minor taught.

Minor White, 1957. Photograph by Walter Chappell.

In reproducing *Aperture*'s imagery, White looked over the shoulders of engravers, compositors, and printers at presses at the San Francisco (and later Rochester) printing houses where the quarterly was published. He meticulously went over every page, making endless, expensive, subtle and not-so-subtle corrections and alterations. Even so, he cautioned his readers that the best reproductions were inevitably poor imitations of the original prints.

Unpaid, the photographers appearing then (and now) in *Aperture* had hopes of awakening interest, possibly exhibition and purchase of their work. Some images were offered for sale. In the early 1950s, an astute subscriber could have bought Weston's fiftieth-anniversary portfolio of twelve prints for one hundred dollars, and a reproduction of Adams's classic *Moonrise, Hernandes, New*

Mexico, for six dollars plus tax. No such rewards accrued to the (unpaid) writers Minor needed. For the professionals, Dr. Johnson's admonition that only blockheads ever write except for money probably spoke to their very genetic makeup. Minor was constantly trying to prize out articles, critical essays, reports from conferences, and "advice." That he managed to do so was a credit to his persistence and patience. The Founders helped with essays but, with the exception of Nancy and Beaumont, seldom more than once.

Lange and her son Daniel Dixon coauthored an essay, "Photographing the Familiar," which, typically for Lange, emerged as a manifesto. Decrying the "fear, worship, convenience or custom" that led photography to seem more concerned with illusion than reality, she exhorted, "It is the nature of the camera to deal with what *is*—we urge those who use the camera to retire from what *might be*." Morgan contributed an analytical description of her working technique in the essay "Kinetic Design in Photography," which concluded, "Essentially, kinetic design is a channeling [of] one's discoveries of the central energy of any subject and as such it is a way of being in unison with life." Ansel offered an extended, thoughtful, ten-point plan for the education and training of photographers, reflecting his lifelong commitment to the medium's future practitioners. In it, he included a gamut of requirements—from a thorough training in photographic processes to a solid general education with emphasis on the humanities. He called for experience in community efforts, including relationships to museums and related organizations, which would prove an insight into the nature of *Aperture*'s future way of working. Adams's essay also provided a curious academicism that photography required "severe standards of professional training and professional certification to establish itself as an Art."

White, of course, weighed in with much of the writing—so much so that he began to use pseudonyms to give readers a sense of variety. One of his noms de plume was "Myron White"; another was in the guise of an ambiguously ancient and wise Chinese poet named "Sam Tung Wu," whose verse accompanied photographs of White's own choosing.

Reviews of publications always formed part of *Aperture*'s perceived mission, and in the second issue, Minor revealed himself as a willing controversialist. The object of his polemic was the book *Advanced Photography* by Andreas Feininger. Minor praised Feininger's descriptions and advice on the technical aspects, but deplored what he viewed as Feininger's subjection of the aesthetics and art of photography to the manipulation of such techniques. He criticized the book for misleading truly creative artists.

Minor asked for a reply to his critique of *Advanced Photography*, and Feininger obliged. He engaged issues of the "eternal" versus the "transitory" in photography, and of the "accidental" as opposed to the "controlled" and delved into the meaning of "cre-

"Every photographer who is a master of his medium has evolved a philosophy . . . and whether we agree or not, his thoughts act like a catalyst on our own— he has contributed to dynamic ideas of our time. Only rarely do such concepts get written down clearly and in a form where photographers scattered all over the earth may see them and look at the photographs that are their ultimate expression."

TOP: *Aperture* vol. 3, no. 4, 1955, pages 20–21: photograph by Alfred Stieglitz. MIDDLE: *Aperture* vol. 13, no. 3, 1967, pages 22–23: photographs by Jerry Uelsmann, except (bottom left) painting by René Magritte, and (bottom right) alchemical vessel with tree, manuscript, France, sixteenth century. BOTTOM: *Aperture* 122, 1991, pages 63–64: photographs by Nick Knight.

ative." And he thoroughly objected to being characterized as "naïve" and "pedestrian" on matters of aesthetics. Minor postscripted by accusing Feininger of imposing dogmatic formulae upon creative photography. A few years later, Minor bashed Feininger's *Creative Photography* on much the same grounds, ending with the observation—which must have been a relief to both men—that the author henceforth intended to publish only picture books.

Variety in *Aperture*'s texts was achieved by soliciting reprints, provided for free in that more generous age by the *New York Times*, the *New Yorker*, and other distinguished sources. Thus, Minor was able to publish articles by architect Frank Lloyd Wright on press photography and how he felt about being photographed; by Elizabeth Bowen on the writer's unpremeditated search for a subject; and Kenneth Clark's views on the relations of photography and painting.

Perhaps the most memorable title in *Aperture*'s entire history was from James Thurber's *New Yorker* piece "Has Photography Gone Too Far?" The answer from a nun in a Minnesota priory was unequivocal. It had. She named the photograph that had taken the medium over the edge . . . and its maker could not have been more pleased. Frederick Sommer delighted in mischief.

Born in Angri, Italy, in 1905, Sommer had a remarkable education, was fluent in several languages, and possessed considerable talent in drawing and painting. He had received encouragement from no less a personage than Stieglitz himself, and later from Weston (who according to some accounts gave Sommer his first camera). Almost entirely self-taught, he devoted himself to painting and photography at a young age, became a U.S. citizen, and settled in Prescott, Arizona, where he made his home for the rest of his life.

If there was ever a photographer who, as *Aperture*'s founding mandate invoked, had created "dynamic ideas" and "photographs that are their ultimate expression," it was Sommer. To begin with, he had a long list of "anti-'s." He was anti-organized religion, anti-organized belief, anti-creeds of art and aesthetics, anti-philosophy, and, rather stunningly, anti-metaphysics! He was devoted to the act of attention, to its quality rather than span. And he was a champion of combinatory art—of bringing things together that seemed unrelated, of discovering possibilities within possibilities.

Into his studio Sommer brought "found objects," some that might remain untouched for years until he discovered their coalescing with others, and from these linkages he created photographs of mystery and lingering beauty. It was one of these combinations, containing a severed foot loaned by a medical friend, which so aroused the ire of Sister M. Noemi, O.S.B., of St. Scholastica Priory in Duluth, Minnesota. The ardent eloquence of her letter, written in 1956, would be revisited by *Aperture* editors for decades.

She had recommended *Aperture* for the college library—in itself a rare act as the journal had only a few hundred subscribers—but withdrew the issue from the periodical room because the Sommer print "so trespasses on holy property, so profanes that which is sacred." She had nearly lost her own foot a year earlier to infection, had come to realize how precious it is to its owner and, if lost, how it deserved respectable disposition. Sister M. also noted that as a photographer in the college hospital she had taken "pictures of infections, skin diseases, and surgical cases" that made the Sommer print look mild, but with the intent of a realism that would help doctors in their practice. "That," she added, "is the photographic use of a part of the body in the spirit of Holy Service. But this particular foot [Sommer's] was exploited by a mind that was PERVERTED . . . the motive distortion and EVIL" [capitalization hers].

Sister M. was not Sommer's only detractor. He disliked both Newhalls—Beaumont for his pedantry and Nancy for her sentimentalism—and they thoroughly disliked his work. They wrote an indignant letter to Minor for publishing Sommer's photographs in *Aperture*, and he responded with the only answer he ever offered to Founders or others: "If you don't like it, you can do it yourself." No one ever took up the challenge.

The only time Sommer ever provided a description of his approach to photography was at the first Aspen Conference in 1951, when he suggested the term "imaginative realism." But that might have been to shut up, or at least annoy Lange, for whom photography such as his was as anathematical—although for different reasons—as it was to Sister M. Like Stieglitz, Sommer never met an "ism" that he liked.

As for Minor, he and Sommer were good friends; Sommer had the gift of friendship—even with people he thoroughly disagreed with—and he maintained his delight in mischief up to his death at age ninety-three in 1999.

The cumulative effect of those first few years of publication was for *Aperture* slowly to acquire an identity—and something more. Any periodical originating in ideals and values and purpose begins to take on an organic quality, to have a life of its own. In the pages of *Aperture*, images and writings began to convey a sense of photography as a palpable, living entity. And from the beginning there was a sense of struggle. The cover of the very first issue had been emblazoned with Ansel Adams's own passionate conviction in launching the endeavor: "We have nothing to lose but our photography!" To today's ears, that may have the ring of mock heroics. Fifty years ago, it had a precise, stirring meaning to the few members of the Aperture community who truly understood. If there was such a thing as a living, vital force called Photography, they were engaging a battle for its soul.

Probably the most mature idea ever presented to picture-making photography was the concept of Equivalence which Alfred Stieglitz named early in the 1920s and practiced the rest of his life. The idea has been continued by a few others, notably at the Institute of Design in Chicago under Aaron Siskind and Harry Callahan, and at the former California School of Fine Arts in San Francisco under the efforts of the present author. As a consequence, the theory is in practice now by an ever increasing number of devoted and serious photographers, both amateurs and professionals. The concept and discipline of Equivalence *in practice* is simply the backbone and core of photography as a medium of expression-creation.

At one level, the graphic level, the word "Equivalence" pertains to the photograph itself, the visible foundations of any potential visual experience with the photograph itself. Oddly enough, this does not mean that a photograph which functions as an Equivalent has a certain appearance, or style, or trend, or fashion. Equivalence is a function, an experience, not a thing. Any photograph, regardless of source, might function as an Equivalent to someone, sometime, someplace. If the individual viewer realizes that for him what he sees in a picture corresponds to something within himself—that is, the photograph mirrors something in himself—then his experience is some degree of Equivalence. (At least such is a small part of our present definition.)

. . . At the next level the word "Equivalence" relates to what goes on in the viewer's mind as he looks at a photograph that arouses in him a special sense of correspondence to something that he knows about himself. At a third level the word "Equivalence" refers to the inner experience a person has while he is remembering his mental image after the photograph in question is not in sight. The remembered image also pertains to Equivalence only when a certain feeling of correspondence is present. We remember images that we want to remember. The reason why we want to remember an image varies: because we simply "love it," or dislike it so intensely that it becomes compulsive, or because it has made us realize something about ourselves, or has brought about some slight change in us. Perhaps the reader can recall some image, after the seeing of which he has never been quite the same.

—Minor White, from "Equivalence: The Perennial Trend" (1963), *Aperture* 95, 1984

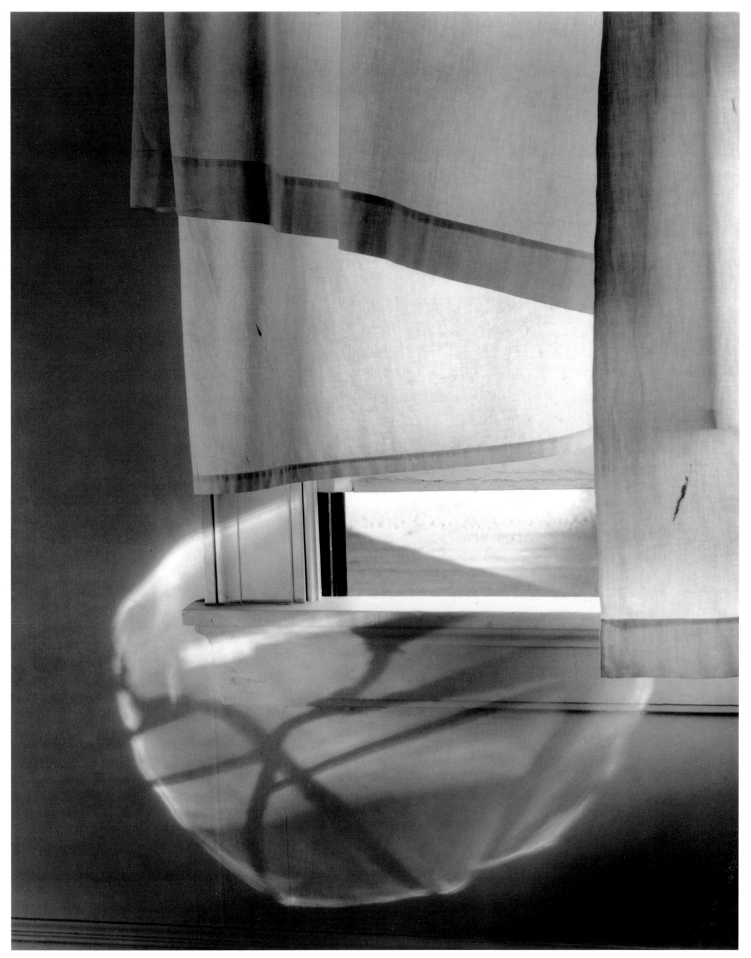

Minor White, *Windowsill Daydreaming*, Rochester, New York, July 1958; from *Aperture* 80, 1978.

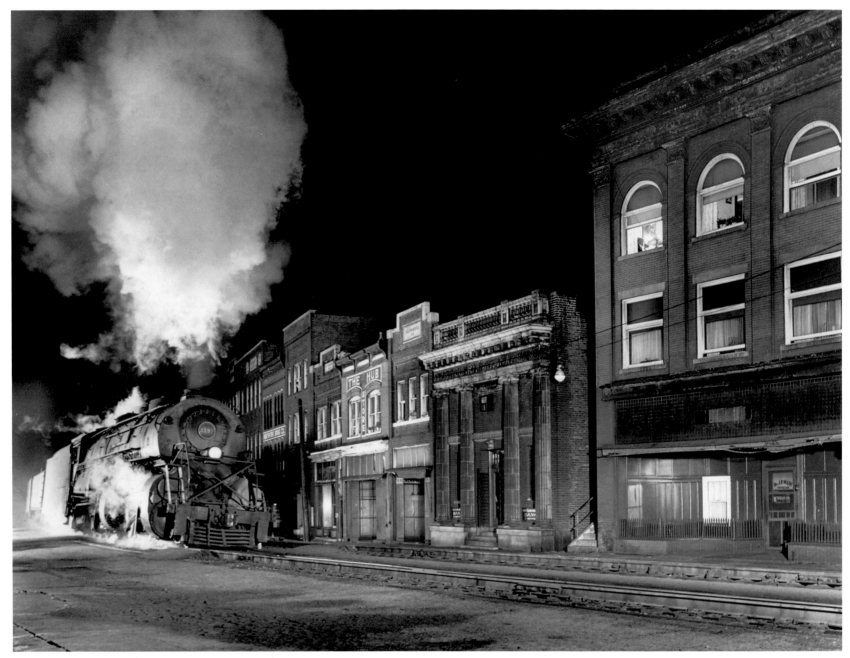

O. Winston Link, *Main Line on Main Street*, 1958; from *Aperture* 127, 1992.

Movement of contemporary life cannot be thought of without the machine. Our viewpoint is through a windshield, through reflected images on plate glass, blurred snatches through an elevator door. We watch quilted land patterns slowly shift far below our propeller blur, and the vibrating wing tip. Time is cogged, margins are tightened, spirit is pressured. Pavement is a child's backyard and the moon is less familiar than a street lamp. If it takes a thief to catch a thief, the camera is the machine to catch the machine age. . . .

—**Barbara Morgan, from "Kinetic Design in Photography,"** *Aperture* **vol. 1, no. 4, 1953**

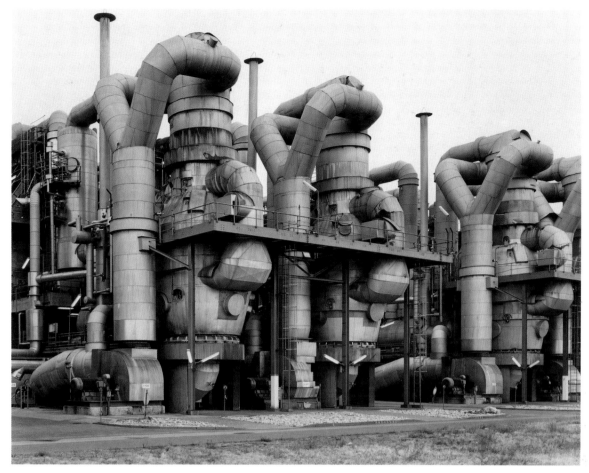

Bernd and Hilla Becher, *Plant for Styrofoam Production*, Wesseling near Cologne, Germany, 1997.

Piallat: Warehouse of agricultural implements (photolithograph)

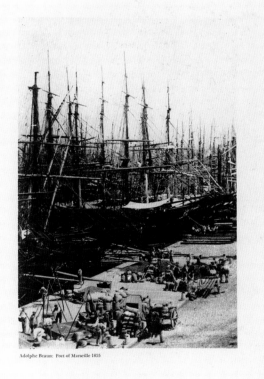

Adolphe Braun: Port of Marseille 1855

Aperture vol. 15, no. 1, 1970, pages 29–30: (left) photograph by Piallat; (right) photograph by Adolphe Braun.

THIS PAGE: photographs
by Lynn Davis.
TOP: *Team Disney*,
Orlando, Florida, 1998.
LEFT: *Jonas Salk Institute*,
La Jolla, California, 1999.

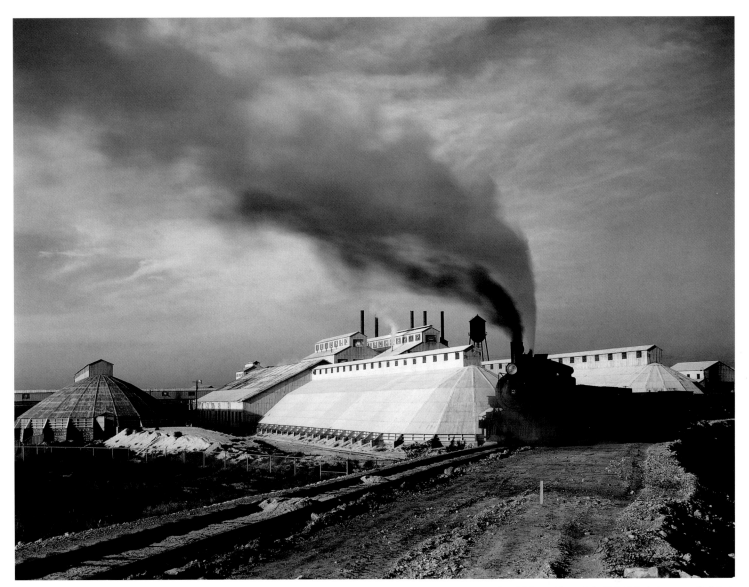

Ansel Adams, *Plant of the U.S. Potash Company*, Carlsbad,
New Mexico, 1941; from *Aperture* vol. 1, no. 3, 1952.

PAOLO GASPARINI
La Capilla De Ronchamp, France
Architect: Le Corbusier

TO PHOTOGRAPH GREAT ARCHITECTURE
OR HUMBLE, THE POET IN THE PHOTOGRAPHER MUST BE ACTIVATED
—WITH BAD ARCHITECTURE, THE SAINT

*The architect is a restless observer. He is
always active and effective in the investi-
gation of Nature. He sees that all forms
of Nature are interdependent and arise
out of each other, according to the laws
of creation. It is the poet in him that is
the great quality in him.*

FRANK LLOYD WRIGHT

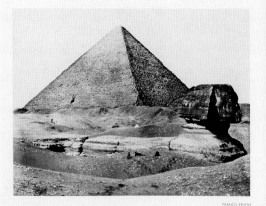

FRANCIS FRITH
Great Pyramid and Sphinx, 1858
Courtesy George Eastman House

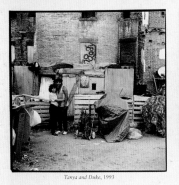

Tanya and Duke, 1993

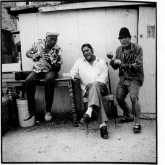

Gumi, Paco, and Hector Playing Folk Music, 1991

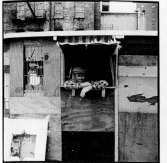

Pepe in Window, 1991

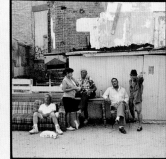

Bushville Residents and Neighbors, July 4, 1991

Neighbors from the nearby projects, most of whom were also Puerto Rican, used the path as a convenient shortcut through the block and would pause to converse in Spanish with the residents of what they *called "little Puerto Rico." A scavenged sign reading "Bushville," which Hector Amezquita nailed onto his house, gave a name and, according to Hector, a feeling of respect to this little village.*

Gumercindo with Dog, 1991

Pepe Gardening, 1993

Juan with Rabbits, 1991

Mario Cooking, Bushville Neighbor, 1993

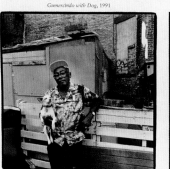

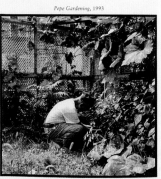

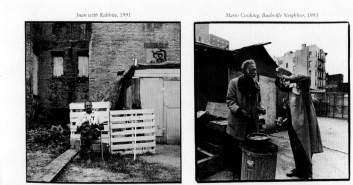

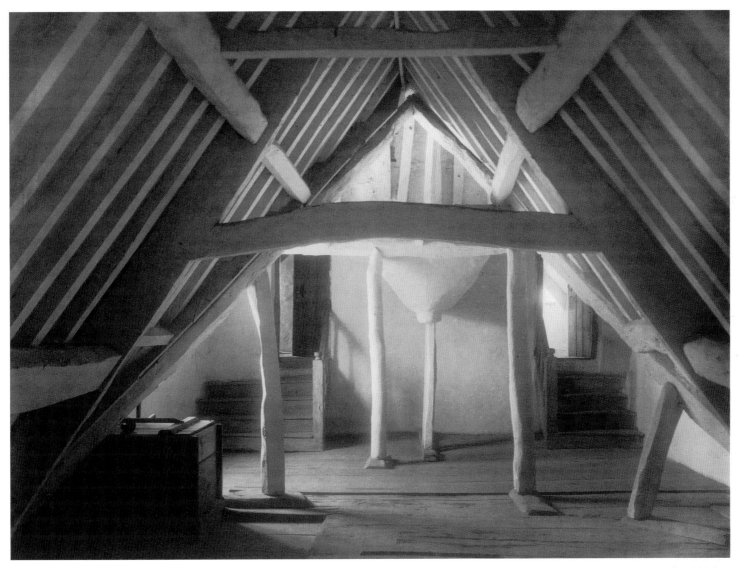

Frederick Evans, *In the Attic*, 1896, from
the album *Kelmscott Manor Photographs*;
from *Aperture* vol. 6, no. 4, 1958.

Architecture is a social art. It becomes an instrument of human fate because it not only caters to requirement but also shapes and conditions our responses. . . . It modifies and often breaks earlier established habit.

—Richard Neutra, from "Substance and Spirit of Architectural Photography," *Aperture* vol. 6, no. 4, 1958

OPPOSITE TOP: *Aperture* vol. 6, no. 4, 1958, pages 174–175: (left)
photograph by Paolo Gasparini; (right) photograph by Francis Frith. BOTTOM:
Aperture 144, 1996, pages 42–43: photographs by Margaret Morton.

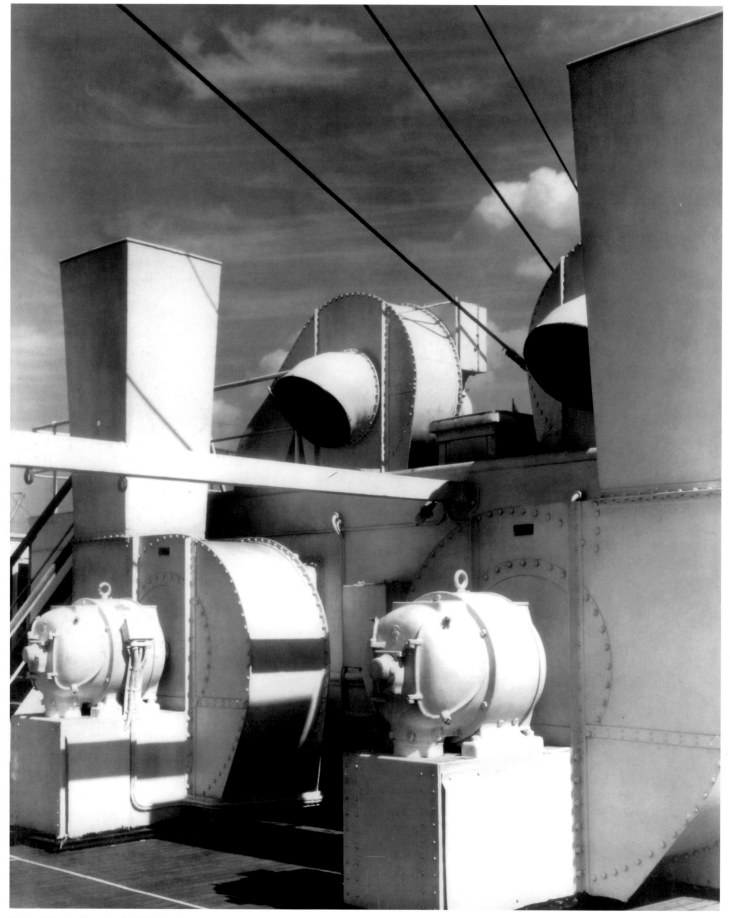

Charles Sheeler, *Upper Deck*, 1928; from *Aperture* 106, 1987.

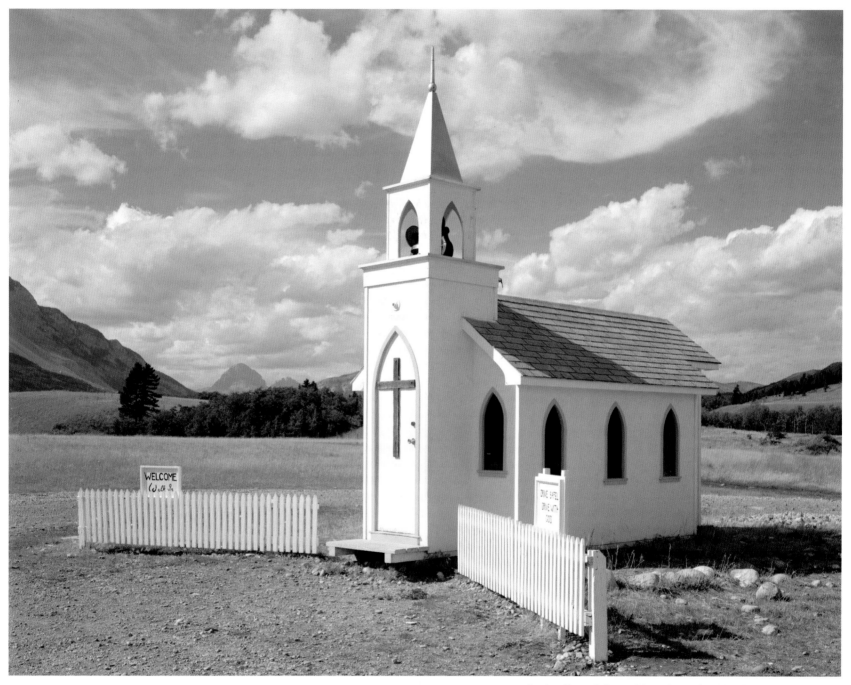

Stephen Shore, *Bellevue, Alberta*, August 21, 1974; from *Aperture* 77, 1976.

The small towns of North America are a far cry from what they used to be. While cities like New York, Los Angeles, and Miami have been, effectively, third-world capitals for some time, now the thousands of smaller towns also reflect this new national character. The combined impact of our nationally subsidized highway program, the once-mighty auto industry, and the new multicultural mix have changed "our towns" into something strange and wonderful. . . .

We are at a critical moment. Our national resources are becoming de-pleted, our old self-image doesn't exactly jive with what we see in the mirror, our economy is shaky, and our status among nations is questionable. And yet we hold the seeds of cultural rebirth and rejuvenation . . . if we are flexible and cool enough to accept a new definition of what we are. We can go down with the ship, proudly saluting the flag and quoting the pledge of allegiance, or we can get on the tramp streamer bound for who knows where. . . .

In a way, these photos are of a nation on the brink. A fond, or angry, goodbye to a dream that never mani-fested in reality. A myriad of ghettoized cultures about to confront one another. Pictures of a chemical reaction about to take place. All the right elements are here, but there's no precedent for the new polymer they'll create. It's a new primordial soup. A funky ooze. Good luck to us all, amigos.

—David Byrne, from "Funky Town,"
Aperture 127, 1992

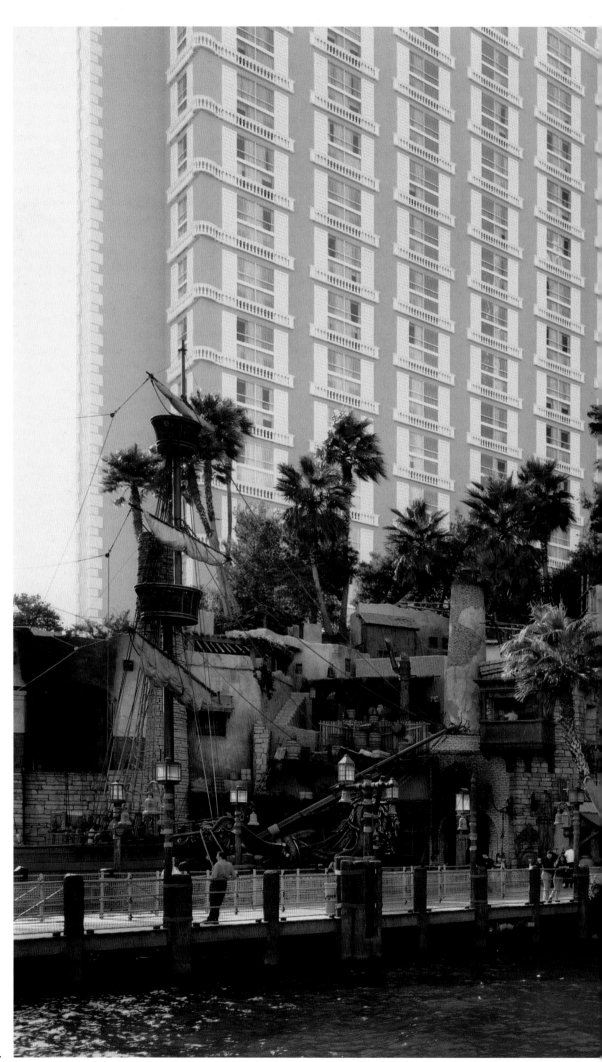

Thomas Struth, *Las Vegas, Nevada*, 1999.

THESE PAGES: photographs by Lois Connor. ABOVE: *Military Museum*, Beijing, China, 2000. BELOW: *Sydney Opera House*, Australia, 2000.

ABOVE: *Military Museum*, Beijing, China, 2000.

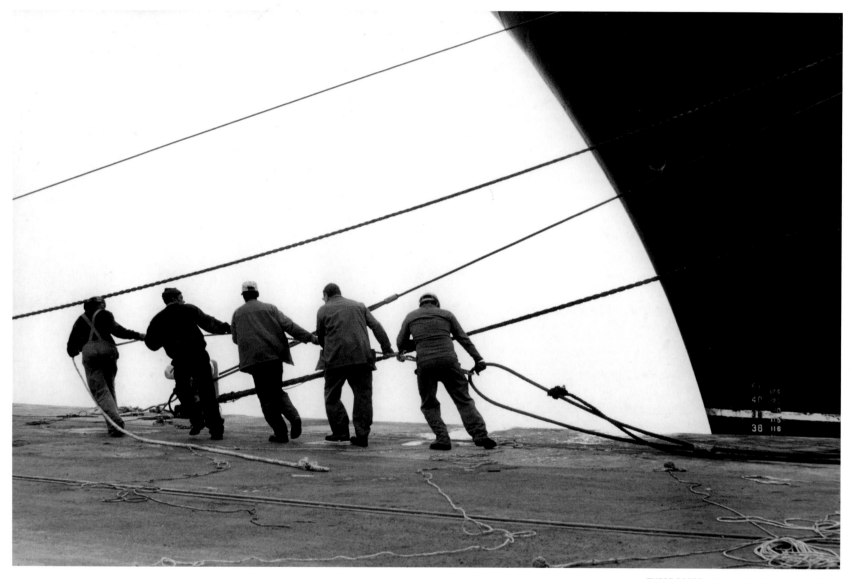

THESE PAGES: photographs by Bruce Davidson.
ABOVE: Securing mooring lines for the *Queen Elizabeth II*, Capetown, South Africa, 1998.
OPPOSITE: The *Queen Elizabeth II* during sand blast operation while in dry dock, Southampton, England, 1996.

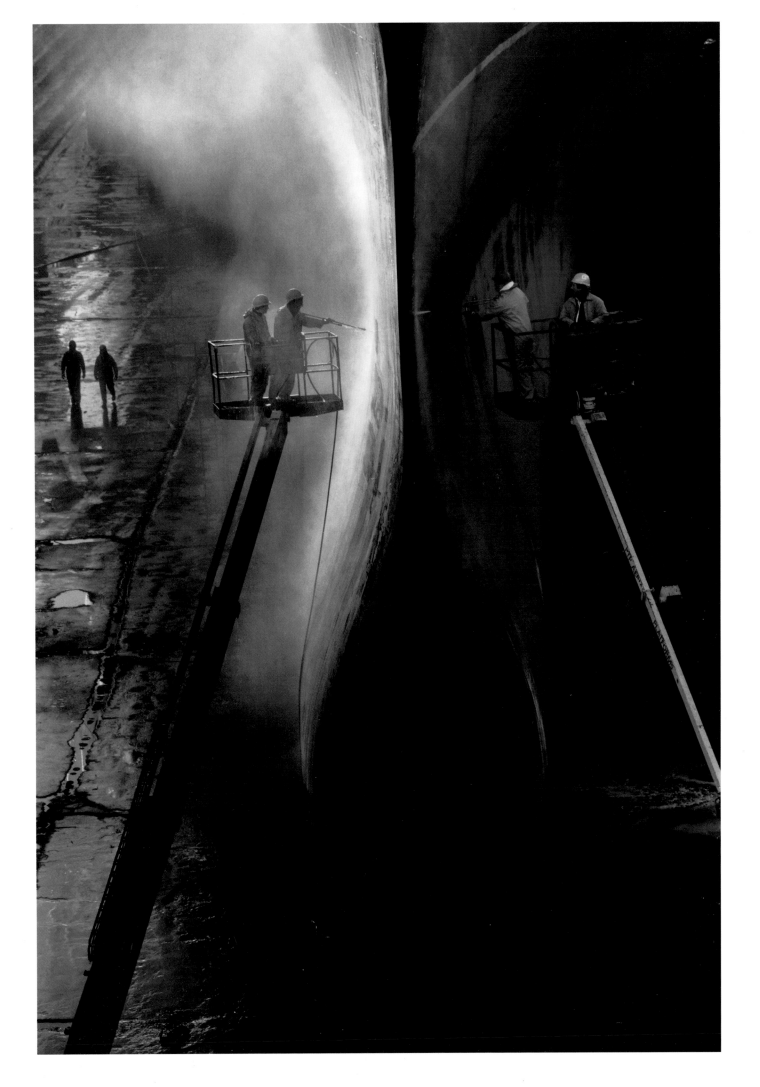

THIS PAGE: photographs by Chuck Close. *Bob*, 2000. *Cindy*, 2000.

Jack Kerouac wrote about his friends in *The Dharma Bums* as a novel, an epic of his own. Anything that resulted in the media is fall-out from his own original creation. The ordinary magazine myth would not exist without the high artistic creation, without a mutual collaborative artistic creation between friends, that involved mythmaking; which means companions were involved in seeing each other as mythical or sacred in a sacred world primarily; or not so much *mythical* as seeing each other as *real* in a really sacred world. So my motive for taking those snapshots was to make celestial snapshots in a sacred world, recording certain moments in an eternity with a sense of sacramental presence. The sacramental quality comes from an awareness of the transitory nature of the world, an awareness that it's a mortal world, where our brief time together is limited and it's the one and only occasion when we'll be together. This is what makes it sacred, the awareness of the mortality, which comes from a Romantic conception (Keats's) as well as Buddhist understanding (as in the "Shambhala" teachings of Chogyam Trungpa, Rinpöche). They are not contradictory origins; and Buddhism was part of the cultural awareness and later practice I shared with Jack Kerouac, Gary Snyder, and Philip Whalen. . . . The poignancy of the photograph comes from looking back to a fleeting moment in a floating world. The transitoriness is what creates the sense of the sacred.

—Allen Ginsberg, from "Allen Ginsberg's Sacramental Snapshots," *Aperture* 101, 1985

Cindy Sherman, *Untitled*, 2000.

Shirin Neshat, *Untitled*, 1996.

Perhaps a mind that is purely masculine cannot create, any more than
a mind that is purely feminine. . . . It is fatal to be a man or woman pure
and simple; one must be woman-manly or man-womanly.

—**Virginia Woolf (1929),** *Aperture* **156, 1999**

Edward Weston, *Charis***, 1936; from** *Edward Weston: Nudes* **(Aperture, 1977).**

Annie Leibovitz, *Ron Vawter*, New York City, 1993; from *Aperture* 133, 1993.

Neal Cassady and his love of that year Natalie Jackson conscious of their role in Eternity: Cassady had been Prototype for Jack Kerouac's 1950 On The Road saga hero Dean Moriarty, as later in 1960's he'd taken the driver's wheel of Ken Kesey's psychedelic era Merry Prankster Crosscountry bus "Further." Neal's illuminated America automobile energy, eager friendships & exotic enthusiasm had already written his name in bright-lit signs in our literary imaginations before movies were made imitating his charm. That's why we stopped under the Market Street marquee to fix the passing hand on the watch, San Francisco around March '55.
Allen Ginsberg

Jack Kerouac, railroad brakeman's rule-book in his pocket, couch pillows airing on fire-escape three flights up overlooking backyard Clotheslines south, my apartment 206 E 7th Street between Avenues B & C, Lower East Side Manhattan. Burroughs then in Residence, Corso visited often, Probably September 1953.
Allen Ginsberg

Gregory Corso, Paul Bowles & William Burroughs; behind him two dead boys, shades of the late Ian Sommerville & Michael Portman deceased crouching before garden wall, we all took our cameras out under blue sky, brilliant summer day, Villa Muneria Tanger 1961. Allen Ginsberg

THIS PAGE: photographs by Allen Ginsberg; from *Aperture* 101, 1985.

Top: Contact sheet from the collection of Hatow Hamid Majid Othman Pasha, Sulaimaniya.
Right: Susan Meiselas, Woman carrying dead child, Haji Omran, April 1991.
Bottom left: Anonymous photograph of Kurdish leader Ismael Simko and his forces, 1920s.
Top center: Postcard from 1895. Photograph by Abdullah Frère.
Bottom center: Rosy Rouleau, a Kurdish school, behind the *peshmerga* front lines, 1974.
Top right: Photos and Western Union telegram by Henry Field, 1930s.
Bottom right: Susan Meiselas, Sister sitting with the skeleton of her exhumed brother at Koreme mass-grave site, June 1992.

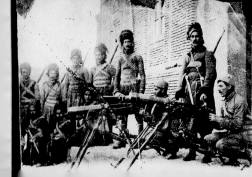

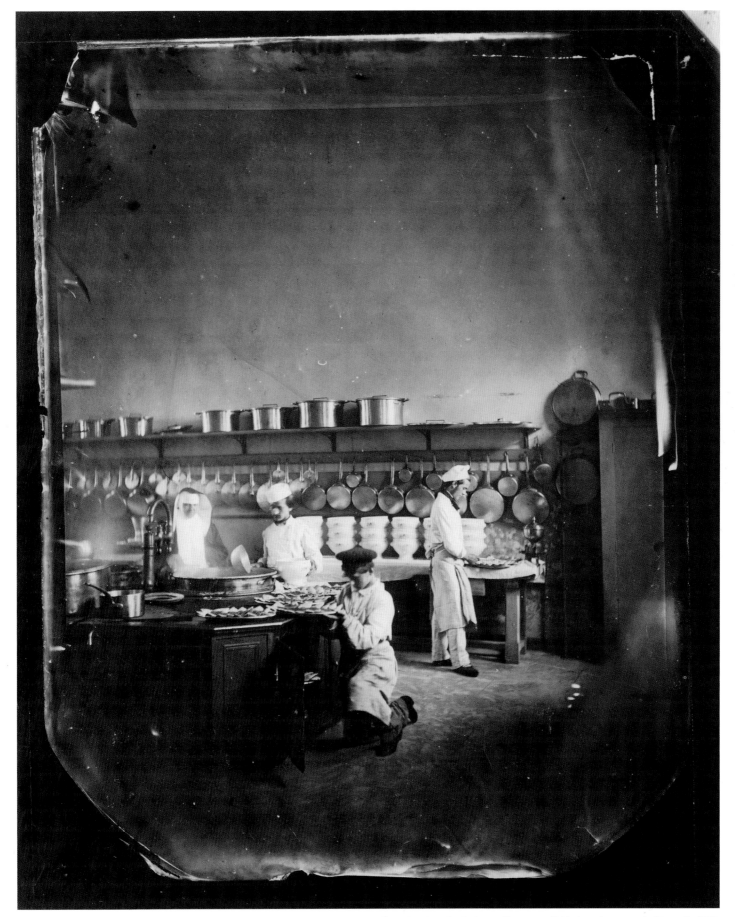

Charles Nègre, *The Imperial Asylum at Vincennes*, 1860; from *Aperture* vol. 15, no. 1, 1970.

OPPOSITE TOP: *Aperture* 90, 1983, pages 36–37: photographs
by Felix Beato. BOTTOM: *Aperture* 133, 1993, pages 30–31:
(left center and bottom right) photographs by Susan Meiselas.

Though not a poet, nor a painter, nor a composer, he is yet an artist, and as an artist undertakes not only risks but responsibility. And it is with responsibility that both the photographer and his machine are brought to their ultimate tests. His machine must prove that it can be endowed with the passion and the humanity of the photographer; the photographer must prove that he has the passion and the humanity with which to endow the machine.

—Dorothea Lange and Daniel Dixon,
from "Photographing the Familiar,"
Aperture vol. 1, no. 2, 1952

Lise Sarfati, *Tieriekhino I*, 2000.

Often it is in dreams that we communicate. . . . I am on a familiar street searching for a particular house. The moment I set foot in this street my heart beats wildly. Though I have never seen the street it is more familiar to me, more intimate, more significant, than any street I have known. It is the street by which I return to the past. Every house, every porch, every gate, every lawn, every stone, stick, twig or leaf speaks eloquently. The sense of recognition, compounded of myriad layers of memory, is so powerful that I am almost dissolved.

The street has no beginning nor end; it is a detached segment swimming in a fuzzy aura and complete in itself. A vibrant portion of the infinite whole. Though there is never any activity in this street it is not empty or deserted. Indeed, it is the most alive street I can think of. It is alive with memories, like an arcane grove which pullulates with its swarms of invisible hosts. I can't say that I *walk* down this street, nor can I say either that I *glide* through it. The street invests me.

—Henry Miller, from *Plexus, The Rosy Crucifixion, Book Two* (1965), *Aperture* 101, 1985

Gianni Berengo Gardin, *Milano, servizio fotografico, pausa di lavoro*
(Milan, photographic service, work break), 1987; from *Aperture* 132, 1993.

Dorothea Lange, *Spring in Berkeley*, 1951; from *Aperture* vol. 1, no. 2, 1952.

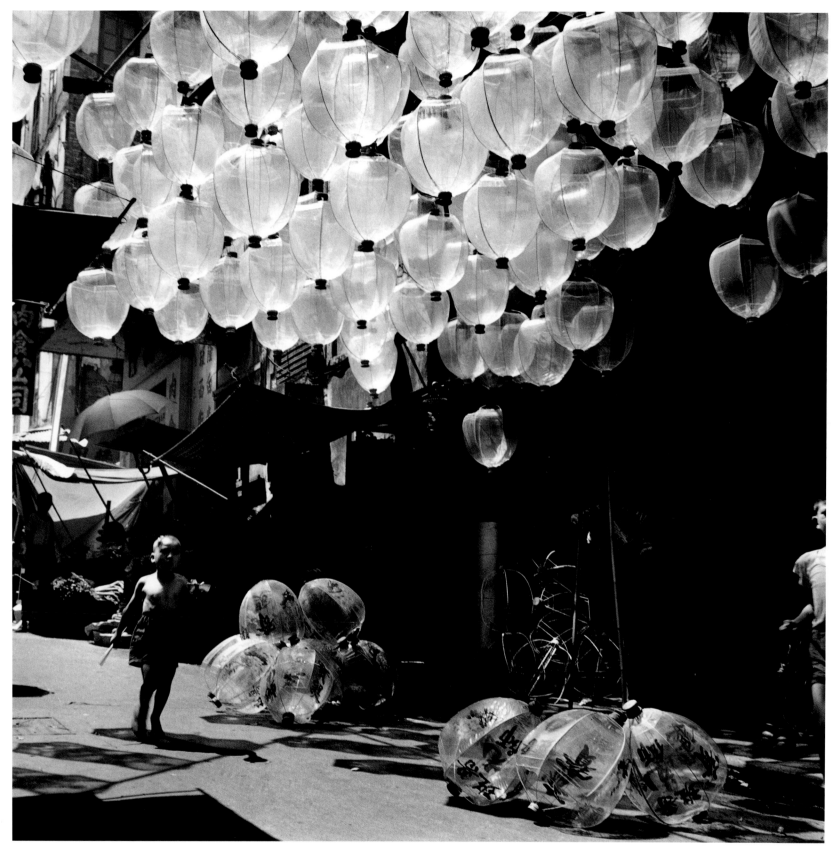

Josef Breitenbach, *Hong Kong*, 1964; from *Aperture* vol. 12, no. 4, 1965.

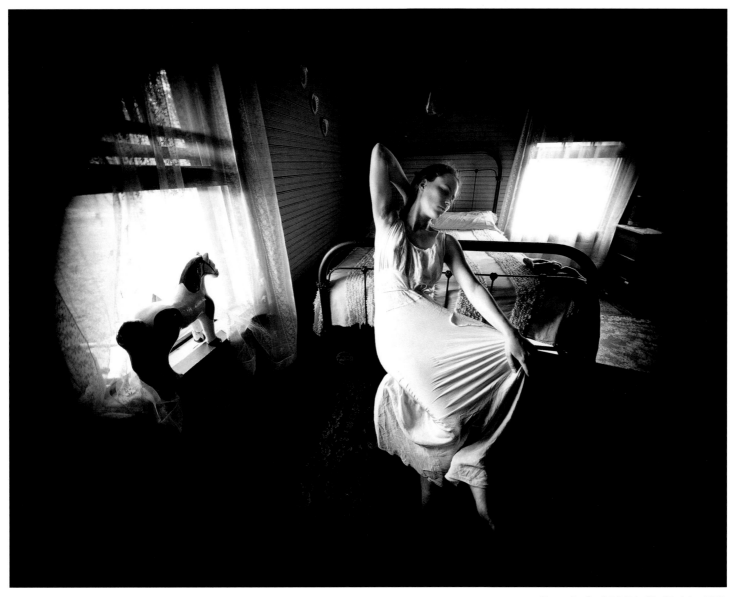

Emmet Gowin, *Edith*, Danville, Virginia, 1971.

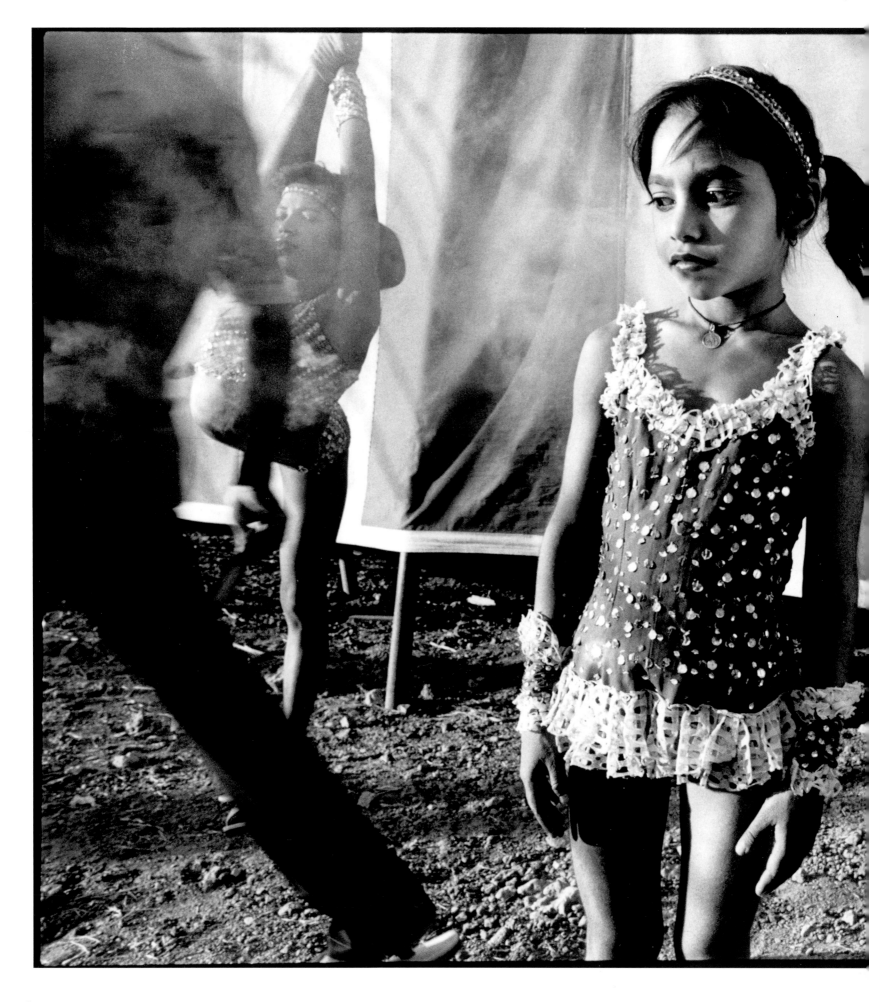

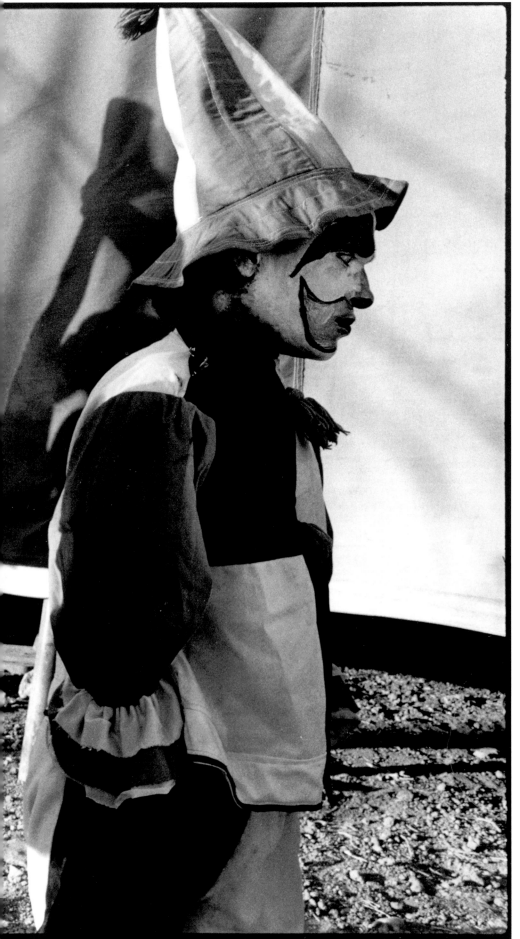

Mary Ellen Mark, *Pinky with Clown Man Passing on Left Side*, Royal Circus, India, 1990.

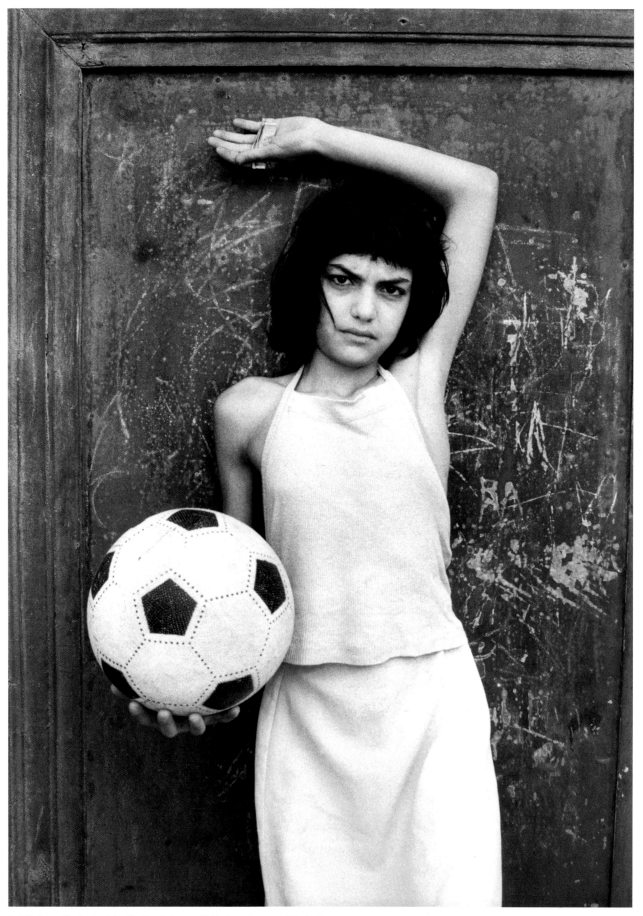

Letizia Battaglia, In the Cala district, Palermo, 1980; from *Aperture* 156, 1999.

OPPOSITE: Leonard Freed, *Summer in Harlem*, New York, 1963; from *Aperture* 148, 1997.

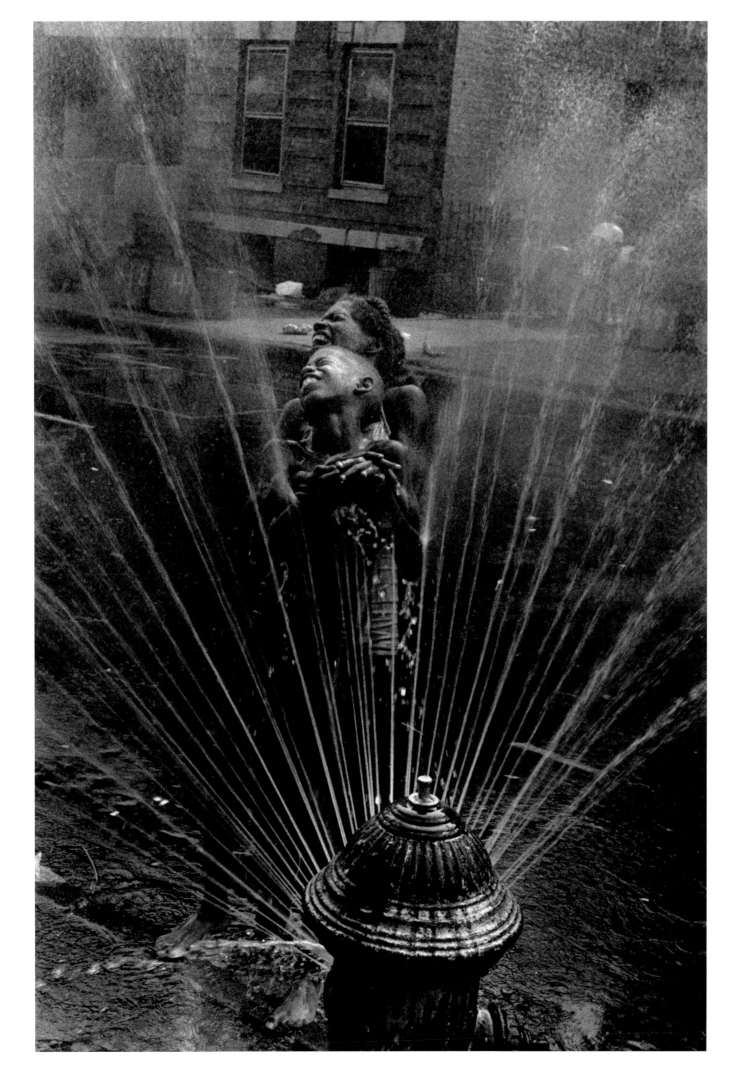

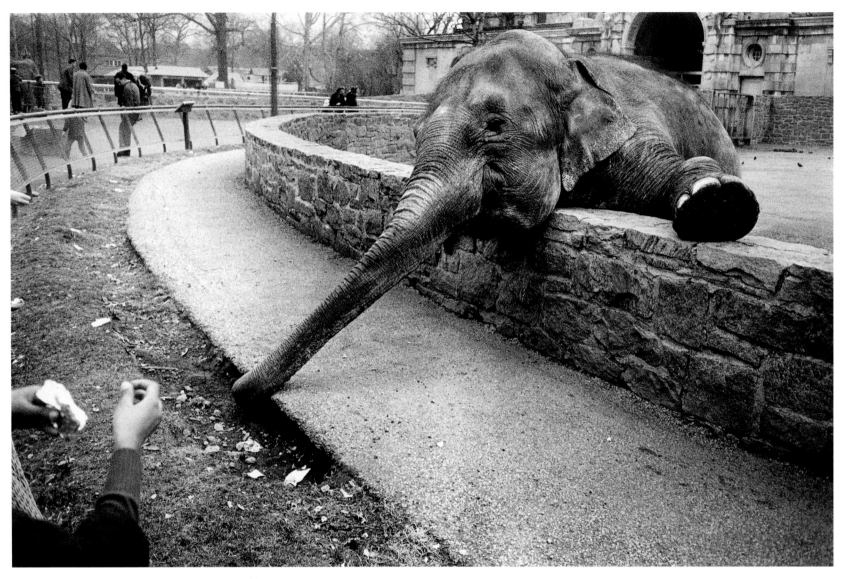

Garry Winogrand, *New York*, 1963; from *Aperture* 143, 1996.

I could take a cow and implant a camera in it and let it amble around in the city or in its own domain (I say a cow because a human being I would not trust). If the camera was programmed to go off at an indeterminate series of moments, the samplings would be fantastic.

We're not so damned inspired every day! If we rely on what we meet, some inspiration will arise. As an example, if I go into a grocery store . . . if I am smart I will take home what is best that day. I will not say that I want to

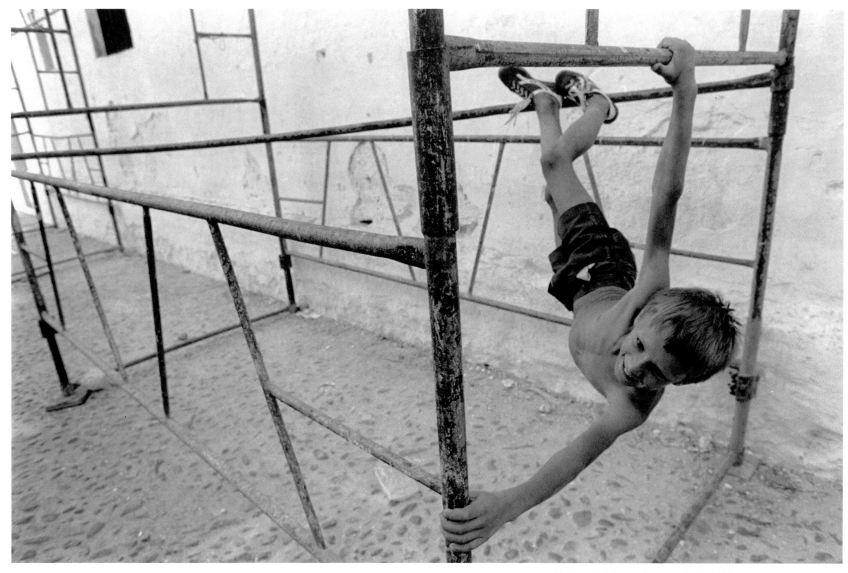

Ferdinando Scianna, *Carmona, Spain*, 1983; from *Aperture* 151, 1998.

buy apples today or that I want to buy oranges today. . . . I buy the best of what there is that day. If the beef looks good, I'm not going to buy lamb. . . .

The point of this is: if you work this way, if you live this way, if you just exist this way, you will find that by some strange coincidence (which I now know is not so strange), you will have brought together a number of things which make a magnificent meal. You consume this thing with champagne if you can afford it, and if not, you consume it just with enthusiasm.

—Frederick Sommer, from "An Extemporaneous Talk at the Art Institute of Chicago" (October 1970), *Aperture* vol. 16, no. 2, 1971

Jacques Henri Lartigue, *Gerda*, Hendaye,
France, 1937; from *Aperture* 156, 1999.

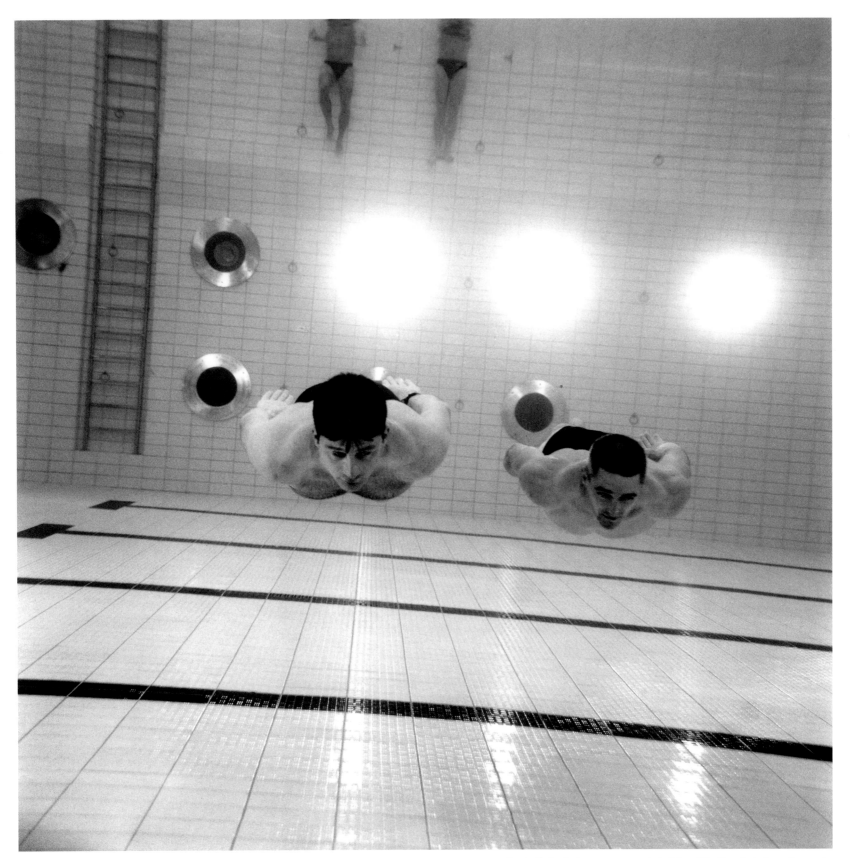

Giorgia Fiorio, Underwater commando training of the Kampfschwimmerkompanie, Eckernförde, Germany, November 1999; from *Aperture* 163, 2001.

Tracey Moffatt, *Fourth (No. 18)*, 2001.

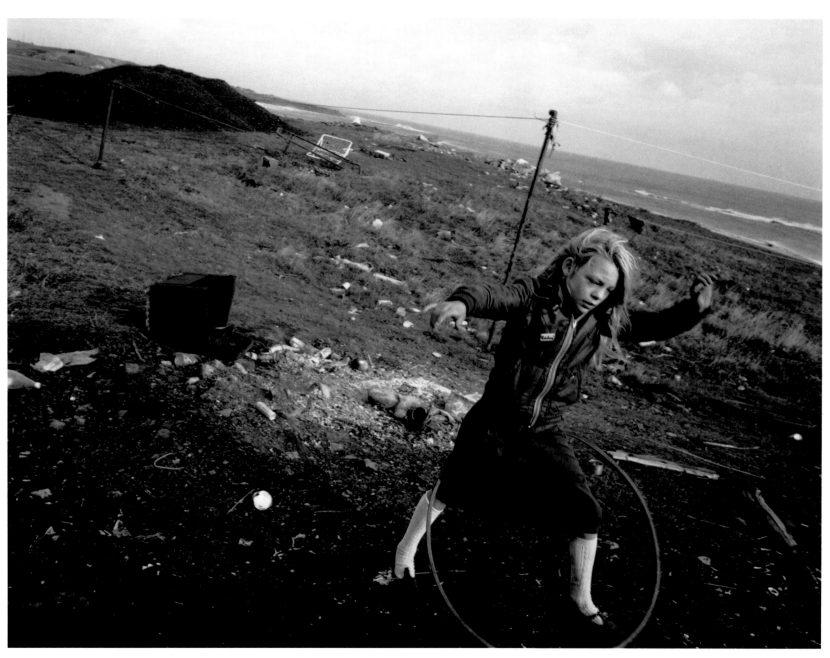

Chris Killip, *Helen and Her Hula Hoop*,
Lynemouth, 1983; from *Aperture* 103, 1986.

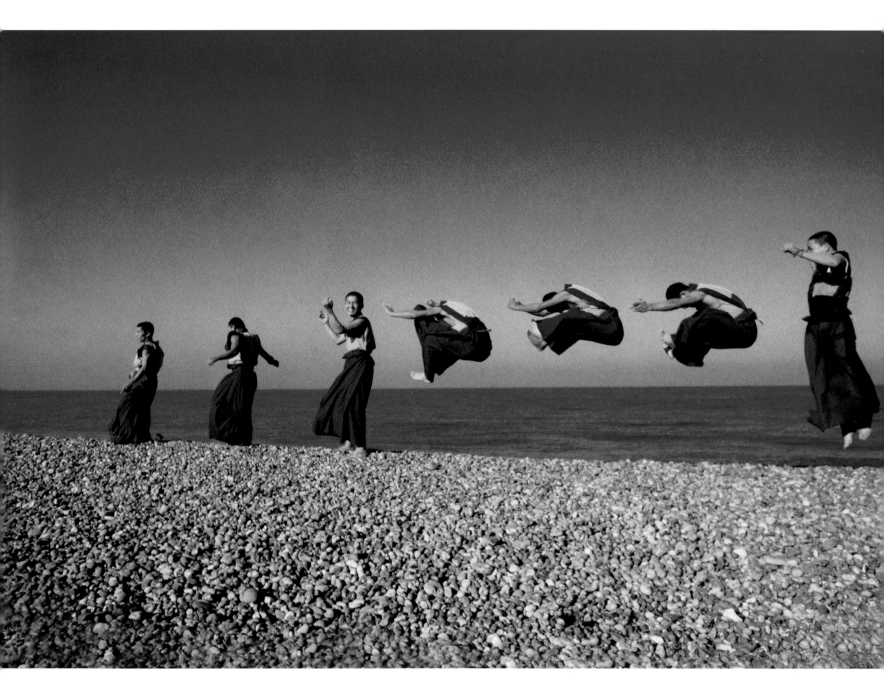

Matthieu Ricard, *Moines volants* (Flying monks), 2000; from *Aperture* 164, 2001.

A photograph that celebrates is an affirmation of existence. It may celebrate life by documenting the actual celebrations of man and the commonality and continuity of human experience. It may rejoice in life through visual equivalents and expressive symbols. A photograph that celebrates may glorify the elemental forces of birth and death, sex and energy. A photograph that celebrates may exult in the imagination and the intellect, in consciousness and intuition, in the spirit and the sublime. A photograph that celebrates delights in the transition from sight to insight and extols the mystery that falls between conception and creation.

—Jonathan Green, *Aperture* vol. 18, no. 2, 1974

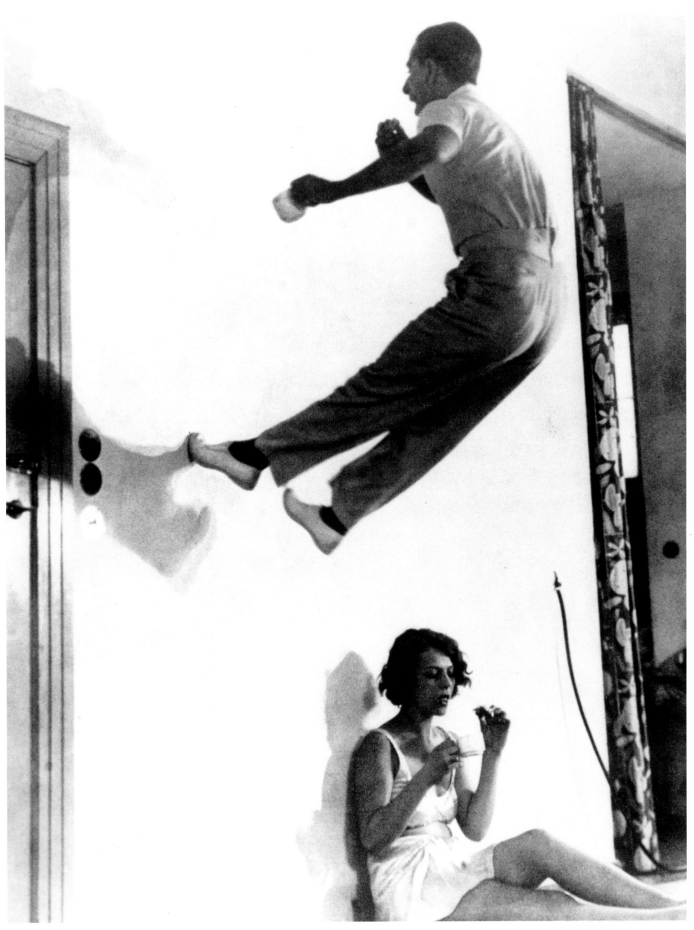

Martin Munkacsi, *Having Fun at Breakfast,* Berlin, ca. 1933; from *Aperture* 128, 1992.

4

2

5

A 3

6

7

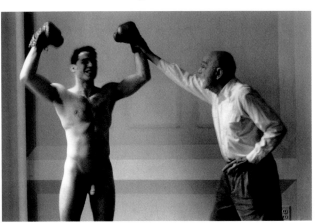

Perhaps the old literacy of words is dying and a new literacy of images is being born. Perhaps the printed page will disappear and even our records be kept in images and sounds. Perhaps the new photograph-writing—so new we have no word for it— is a transition form, and perhaps, instead, it is, in embryo and by virtue of principles now being discovered and applied, the form through which we shall speak to each other, in many succeeding phases of photography, for a thousand years or more.

We are not yet taught to read photographs as we read words. Only a few thousands, among our hundreds of millions, have trained themselves like photographers and editors to read a photograph in its multilayered significance. Yet more and more photographers have discovered that the power of the photograph springs from a deeper source than words—the same deep source as music. At birth we begin to discover that shapes, sounds, lights, and textures have meaning. Long before we learn to talk, sounds and images form the world we live in. All our lives, that world is more immediate than words and difficult to articulate. Photography, reflecting those images with uncanny accuracy, evokes their associations and our instant conviction. The art of the photographer lies in using those connotations, as a poet uses the connotations of words and a musician the tonal connotations of sounds.

—Nancy Newhall, from "The Caption: The Mutual Relation of Words/Photographs," *Aperture* vol. 1, no. 1, 1952

Duane Michals,
The Kentucky Kid 1–10, 2001.

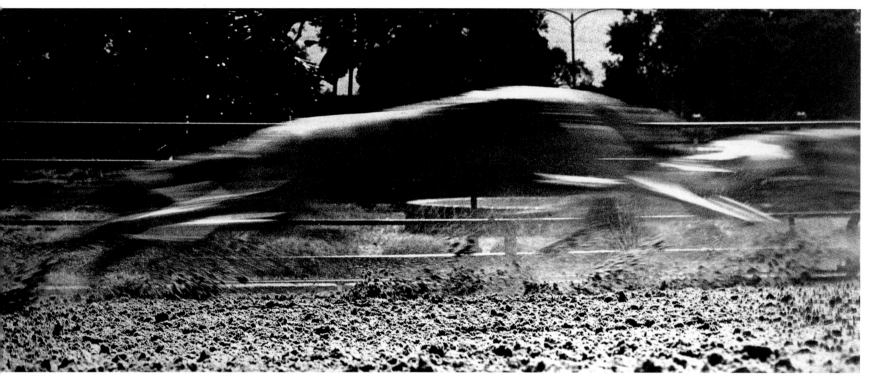

Graciela Iturbide, *Galgo* (Greyhound), Hernan de Soto's, Tampa, Florida, 1996.

The camera is a means of expression with virtues and limitations of its own; the photograph which looks like a drawing, etching or painting, is not a real photograph. The peculiar virtue of photography, and at the same time, in the hands of a purely mechanical operator, its severest limitation, is its power of revealing all textures and revealing all details.

The art of photography is to be sought precisely at this point: it lies in using this technical perfection in such a way that every element shall hold its place and every detail contribute to the expression of the theme. Just as in other arts there is no room here for the non-essential. Inasmuch as the lens does not in the same way as the pencil lend itself to the elimination of elements, the problem is so to render every element that it becomes essential; and, inasmuch as in the last analysis there are no distinctions in Nature of significant and insignificant, the pursuit of this ideal is theoretically justified. A search for and approach to this end distinguishes the work of Alfred Stieglitz. It must not be supposed that the adoption of a particular equipment (such as lenses of critical focus or particular color screens) can by itself achieve the desired result; here, as elsewhere, it is the man behind the tool, and not the tool, that counts.

—Coomaraswamy, *Aperture* vol. 16, no. 3, 1972

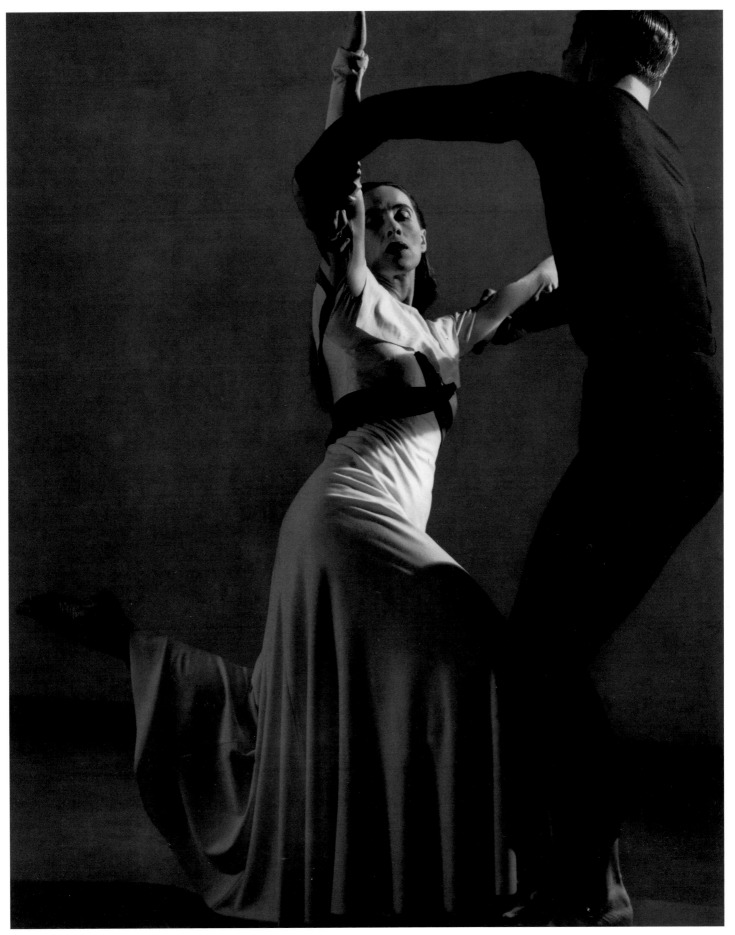

Barbara Morgan, *Martha Graham—American Document—Puritan Love Duet (with Erick Hawkins)*, 1938.

Context, Conflicts, and Congeries

Eternity is in love with the productions of time.
—William Blake, *Proverbs from Hell*

Comprehending the history of anything is largely a matter of context, and what is left out can be as revealing as what lies within. A viewer/reader of *Aperture* in its early years wouldn't find a hint that the United States was in the thrall of an anti-Communist witch-hunt. Or that it was involved in a slaughterhouse war in Korea. Or that people throughout the world had begun the decades of living with the nightmare of nuclear holocaust.

Nor was there much concern in the journal with art in general. No glimpse of the furor caused by Allen Ginsberg's riotous poem "Howl." Nor with the indignant reactions to the thrusts and drips of color on Jackson Pollock's "Action Paintings." Nor with the dismaying arrival from France and Italy of a new wave of erotic, existentialist filmmaking. It was a time when popular art comforted with Norman Rockwell illustrations in magazines, *I Love Lucy* on television, and paint-by-numbers kits that had hobbyists by the millions daubing coded colors onto numbered diagrams from which emerged manufactured scenes of dire sentimentality. It was a period of art when the elite was outraging the proletariat which, in turn and fairly enough, was appalling the elitists. It was not a new story.

Exactly thirty years before *Aperture* was founded, Stieglitz put forth his ideal in art of "equivalents." And it was also in 1922 that Sinclair Lewis published his novel *Babbitt*, whose hero was to become the immortal spokesman of the American cultural philistine. As George F. Babbitt memorably points out in his speech to his business community's hail-fellow Booster Club:

> In other countries, art and literature are left to a lot of shabby
> bums living in attics and feeding on booze and spaghetti;
> but in America the successful writer or picture painter is
> indistinguishable from any other decent businessman . . .
> [and] has a chance to drag down his fifty thousand a year,
> to mingle with the biggest executives on terms of perfect
> equality, and to show as big a house and as swell a car as
> any Captain of Industry.

It was within a context of Babbittry that Stieglitz had devoted his efforts to the "shabby bums," the visionaries both foreign and domestic of twentieth-century art. A generation later, *Aperture* was giving its pages to a visionary ideal of photography; it was an ideal charged with challenges and conflicts aplenty.

When Ansel proclaimed, "We have nothing to lose but our photography," he was not speaking about photographs and photographers. He was in broad strokes warning about the overpowering context of "their" photography. "They" were those who used the medium for purposes other than the artist's intent. "They" included art directors, designers, and photo-editors of magazines, advertising agencies, and other commercial or propagandistic enterprises. "They" engaged individuals of enormous talent, and the results were often brilliant: the riveting photo-essays of *Life* magazine, the lush color explorations in *National Geographic*, and the hypnotic fashion shoots of *Vogue* and *Harper's Bazaar*, to mention only a few. "They" also paid the bills—which "art photography," as it was then called (often disparagingly), did not. But these had always been the background conditions in the struggle to advance photography as an art form. The more serious threat, as some viewed it—Ansel among them—was emerging closer to the source in the person of one of the century's early champions of the art of photography, one of its foremost practitioners: Edward Steichen.

It is open to question whether Alfred Stieglitz was the most influential figure in American photography throughout much of the twentieth century. It is less arguable that his protégé Steichen was the most commanding.

Fifteen years younger than Stieglitz, Steichen was the son of immigrants from Luxembourg, who settled in Milwaukee. His sister Lillian became a brilliant teacher and socialist activist, and the wife of poet Carl Sandburg. As for Edward, he was in every sense of the word self-made. After apprenticing as a lithographic designer and photographer for an advertising agency, Steichen at age twenty-one set out for Paris to study and establish himself as a painter and photographer. En route, he paid a call on Stieglitz, beginning an extraordinarily fruitful twenty-year collaboration to advance the art of photography and the Modernist movement in all of the plastic arts.

Theirs was a close kinship during most of those years, when Steichen divided his time between New York and his beloved Paris, and Stieglitz held forth in Manhattan. Stieglitz from the outset believed in Steichen as both painter and photographer. For his part, Steichen's independence was tamed to the older

Stieglitz and Steichen had fought side by side for their vision of the medium, under the rubric of the Photo-Secession, which was generally what Stieglitz deemed it to be: a break from the past, a way of making photographs to be seen as pictures *and not as illustrations, documents, or derivatives of painting.*

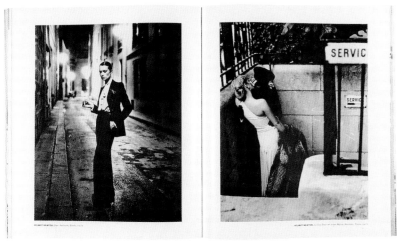

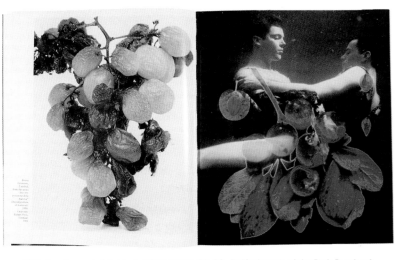

TOP: *Aperture* vol. 14, no. 1, 1968, pages 28–29: (left) photograph by Ruth Bernhard; (right) photograph by Lotte Jacobi. MIDDLE: *Aperture* 122, 1991, pages 94–95: photographs by Helmut Newton. BOTTOM: *Aperture* 143, 1996, pages 24–25: (left) photograph by Bruna Ginammi; (right) photograph by Robert Flynt.

man's taste, judgments, and adversarial stances. While Stieglitz is credited with introducing American audiences to the works of Rodin, Matisse, Picasso, and other European Modernists, it was Steichen who introduced them to Stieglitz—arranging for their works to be transported for exhibition at the 291 Gallery (which Steichen and his wife Clara had designed) and reproduced in *Camera Work*. This occurred in 1908, five years before the legendary New York Armory show that is purported to have launched Modern art in America.

By Steichen's twenty-second birthday, he had already achieved considerable renown in Europe, particularly for his flawlessly rendered "Impressionistic" pictures. His concentration upon a subject was obsessive. He spent a year photographing Rodin once or twice a week in his studio, then countless hours in the darkroom to create the picture of the master with his sculptures of *The Thinker* and Victor Hugo. By the end of World War I (and continuing into the following years), Steichen had created a body of photographic works that are among the medium's finest achievements.

The rupture between Stieglitz and Steichen began in the 1920s. It was inexorable, painful to both men, and had a profound effect on photography for decades. They had fought side by side for their vision of the medium, under the rubric of the Photo-Secession, which was generally what Stieglitz deemed it to be: a break from the past, a way of making photographs to be seen as *pictures* and not as illustrations, documents, or derivatives of painting. Stieglitz and Steichen also were generous, indefatigable promoters of other artists. They both had suffered, and supported one another through difficult first marriages. They were friends.

But there was an important difference between the two men. Stieglitz had been born to money, married money, and in his later years was supported by his successful second wife, Georgia O'Keeffe. Steichen had worked for every dime he ever made, and supported not only an ex-wife, a wife, and two daughters, but also his parents. Tired, as he said, of starving, he began after World War I to devote his energies to commercial photography. As the 1920s progressed, he became America's foremost, and most highly paid, portraitist and advertising photographer, and the senior photographer for Condé Nast's *Vogue* and *Vanity Fair*. But even more unforgivable than this, from Stieglitz's point of view, was Steichen's glorification of commercial photography as "art." The two men seldom, if ever, spoke to one another for the last twenty years of Stieglitz's life.

In his sixties during World War II, Steichen led the U.S. Navy's aerial combat photography units, and his cameramen captured the historic, breathtaking scenes of battle in the skies over the Pacific. It was in the war's immediate aftermath that he made the boldest move of an already adventurous career.

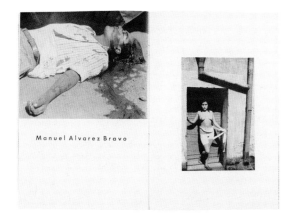

Manuel Alvarez Bravo

*"To see through, not merely with, the eye,
to perceive with the inner eye, and by an act of
choice to capture the essence of that perception.
This is the very core of the creative process."*

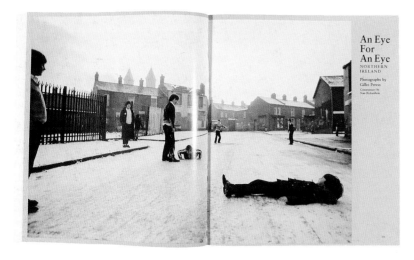

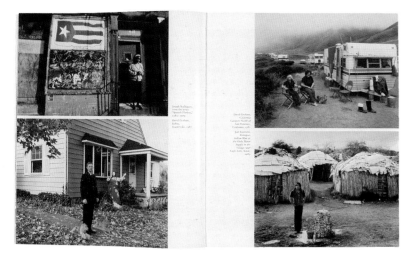

TOP: *Aperture* vol. 1, no. 4, 1953, pages 28–29: photographs by Manuel Alvarez Bravo.
MIDDLE: *Aperture* 97, 1984, pages 28–29: photograph by Gilles Peress. BOTTOM: *Aperture*
127, 1992, pages 10–11: (top left) photograph by Joseph Rodriguez; (bottom left and top right)
photographs by David Graham; (bottom right) photograph by Joel Sternfeld.

Throughout the war, Beaumont and Nancy Newhall exchanged a slew of lengthy letters discussing their plans for the photography department of the Museum of Modern Art, which Beaumont fully expected to head. They looked forward to expanding the collection, which they had created, and to furthering what Beaumont always referred to as "our" photography—devoted to dignified exhibitions of the medium's masters, past and present. Steichen's biographer Penelope Niven evenhandedly renders the ensuing events.

The first intimation that Steichen was interested in taking over the reins at the museum surfaced just after the war's end, when Stieglitz warned Nancy Newhall, "Look out for Steichen . . . he wants your department." The warning was soon a fait accompli, engineered by Steichen enthusiasts among the museum's administrators and trustees. Steichen's "coup" took place behind the backs not only of the Newhalls, but also of the museum's thirty-member Photography Advisory Committee, led by Ansel Adams. The Newhalls and the entire committee resigned, and Ansel wrote to the administration of his "profound shock and disappointment." He described the new regime as "inevitably favorable to the spectacular and 'popular'. . . a body blow to the progress of creative photography." Steichen claimed innocence of conspiring for the new post as director of photography.

Then, in his seventies and a survivor of many battles of peacetime arts and wartime combat, Steichen launched a three-year project to mount the greatest spectacle in the history of photography exhibitions—"The Family of Man." It was unabashedly a "message" show: the anodynes to the horrors of war were the innate goodness of the individual and the common bonds that unite all of humanity into a single family. From more than two million images, Steichen and a colleague, *Life* photographer Wayne Miller, culled a final selection of 503 photographs submitted by 273 professionals and amateurs from 68 countries. The show was designed as a walk-through installation, with partitioned sections of giant blow-ups that displayed humanity at its "universals"—loving, playing, working, eating, dancing—and ended in a darkened room with a giant color transparency of a nuclear explosion.

Opening January 24, 1955, "The Family of Man" then hived off into traveling exhibitions that roamed the world for the next half-century. It ultimately attracted more than nine million viewers. The catalog was indifferently designed: cluttered pages of pictures, with a giddy, pseudo-Whitmanesque prologue by Steichen's brother-in-law Sandburg. But the publication was inexpensively priced to be available to the average buyer. It sold more than five million copies, and is still in print.

With the exception of Minor White, whose work would probably have been unsuited, all of *Aperture*'s photographer-Founders appeared in "The Family of Man" (including Ansel!). Years later,

a fair body of conventional wisdom would hold that Minor was the adversarial epitome of "The Family of Man" and similar uses of photography. Such was not the case. In the pages of *Aperture*, Minor announced Steichen's early preparations, advised photographers how to submit images, and reported on progress. He publicized the tour schedule and devoted a large segment of a 1955 issue of the journal to a judicious selection of viewpoints pro and con. Moreover, as Niven retells, Minor described some of the show as "really magnificent aesthetically," and personally mounted the exhibition when it moved to Rochester, New York, where Beaumont was then head of the George Eastman Museum of Photography. Years later, Minor was asked by an interviewer if "The Family of Man" may have "put back the art of photography many years." He replied, "It may have put back the aesthetic thing a little bit, but that didn't hurt. It was good to have that setback." In retrospect, part of that good was that it helped *Aperture* evolve toward a more sharply defined identity.

The controversy had in effect cleared the air, and the divergence of views about photography were best summed up in affirmations of intent by Steichen and Minor. From Steichen: "These are photographs that talk to people. There is no esoteric appeal here—just man explaining man to man." And from Minor, in an introduction to a photo-sequence in *Aperture* titled "Perceptions": "Their [photographers'] attempt is to see through, not merely with, the eye, to perceive with the inner eye, and by an act of choice to capture the essence of that perception. This is the very core of the creative process." And as the ever-sensible Dorothy Norman observed in her commentary on "The Family of Man," photography was a generous enough medium to accommodate both approaches.

While Steichen garnered an audience in the millions, Minor had at his disposal a journal that—even if it reached only a few hundreds—could be used to explore and teach. And this he did not with polemics, but with demonstrations of the richness of photographic experience, for both makers and viewers of an image. *Aperture* devoted lengthy pages to ways of experiencing a photograph, of "reading" an image, and he emphasized the need for a new dimension of "greatness," as opposed to competence, in photographic criticism. Essays had titles such as "Photographing the Reality of the Abstract" by Beaumont Newhall; "Can Photography as an Art be Taught?" by William Rohrbach, and a lively, analytical excursion coauthored by Minor and colleague Walter Chappell, "Some Methods for Experiencing Photographs."

White knew that the ultimate method for conveying the less understood potentials of the medium lay in the photographs themselves. By the end of the 1950s, he had expanded the journal's format to 8 by 9½ inches, to allow for improved vertical reproduction. With few venues for exhibition of serious photography beyond metropolitan art centers (and only a handful there), he

offered readers a chance to contemplate known images in a new way, and also introduced to his select audience a stream of artists many had never encountered. An example of the familiar viewed fresh was a portfolio in 1957 of portraits by *Life* magazine's Alfred Eisenstaedt—without accompanying text. For many, it was the first view of Eisenstaedt as artist, not illustrator of stories. There were essays, sometimes entire issues, devoted to the recognized masters, including Norman's first edition of the classic *Alfred Stieglitz: An American Seer*; portfolios by Imogen Cunningham, Harry Callahan, and Paul Caponigro, and early glimpses of artists later to be included in the first rank of photography's practition-

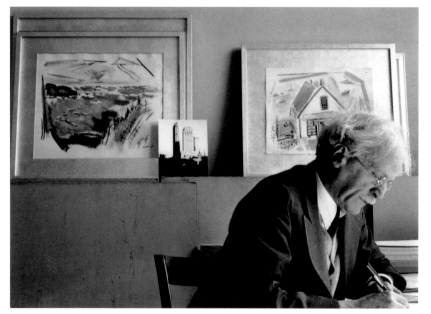

Alfred Stieglitz spotting portrait of Dorothy Norman (with John Marin paintings and Stieglitz photograph in the background), An American Place, 1930s.
Photograph by Dorothy Norman.

ers, such as Aaron Siskind, Ray K. Metzker, Robert Frank, and Bruce Davidson.

In 1958, White published an issue destined to be one of *Aperture*'s most successful and influential efforts. At dawn of New Year's Day that year, the almost totally paralyzed Edward Weston had managed to pull himself into a rocking chair facing the Pacific at his home on Wildcat Hill in Carmel, and there his ten-year struggle with Parkinson's disease came to an end. White's testament appeared initially as *Edward Weston: Photographer*, with a selection of the artist's masterworks accompanied by excerpts, edited by Nancy Newhall, from Weston's *Daybooks*. As a monograph, later named *The Flame of Recognition*, it would become one of the best-selling photography books ever published. But even in the early years, the Weston issue would profoundly influence *Aperture*'s future, indeed its very survival—not least of all because it fell into the hands of a fifteen-year-old boy.

Michael Hoffman was, in every sense, an "interesting" child. Born July 5, 1942, in New York City, he was the only son of Myron and Dorothy Hoffman. His father was a transplanted Iowan who had built a successful career in an importing firm. His mother, whose family roots Michael later described as "Jewish-Calvinist from Kentucky," had widespread connections in the artistic and intellectual life of New York. Michael and his younger sister, Jill, were raised in a spacious Upper East Side apartment and summer vacations were spent in Westchester county and Connecticut.

Among his earliest recollections, Michael at age five wandered off into the woods near a vacation house and came across a fruit tree—he could not recall whether it was apple or cherry—in full bloom, a tree filled with a "radiant light" that held him transfixed. The next year brought another formative experience: a riding and jumping class taught by a former White Russian colonel named Gary. Hoffman had a gift with horses, and this was honed to a sense of discipline and personal growth by the colonel, whom Michael would ever after count among the decisive influences of his life.

Still, Michael often felt miserable and misfit. Sent annually to a summer camp of two hundred boys fanatically urged to competition, including boxing (which he hated), he ran away three out of four years. The following summer, his exasperated mother took him by train to a camp in northwestern Montana, which—he assumed this was unknown to her—was devoted to the reform of juvenile delinquents. It was a brutalizing environment ("I'd go to a special tree and cry"), until he met a grizzled cowboy named Sam Wicker. "Sam was on his eighth or ninth wife; rolled cigarettes with one hand, and lived by a bare-bones philosophy: 'It's a hard life if you don't weaken, harder if you do.'" Sam offered the boy a job as cook and flunky, and Michael simply drifted away from his camp and took a job among horse packers.

During his first summer working with horses Michael, thirteen years old, had another moment of visual and spiritual epiphany. "My horse had gotten away from me, and I'd hiked for hours trying to get back to camp. I wandered onto an Indian burial ground . . . and later came to an emergency landing field. It was late afternoon and suddenly everything seemed different: the sky was luminous, the trees and flowers filled with light. It was totally out of the ordinary. I just sat on a log and looked." Eventually, Sam, who had raised hell with the other wranglers for losing the boy, came and found him.

Michael's parents sent him to a progressive boarding school in upstate New York, the Millbrook School, founded by its headmaster, Edward Pulling. Pulling had created an environment rigorous in academics while tolerating his students' idiosyncrasies and urging them to explore their own interests. Hoffman's summers were spent in the West, leading horses packed with supplies into otherwise inaccessible camps for tourists and forest rangers. He also began breaking horses and doing stints as a rodeo rider.

Michael had received his first camera at age eight; in his teens he set up a photography service at Millbrook with Pulling's encouragement. For his fifteenth birthday, a friend named Florence Benedict gave him a subscription to *Aperture*—beginning with the Edward Weston issue. Hoffman was first drawn not to the pictures, but to Nancy Newhall's excerpts from the photographer's *Daybooks*. A bookish, predawn riser himself, Michael immediately identified with the opening photograph Weston had taken of his tall, book-crammed desk, with the hand-scrawled caption, dated February 2, 1931: "Peace again!—the exquisite hour before dawn, here at my old desk—seldom have I realized so keenly, appreciated so fully, these still, dark hours."

Otherwise, the pictures had little effect on the boy. "Then, one day I sat down to look at it . . . and three hours later I came back changed. I had never had such an experience of total immersion." In the next few years, he carefully studied *Aperture* and developed a deepening curiosity about its editor.

After high-school graduation, and despite his parents' misgivings, Michael broached the subject of his summer plans to Saul Siegal, the president of his father's importing firm. He wanted to sell glass beads—which the firm, Elliot Greene & Company, imported from Czechoslovakia—to Native Americans in the Western states. With a fifty-dollar loan, Michael bought a heavy-cruising 1939 Buick that he named "Antigone." His father relented enough to teach him to drive, and Michael set out for Montana. Over the course of his first summer on the job, he logged 25,000 miles in sales trips to tribal elders and artisans and trading posts in Oklahoma, the Dakotas, and New Mexico. "I wore shined cowboy boots, a shirt with mother-of-pearl buttons, and I was deeply tanned. I looked like an Indian, and my friends on the reservations gave me contacts and routes most people never knew about. It turned out that I was very successful at selling. The Indians loved the old Buick—they thought it was hilarious."

Michael attended a small college, St. Lawrence University in Canton, New York, near the Canadian border. Majoring in literature and religion, he came under the influence of a remarkable, demanding faculty. They inspired him to search for interrelationships in literature, religion, music, and science; it was a succession of mind-opening studies that fed into Michael's early encounters with Minor White.

The first of these occurred in the summer of 1962, when Michael diverted from his itinerary in Indian country to attend Minor's workshop in Denver, Colorado. The workshops were limited to ten participants. Minor asked for no photographs from applicants—only a general statement of background and interests. At their first meeting, Michael didn't recognize Minor: "When I arrived at the

CLOUD OVER THE PANAMINTS Death Valley 1937

Wild cat Hill

The painters have no copyright on modern art! . . . I believe in, and make no apologies for, photography : it is the most important graphic medium of our day. It does not have to be, indeed cannot be—compared to painting—it has different means and aims.

(When the article title, Edward Weston, Artist, was sent to him in galley, he circled the word "Artist" with the comment: "Cut, or change to 'Photographer,' of which title, I am very proud.")

40

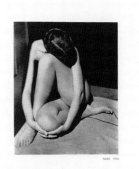

NUDE 1936

Aperture vol. 6, no. 1, 1958, pages 40–41: photographs by Edward Weston.

"Minor and the people around him really believed that if you sat down for an hour and looked at a great photograph such as Weston's Pepper No. 30 *. . . you'd be changed, and you'd be changed for the better, reaching into the heritage of intellectual and emotional tradition that was the mainstream of human endeavor."*

workshop, I found it to be quite a bohemian setting. In the room there was a tall man with a beard, rather handsome, rather formidable—and I was sure he had to be Minor White. To the right of the door there was another man with an open white shirt, loose-fitting trousers, and sandals. I remember thinking he was in the way and wished he would leave so we could get on with something important. Of course, the man in the white shirt was Minor." His manner, it turned out, was unassuming, gracious, and accepting.

Minor's workshops were devoted to the "art of seeing," with or without a camera. His ideas, processes, and techniques over the years usually divided his students into two groups: those who immediately or gradually came to understand what he was up to, and those who in dismay or annoyance headed for the door. His fundamental premise was that the ability to see well was inhibited by laziness, bad training, and constant exposure to badly organized images. All of these inhibitions might be overcome through work, discipline, and a nurtured openness.

Introductory exercises involved rapid sketching of a simple subject such as a strand of wire or a table leg, beginning an awareness of the relationships between what the eye sees and the kinetic motion of eye, fingers, hand, and body. The association of motion and imagery would remain a constant in Minor's teaching, involving preparation of the body through absolute stillness segueing into postures, then movement derived from theater and dance exercises. With photographs of his own making or those of other masters he would guide students into looking at an image with constant attention to the movement of the eye as it traveled within the subject and around the boundaries of the image. With this Minor introduced the concept of "dominant image," contain-

ing a documentary element but more importantly conveying both a summation and an essence of the subject.

Other exercises were devoted to seeing and sensing without camera or image. Particularly excruciating to Michael and others was a requirement to simply stand, alone and still, for a long period at a busy Denver intersection. Another involved a non-camera, a rectangular, open-ended box through which a student alternated looking as though selecting a subject, then looking without the box afresh at an entire scene. This was an introductory exploration of "camera eye."

Minor's students photographed in the morning, often with a break for a lecture, then spent afternoons in the darkroom processing film and printing. Evenings were devoted to presentations and discussions. Minor, throughout his years of workshops, constantly pressed students to articulate what they saw and felt in an image, "to use words freely because they are both expedient and expendable . . . useful in the learning process. The ultimate aim," he would add, "is visual experience visually grasped." He required, however, that certain words be prohibited, among them: *like, dislike, good, bad, right, wrong, interesting,* and *should.* He gently prodded his students toward words more precise, metaphors more meaningful—and through these metaphors to begin comprehending (although Stieglitz's name was seldom mentioned) the nature of "equivalents."

Michael almost abandoned Minor during the group's first photographic junket—to a garbage dump. "I thought, this is the limit, this is the end . . . and then things began to transform themselves before my eyes." At a later workshop excursion to a state park in New York, Michael's impressions take on more detail: "He talked

The association of motion and imagery would remain a constant in Minor's teaching, involving preparation of the body through absolute stillness segueing into postures. . . . he would guide students into looking at an image with constant attention to the movement of the eye as it traveled within the subject and around the boundaries of the image.

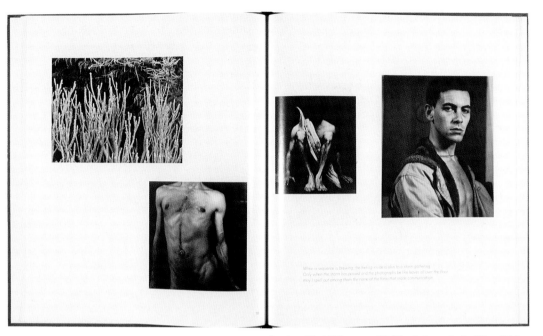

Aperture 80, 1978, pages 70–71: photographs by Minor White.

to us at length before we left, in such a way that you almost felt there were gremlins, pixies, and elves waiting, if only you were ready to see them. . . . A mood began to take hold. . . .The silence and spaciousness offered a new way of seeing. Different and significant forms emerged in the forest . . . forms skirted just off the edge of vision. They became subjects making themselves available to the camera."

Barely out of his teens, Michael discovered his personal quest, articulated in simple but adequate terms: "to live life beyond the ordinary." He decided Minor White was a needed guide and ally. The problem was how to turn Minor into something more than an instructor, into a true mentor. It wasn't easy because Minor, although the most generous of teachers and a creator of live-in workshops for his students, was also an intensely private man. Even his closest friends, colleagues, and lovers encountered boundaries. The sorcerer brooked no apprentices unless, as one of his earlier students discovered, one could make oneself indispensable—especially in the agonizing task of getting out issues of *Aperture*.

Peter Bunnell retired in 2002 from his post as McAlpin Professor of the History of Photography and Modern Art at Princeton University, after a long and distinguished career as teacher, writer, historian, and curator. As a freshman forty-seven years earlier, he had been one of Minor's first students at Rochester Institute of Technology, beginning a lifelong friendship and professional collaboration. Largely because of the Newhalls, Rochester then was the nexus of creative photography in the East—with an axis that extended to the publications and institutions in New York, and also to the Limelight Gallery, where Lisette Model, Berenice Abbott, Cornell Capa, W. Eugene Smith, Robert Frank, and Walker Evans, among

others, were habitués. At Rochester, Bunnell's first close encounter with Minor came when he joined the Newhalls, photographer and mystic Walter Chappell, and a group of students for Minor's Thanksgiving party in 1955—where, Bunnell recalls, dinner "had a slightly Oriental touch, with broth in a porcelain bowl, and then out comes the roast with chopsticks. . . . You can imagine how bizarre we thought this was."

Minor accepted Bunnell as a working associate because he needed help.

As far as *Aperture* was concerned, I started typing letters and organizing things, and then he says, "Look, why don't you take over circulation?" Which sounded like I was being given some executive position. It turned out that we typed every single mailing label by hand. We recorded every single check that came in. And then, of course, all the magazines would arrive from [the printers in] California, and we would stuff each one in an envelope, put the label on, buy stamps. Then— I still don't know why—we couldn't take them to the post office. We would have to drive all over Rochester dropping ten or fifteen issues in the mailboxes to get them out.

Bunnell and a couple of friends made the deliveries in Minor's old Chevy paneled truck, which they painted silver and white with the *Aperture* logo, the crossed lines and circle, on the door of the front cab. "Minor was horrified, but he stayed with it."

Minor worked like a horse, Bunnell recalls, but in those early Rochester days, "he was also as fun as hell. He drank like a fish, and had these quirky parties and dinners and loved to dance—particularly to Berlioz's *Symphonie Fantastique*." This he played at full

blast on his only luxury, a well equipped hi-fi set. Otherwise in Minor's cold-water loft, there were no radio, newspapers, or television. Books purchased for research into *Aperture* essays were read, marked up, used, and then left in a cardboard box for any student who might want them. There was also, Bunnell adds, a sense of religious calling about *Aperture* . . . and an innocence. "Minor and the people around him really believed that if you sat down for an hour and looked at a great photograph such as Weston's *Pepper No. 30,* or a Siskind or Sommer print, you'd be changed, and you'd be changed for the better, reaching into the heritage of intellectual and emotional tradition that was the mainstream of human endeavor."

As he had done at the Millbrook School, Michael created a photography service at St. Lawrence. In 1963, he arranged for Minor to give a series of summer workshops at the university. Minor and the university—with its faculty devoted to ways of harmonizing intellectual, intuitive, and emotional potentials in their students—proved an ideal fit. St. Lawrence's president Andrew Bewkes agreed not only to pay for students to attend the workshops, but also later financed student travel and costs to attend Ansel's workshops in California.

Subsequently, Michael arranged for Minor's workshops at Millbrook and also at the prestigious Hotchkiss School in Lakeville, Connecticut. Michael handled all of the arrangements and Minor, he recalled, "sort of woke up to the fact that here was somebody who could accomplish something . . . that he didn't have to do everything himself. I could get things organized, get the mailings out, get the people there, collect the money, make sure Minor got paid and had assistants. I was a pretty good factotum." So good, in fact, that Minor invited Michael to join him for advanced study in photography and also to assist him upon Michael's graduation in 1964.

Viewed in retrospect, the next year of Michael's life takes on dazzling complexity. He studied with Minor; entered the U.S. Army; fell in love; and set in train the efforts that would save *Aperture* from extinction. An enduring characteristic of Michael's life, in youth and later, was a disinclination to indulge in even the briefest interludes of idleness.

Michael revealed in the workshops an uncanny way of apprehending images—as if he were seeing with Minor's eyes. Michael recalled that, working in Rochester on sequences, he had "almost out-of-body experiences." It was as though his time in the Western wilderness had awakened a sort of extrasensory awareness. Minor was amazed that Michael could interpret a sequence exactly the way Minor had experienced it.

> He would put these photographs up late at night and I would start speaking about how I related to them . . . allowing the rational mind to go to sleep and allowing the intuitive senses

and emotions to gain greater prominence in exploring the metaphors represented in the images. I began to be able to read them and understand them more from the heart and the mind in a way that was equivalent to what Minor had been experiencing when he was making them. It was very spooky, and it unnerved Minor!

After an intense three-month association with Minor, Michael—who had belonged to the small group of ROTC candidates at St. Lawrence—began officer training. His motives were practical. With the draft inevitable, he knew life would be easier as an officer than as an enlisted man. In fact, he relished the discipline, the training, his newly discovered ability to meet the demands of mil-

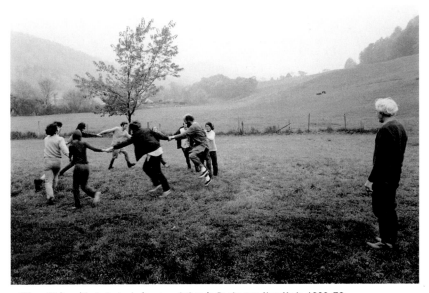

Minor White with students during a workshop in Rochester, New York, 1969–70. Photograph by Jonathan Saadah.

itary life. Receiving his commission during the incipient American buildup of the Vietnam War, he was posted as a transportation officer at the Brooklyn Army Depot. It was one of the cushiest assignments the military had to offer, and it allowed him enough free time to continue working with Minor—and to pursue a young woman named Katharine Perkins Carter.

Michael met her in one of Minor's workshops at the Millbrook School. They discovered a range of mutual interests, and began dating—at first casually for her, intensely for Michael from the beginning. "I'd never met anyone like her," he recalled many years later. "She seemed absolutely unattainable . . . impossible that we could really be together." But another of Michael's intrinsic characteristics, persistence, ultimately paid off. A few months after he was posted to Brooklyn, he and Misty moved in together in a small walk-up apartment with a view of the harbor. Within two years, they were married.

———————

Meanwhile in 1964, Minor was preparing the final issue of *Aperture*. The journal actually had folded ten years earlier at the behest of the Founders. With the exception of Ansel, none of them had any money to support the publication. In that ostensibly final issue of 1954, Minor had written to the subscribers a decidedly testy appeal:

WHY APERTURE IS LATE: If you have wondered why this issue of *aperture* [sic] is ungodly late, the reason is that a thousand dollars had to be raised before it could be published . . . we feel that you would like to know the situation. . . . It is annoyingly simple . . . [the journal] costs $5,000 a year to produce. You subscribers number about 450 and account for about $2,600. . . . To continue the quarterly at its present standard . . . it is obvious that each present subscriber will have to find at least one more subscriber or take out a Retaining Subscription.

Otherwise, Minor warned, the subscribers would receive a refund for any monies due and the publication would end. The early "retaining subscriptions" were ten dollars—six dollars for four issues, the balance to help support "an ideal in photography for which the quarterly stands." Minor's relationship to his subscribers was always conceived as an act of service to a community of interest—but one that he felt imposed an obligation of support upon that community. Nevertheless, he laboriously sought out subscribers, gathering names, writing personal letters, and sending free issues to individuals he hoped would send back a six- or ten-dollar check. It was a process that over the next decade netted between fifty and one hundred new subscribers.

The decisive help, however, came from a photographer who was an "amateur" in the true sense: one who does the work strictly out of love. Shirley Burden was a Vanderbilt heir who was to become *Aperture*'s most enduring and important patron. In the 1950s, he picked up the deficit and published the journal jointly with Minor.

Still, each issue was a monumental task, in terms not only of financing but also of maintaining the extraordinary standards Minor set. There was at the time nothing comparable to *Aperture* in the world of photography, albeit Minor's vision of the ideal was not without detractors. As the 1950s progressed, the notion of a "quarterly" gave way to the reality that the journal was "published intermittently." There were occasions when few or no photographs appeared because there was no money to pay the engravers. And in 1963, not a single issue was published. At that point, Minor declared that it had always been his intention to shut down the journal upon its fiftieth issue—according to the tradition set, he said, by Stieglitz's *Camera Work*.

Michael later expressed the belief that Minor's decision reflected a profound shift in Minor's own interest and direction. "The spirit of *Aperture* was gone for him because he had been using it as a creative force in his own life." Minor progressively was turning his

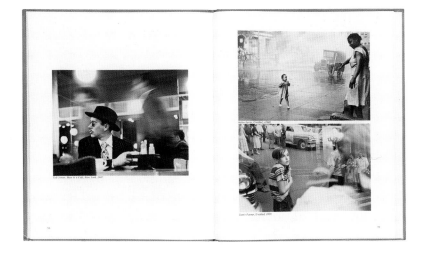

An image published in Aperture *was not intended to be a facsimile of the photographer's print. Minor said, "This is ink; it's not silver. You're going to have to intensify it . . . to make it deeper, richer than a silver print would be. You've got to make it more intense in order to give it the same resonance."*

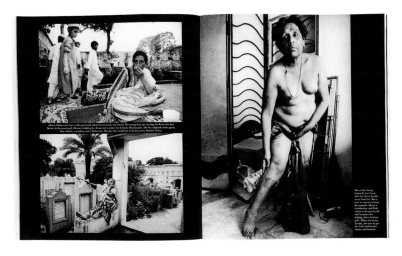

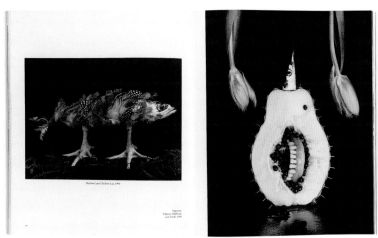

TOP: *Aperture* 81, 1978, pages 70–71: (left) photograph by Ted Croner; (top right) photograph by Helen Levitt; (bottom right) photograph by Louis Faurer.
CENTER: *Aperture* 154, 1999, pages 18–19: photographs by Dayanita Singh.
BOTTOM: *Aperture* 130, 1993, pages 56–57: photographs by Michiko Kon.

attention to his own photography; to his workshops, which might number as many as ten coast-to-coast sessions during the year; and to the further evolution of his theories and teaching.

He had published forty-four issues, and among them are some of the most original, provocative contributions ever offered to devotees of the medium. Most of these issues are now rare possessions of university, museum, or private collections. Or dimly viewable on microfilm. Only a few of the early issues, such as those devoted to Weston and Stieglitz, made the transition into monographs. Among the virtually lost classics are "The Substance and Spirit of Architectural Photography" (1958); "Death of a Valley (California's Water Problem)" by Dorothea Lange and Pirkle Jones (1960); and "Three Phantasts: Laughlin, Sommer, Bullock" (1961). After the publishing drought of 1963, Minor launched his intended final year with an issue devoted to Barbara Morgan and designed by her. The grand finale was to be another single-artist publication, "Imogen Cunningham," and he asked for Michael's help in producing it.

It was a daunting task, requiring lengthy commutes each weekend from his military duties in Brooklyn, and it was Michael's first involvement with the knotty details of the printing process. "Minor had a great sense of how things should look, and of course he was a magnificent printer." The first lesson was that an image published in *Aperture* was not intended to be a facsimile of the photographer's print. Minor said, "This is ink; it's not silver. You're going to have to intensify it . . . to make it deeper, richer than a silver print would be. You've got to make it more intense in order to give it the same resonance." It was an invaluable lesson, Michael recalled, because "all of the other printers were trying to match the original and they couldn't, and ended up with a sort of grayish reproduction."

Michael learned of the necessity for the highest-quality paper, which would hold intense inking from the presses yet remain even and smooth. And he discovered the value of running the printed pages through the presses yet again for a coat of varnish that would heighten luminosity. He watched Minor, original print in hand, standing over those presses as each sheet—four journal pages at a time—emerged, often rejecting and correcting two or three times. And in the process, Michael learned why the costs were so exorbitant for uncompromising quality.

The experience was life-altering because Michael's previous studies had been devoted to his own photography. His energies now turned to the possibility of continuing the magazine. "I said to Minor, 'I think we should keep this alive.' And he said, somewhat reluctantly, 'Go ahead if you want to. But you'd better go and see the accountant first.'"

Michael found the bookkeeper in an old, dilapidated building. "It was very depressing, very surreal, like a Kafka novel. He told me, 'Well, you don't have any money and you owe $25,000 to your subscribers.' So I went back to Minor and said, 'I know you

don't want to do this. But I think if I could be a rodeo rider, if I could sell beads to the Indians, and if I could be an infantry officer, I suspect there's a chance I can do this.'" Minor then said he would help, but only in an advisory fashion. And at that moment he offered a piece of advice from his own experience: "Never apologize. For anything—not for what's in the magazine, not for being late. Apologize for nothing. It only makes matters worse!"

Michael was determined that his first publishing effort, in 1965, would be an expanded version of the Edward Weston issue that had been his inspiration. The Newhalls, primarily Nancy, encouraged his efforts to sustain *Aperture*, and she provided more extensive material from the *Daybooks*. The ensuing months were a frantic scramble for funds, for engravers and printers. To heighten the drama, Michael underwent knee surgery and, with Misty and Nancy helping, directed much of the work from an army hospital bed. Also, he had decided on a tremendous gamble: to print thirteen thousand copies—six times the normal print run—in hopes of selling the excess as a profitable book.

It was a disaster.

More than three decades later, Michael still cringed at the memory. "We couldn't afford the varnish, which gave it the luminosity. It was flat, with none of the quality of the earlier issue— or any previous *Aperture*. I had a fight with the printers, and I took the whole thing very, very personally. I felt very upset that I had let the public down. But I learned from the start what was right and what was wrong, what worked and what didn't. That lesson was essential to everything we did later."

Michael's knee turned out to be an unlikely stroke of good luck. The army deemed him unfit for active duty, and discharged him with a small disability pension—freeing his time for unfettered concentration upon the journal. Two more issues emerged in 1965, one of which included the first true Minor White photograph ever published in *Aperture*. For thirteen years, Minor had only published his own work as technical illustrations, virtually devoid of his considerable artistry.

The greatest assets, so often the case in *Aperture*'s early history, were the irrepressible Nancy and her power of networking. She made Michael known to an ever-widening group of influential and supportive individuals, pressed his cause, and touted his abilities. In particular, she persisted in urging him to meet one of photography's living masters from the Stieglitz era, Paul Strand. "I didn't understand why," Michael remembered. "I'd never actually seen a Strand print—almost no one had. At the time, I actually had him classified as a documentary photographer. I still can't believe that I felt that way!"

Their meeting would lead to a collaboration that would not only save *Aperture* at critical moments, but would also redefine its role in the history of photography.

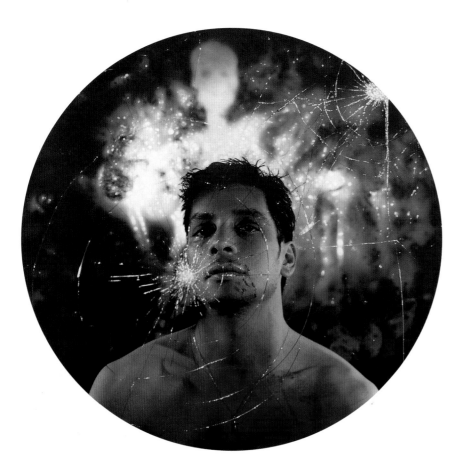

To the vast majority of people a photograph is an image of *something* within their direct experience: a more-or-less factual reality. It is difficult for them to realize that the photograph can be the *source* of experience, as well as the reflection of spiritual awareness of the world and of self. The painters have done little to dispel the impression of their superiority in the creative graphic fields; they point with scorn (and often correctly) to the shallow "storytelling" aspects of photography, and they also disapprove of photographers who attempt superficial "abstract" or "non-objective" effects within the limits of the photographic processes. To a large majority a photograph bears the same relationship to a fine painting as a contractor-designed house does to a fine architectural creation. This situation would be ridiculous were it not so tragic. The truth is that photography is limited only by the photographers!

—Ansel Adams, from "The Profession of
Photography," *Aperture* vol. 1, no. 3, 1952

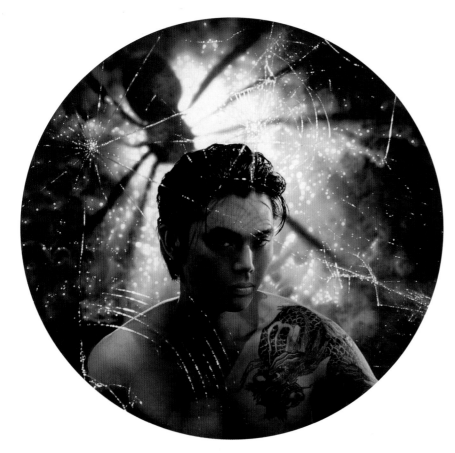

THIS PAGE: photographs by Pierre et Gilles.
TOP: *Fight—Ken*, 2001.
BOTTOM: *Fight—Osamu*, 2001.

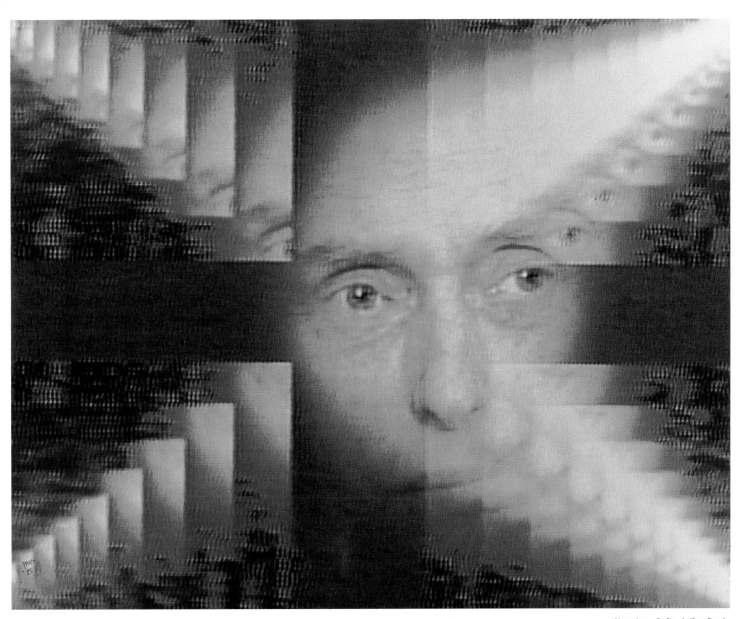

Nam June Paik, *Julian Beck*,
laser photograph, 1985;
from *Aperture* 106, 1987.

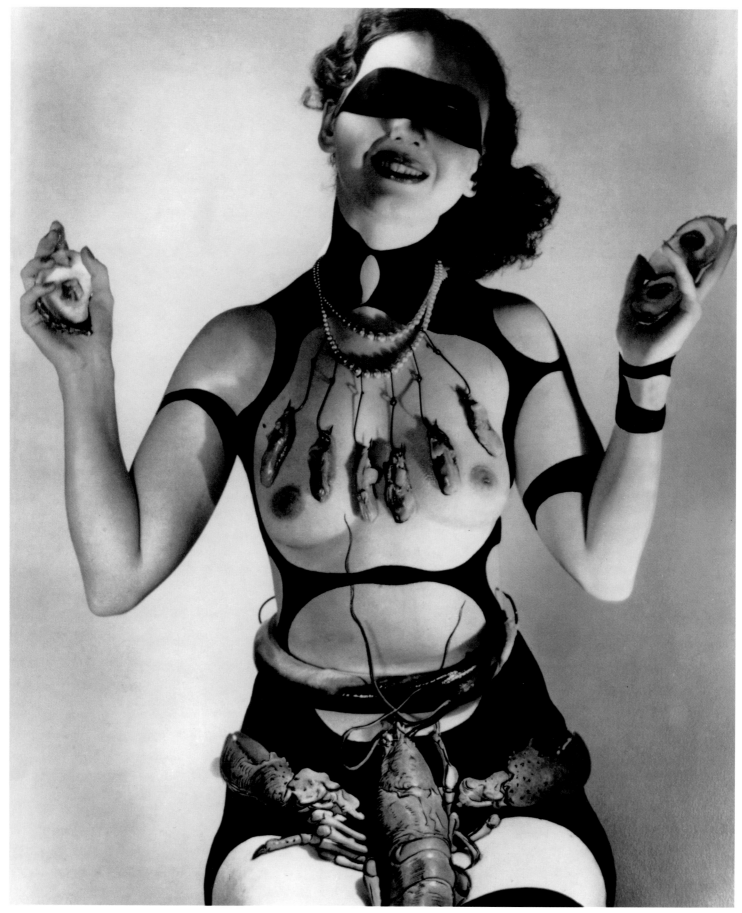

Salvador Dalí and Horst P. Horst, Costume design for the film
The Dream of Venus, 1939; from *Aperture* 103,1986.

John Coplans, *Self-Portrait (Standing Hand)*, 1987; from *Aperture* 125, 1991.

What is so ghastly about exposed intestines? Why, when we see the insides of a human being, do we have to cover our eyes in terror? Why are people so shocked at the sight of blood pouring out? Why are a man's intestines ugly? Is it not exactly the same in quality as the beauty of youthful, glossy skin? What sort of a face would Tsurukawa make if I were to say that it was from him that I had learned this manner of thinking—a manner of thinking that transformed my own ugliness into nothingness? Why does there seem to be something inhuman about regarding human beings like roses and refusing to make any distinction between the inside of their bodies and the outside? If only human beings could reverse their spirits and their bodies, could gracefully turn them inside out like rose petals and expose them to the spring breeze and to the sun. . . .

—**Yukio Mishima, excerpt from *The Temple of the Golden Pavilion* (1956), *Aperture* 143, 1996**

Walter Chappell, *Feather Torso Ceremonial*, 1967; from *Aperture* 79, 1977.

Ralph Eugene Meatyard, *Untitled*, n.d.; from *Aperture* vol. 7, no. 4, 1959.

How astounding is camera! With its unique ability to register continuous value
or tone, camera can sanctify even the ugly and the dead, clarify the ordinary, and,
in a moment, turn a hundred-and-eighty degrees to play iconoclast.

—Minor White, *Aperture* vol. 15, no. 3, 1970

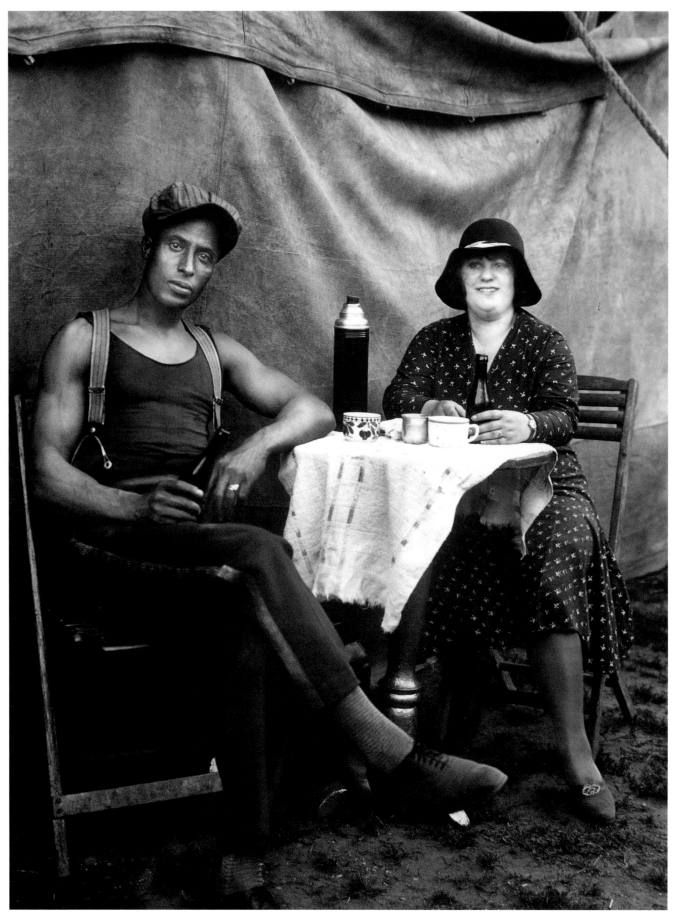

August Sander, *Fair and Circus People, Circus Workers*, Düren, 1930; from *Aperture* 83–84, 1980.

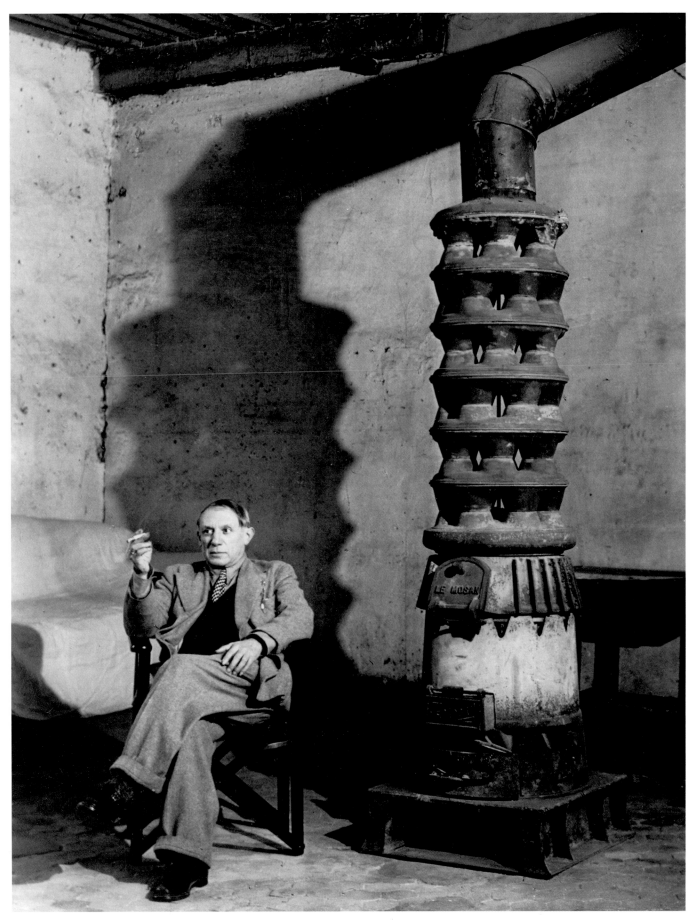

Brassaï, *Picasso and Stove*, n.d.; from *Aperture* vol. 14, no. 2, 1969.

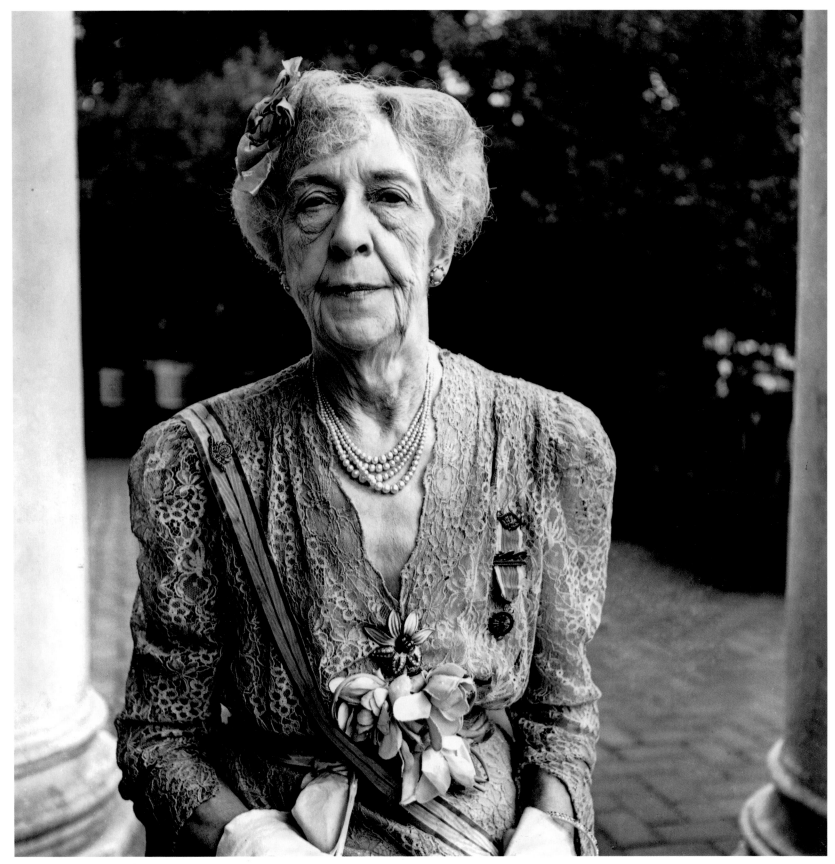

Alfred Eisenstaedt, *Mrs. Bun Wylie, Honorary Regent of Georgia's D.A.R.*, n.d.; from *Aperture* vol. 5, no. 3, 1957.

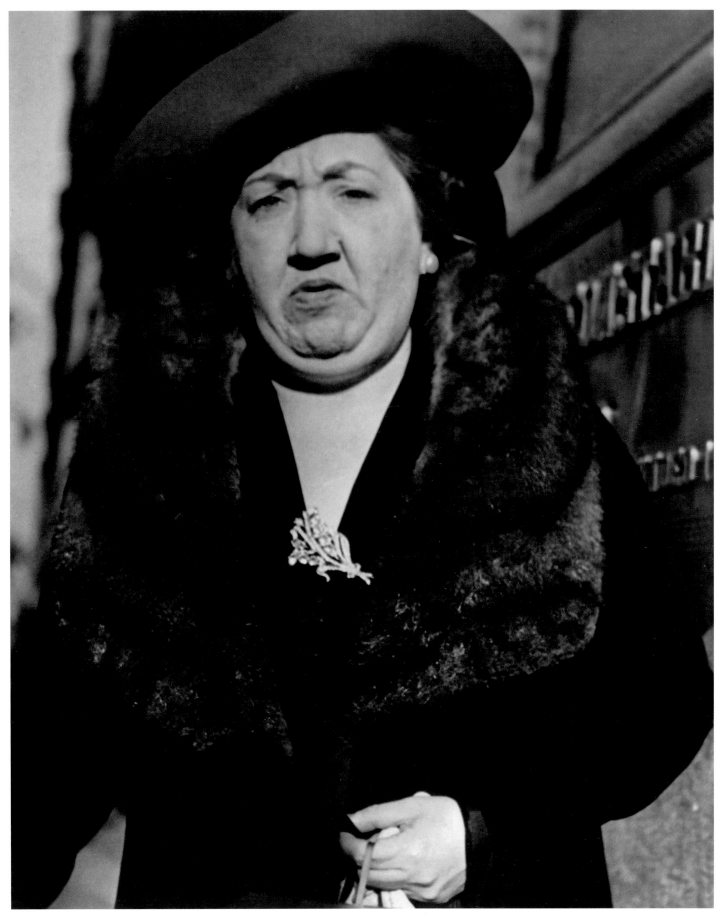

Lisette Model, *Fifth Avenue,* New York, ca. 1945; from *Aperture* 86, 1982.

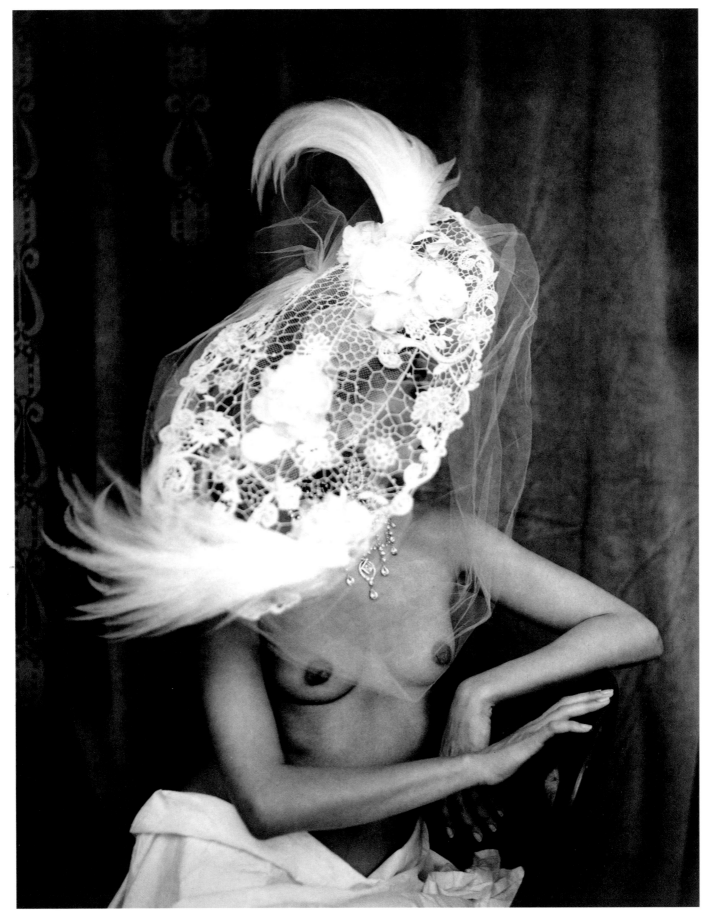

David McDermott and Peter McGough, *Varying greatly in style, shape, and materials, Anh Duong, 1917*, 2001.

W. Eugene Smith, *Charlie Chaplin, Limelight*, 1952; from *Aperture* vol. 14, nos. 3–4, 1969.

The photographer has the power and the talent to make his model come to life. In his creative state he works *with*, not *from* the model. In his creativity he *is*, and when he *is*, his model can *be*.

—Minor White, *Aperture* vol. 15, no. 3, 1970

Inge Morath, *Marilyn Monroe,*
Reno, Nevada, 1960; from *Portraits:*
Photographs by Inge Morath
(Aperture, 1986).

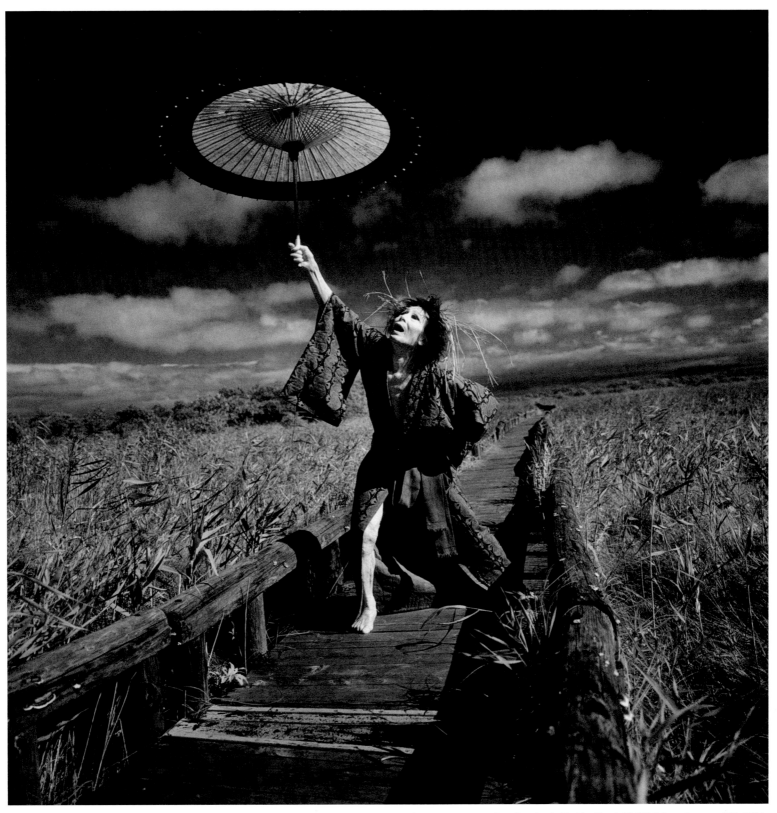

Eikoh Hosoe, *Kazuo Ohno Dancing in Kushiro Marsh IV*, 1994; from *Aperture* 165, 2001.

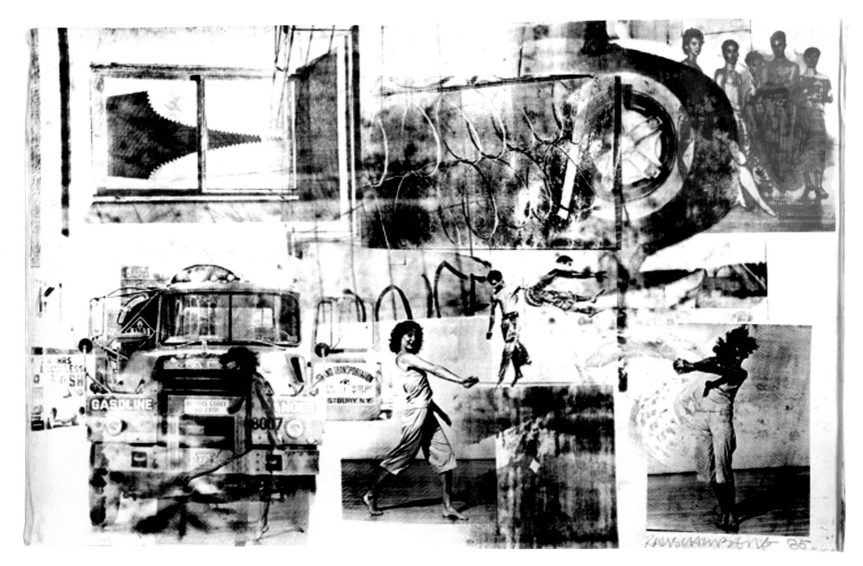

Robert Rauschenberg, *Untitled*, 1985; from *Aperture* 125, 1991.

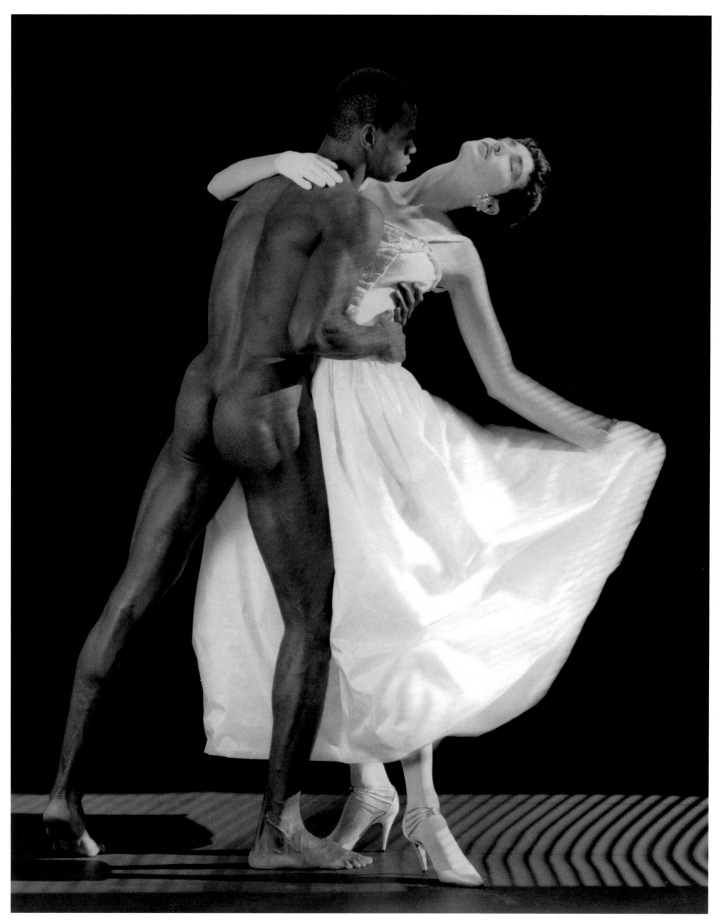

Robert Mapplethorpe, *Thomas and Dovanna*, 1986.

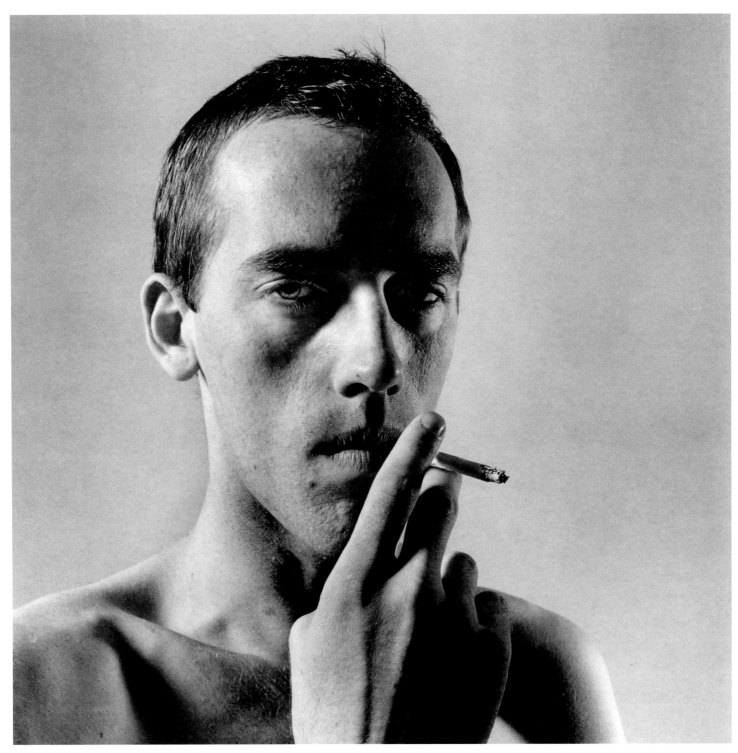

Peter Hujar, *Portrait of David Wojnarowicz*, 1981; from *Aperture* 114, 1989.

Photographers, when you get accosted by painters who, in their innocence, revive that tiresome old argument that Photography is *not* an art (which is true), reply that Painting is *not* an art. This last is also true.

Painting and photography, sculpture and photography, pottery and photography are only media, vehicles, pushmobiles, laundry chutes that get an intangible something from one unfindable part of one man to an unlocatable part of another person. And the ineffable something is not art because to name it implies that art is an object, or a thing, or a biscuit, or a building that can be moved about and grasped with the hands. As many have said *there is no art, only artists*. Every creative photographer has to find out for himself that it's the man behind the camera that is the artist, or not—wearisome as this may be to those who have gone through the process.

—Minor White, from "That Old Question Again,"
***Aperture* vol. 7, no. 1, 1959**

David Hockney,
***Henry Geldzahler #1*,**
September 5, 1990;
from *Aperture* 125, 1991.

THESE PAGES: photographs by Diane Arbus.
Identical twins, Roselle, N.J., 1967; from *Diane Arbus: An Aperture Monograph* (Aperture, 1972).

Girl in her circus costume, M.D., 1970; from
Diane Arbus: An Aperture Monograph (Aperture, 1972).

THESE PAGES: photographs by Nan Goldin.
TOP: Valerie on the stairs in yellow light, Paris, 2001. **BOTTOM:** Simon and Jessica, faces lit from behind, Paris, 2001.

TOP: Valerie in light, Bruno in dark, kitchen, Paris, 2001. BOTTOM: Simon and Jessica looking at each other with faces lit, Paris, 2001.

93

Max Waldman, *Marat/Sade*, 1966; from *Aperture* vol. 13, no. 2, 1967.

Imogen Cunningham, *Morris Graves, Painter*, 1950;
from *Aperture* vol. 3, no. 4, 1955.

We have been preceded by infinite millennia of darkness and silence, and we will be followed by infinite millennia of darkness and silence. We have a half hour or so of sunlight to work up a good heat. Let's have chubby little Eros place his arrow in his golden quiver; let him strike human beings—disguised en masse as heroes, devils, and angels—in all their ardent moments. And let's hope that, with their allegories and dreams, people will still retain the small but extremely important comfort in that quotient of humanity that here, in your media paradise, manages to convey a sympathetic sensation of warmth. For in the end, this always reverberates back to the tender and candidly erotic warmth that existed— before sex, before politics—in the far-off cradles of our infancy. Paradise may seem more lost than ever, even the small human paradises—those that used to give meaning to life. And so we must seriously rethink life, yet again, as a battle between good and evil, and love as a scorching frontier that exists in that half hour of light we call human existence.

—Lina Wertmuller, from *"Del Bene e del Male,* or, Who's on Top?," *Aperture* 132, 1993

THESE PAGES: photographs by Sally Mann.
Untitled (Larry's Arm IV), 2002.

Untitled (Larry's Arm I), 2002.

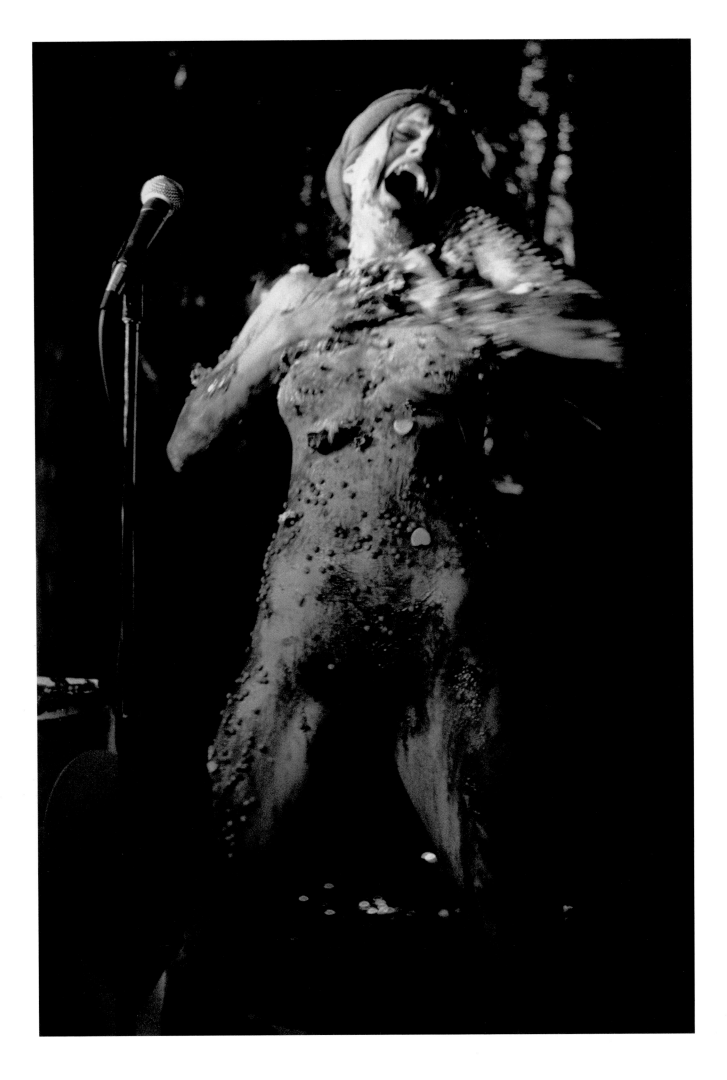

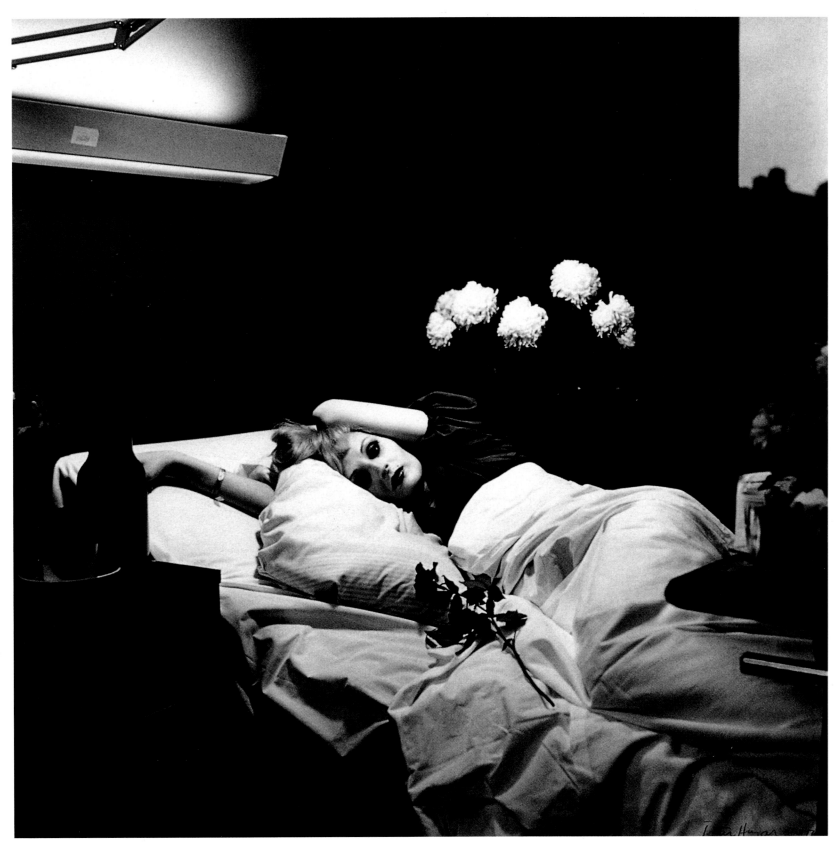

Peter Hujar, *Candy Darling on her Deathbed*, 1973; from *Aperture* 156, 1999.

OPPOSITE: Dona Ann McAdams, *St. Valentine's Day Massacre*, Performance
view at the Pyramid Club, February 14, 1989; from *Aperture* 138, 1995.

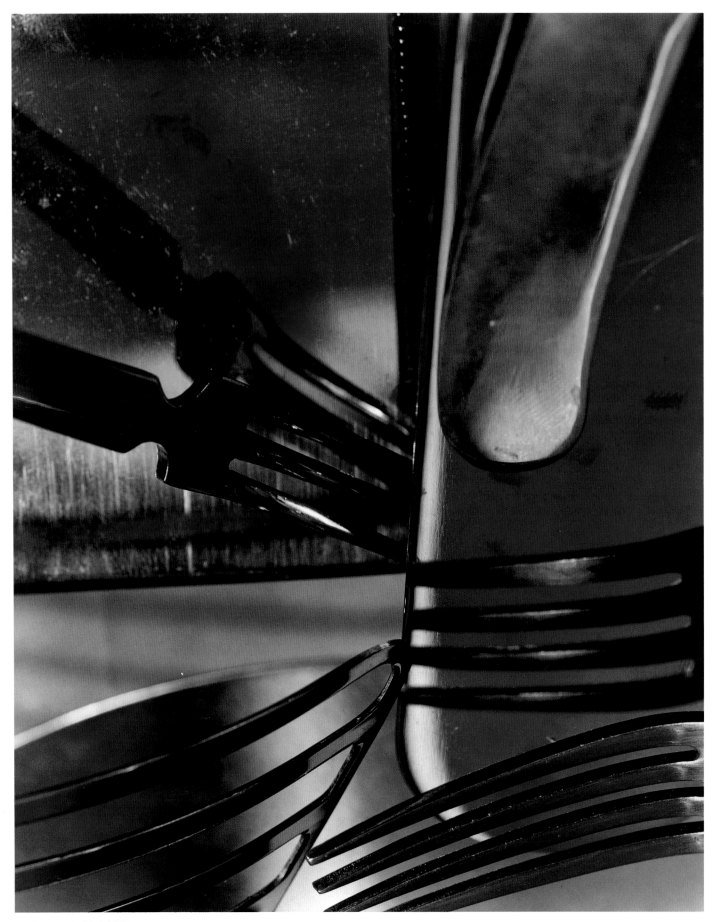

Jan Groover, *Untitled*, 1978.

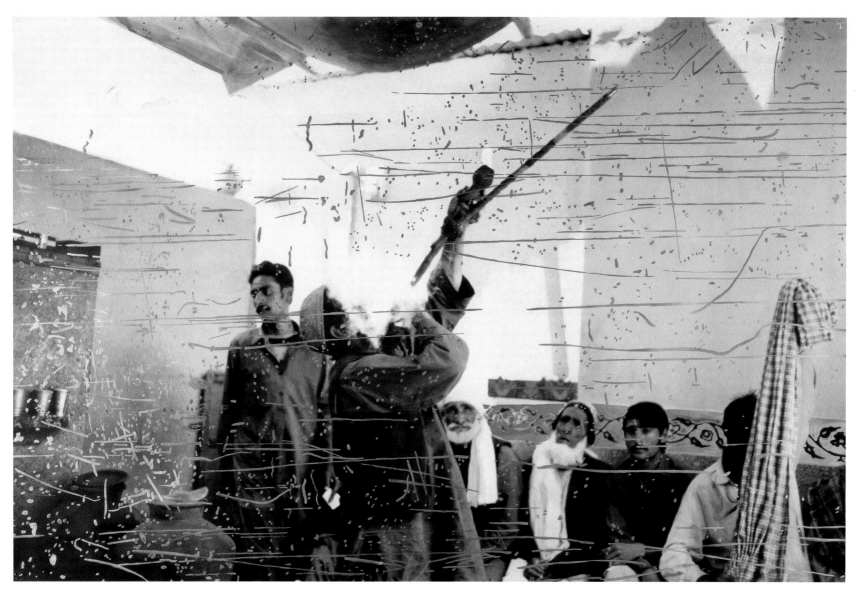

Sigmar Polke, *Quetta, Pakistan*, 1974–1978; from *Aperture* 145, 1996.

Photography's potential as a great image-maker and communicator is really no different from the same potential in the best poetry where familiar, everyday words, placed within a special context, can soar above the intellect and touch subtle reality in a unique way.

—Paul Caponigro, *Aperture* vol. 13, no. 1, 1967

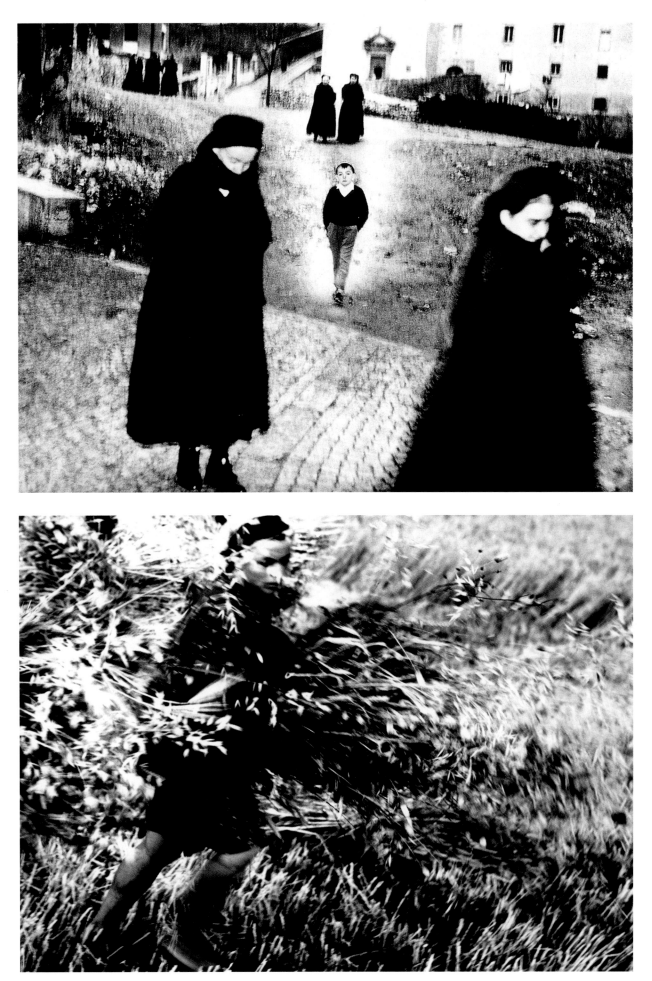

THIS PAGE: photographs by Mario Giacomelli. TOP: from the series "Scanno," 1957–59; from *Aperture* 132, 1993.
BOTTOM: from the series "La buona terra" (The good earth), 1964–65; from *Aperture* 132, 1993.

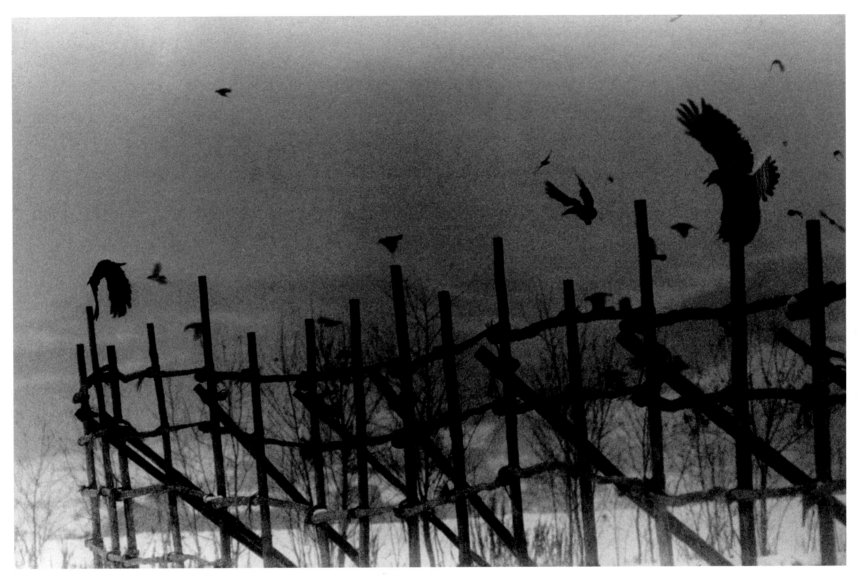

Masahisa Fukase, *Nayoro*, 1977; from *Aperture* 102, 1986.

You see, the extraordinary thing about photography is that it's a truly popular medium. . . . But this has nothing to do with the art of photography even though the same materials and the same mechanical devices are used. Thoreau said years ago, "You can't say more than you see." No matter what lens you use, no matter what the speed of the film is, no matter how you develop it, no matter how you print it, you cannot say more than you see. That's what that means, and that's the truth.

—Paul Strand, *Aperture* vol. 19, no. 1, 1974

Shomei Tomatsu, *Yamaguchi Senji Who Was Injured 1.2 km from the Epicenter of the Blast*,1962, from the series "11:02— Nagasaki"; from *Aperture* 102, 1986.

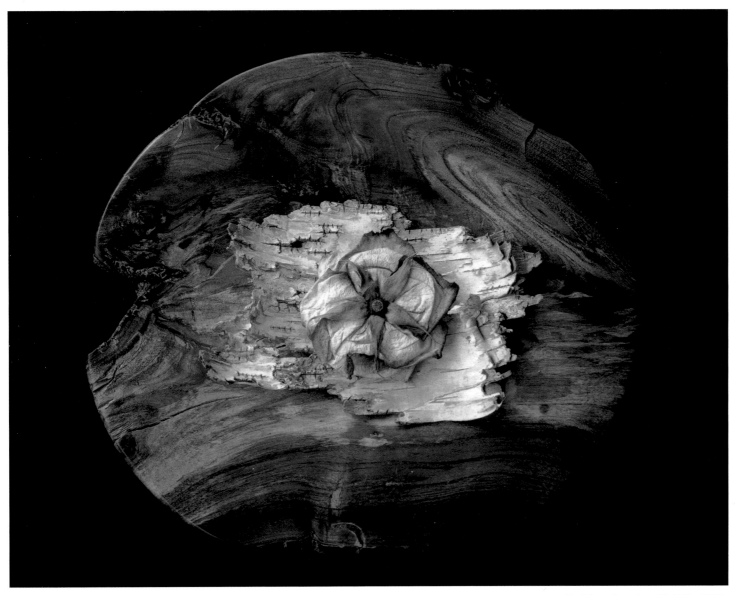

Paul Caponigro, *Inner Night Sky*, 1999.

THIS PAGE: photographs by Marilyn Bridges. TOP: *Burning Man,* Black Rock Desert, 1997. BOTTOM: *Jockey Club,* Argentina, 1996.

László Moholy-Nagy, *From the Radio Tower*, Berlin, 1928.

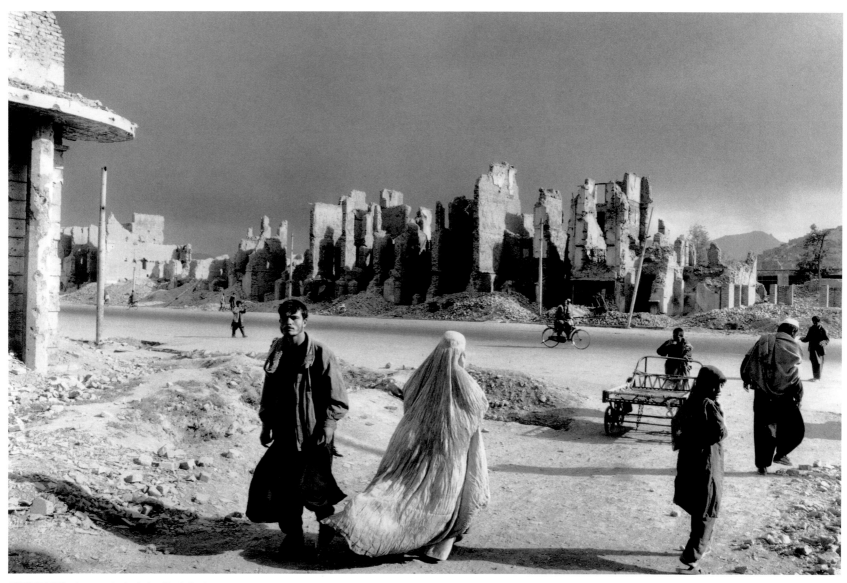

THESE PAGES: photographs by Sebastião Salgado.
OPPOSITE: *The gold mine.* Serra Pelada, State of Pará,
Brazil, 1986; from *Workers: An Archaeology of the
Industrial Age* (Aperture, 1993).
ABOVE: *Kabul, Afghanistan*, 1996; from *Migrations:
Humanity in Transition* (Aperture, 2000).

And never have I found the limits of photographic potential.
Every horizon, upon being reached, reveals another beckoning
in the distance. Always, I am on the threshold. . . .

—W. Eugene Smith, *Aperture* vol. 14, nos. 3–4, 1969

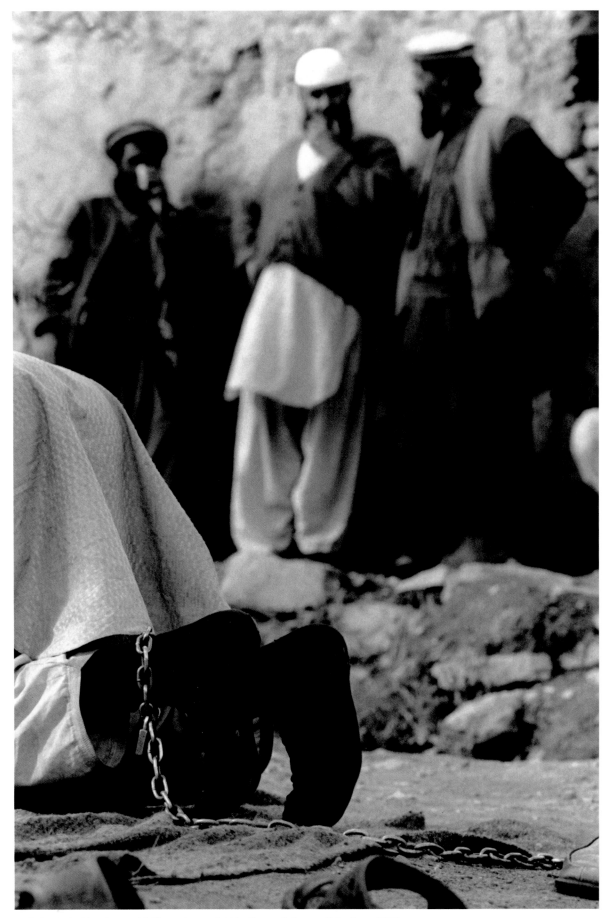

Chris Steele-Perkins, Captured Taliban prisoners held by Massoud's forces, Afghanistan, 2001.

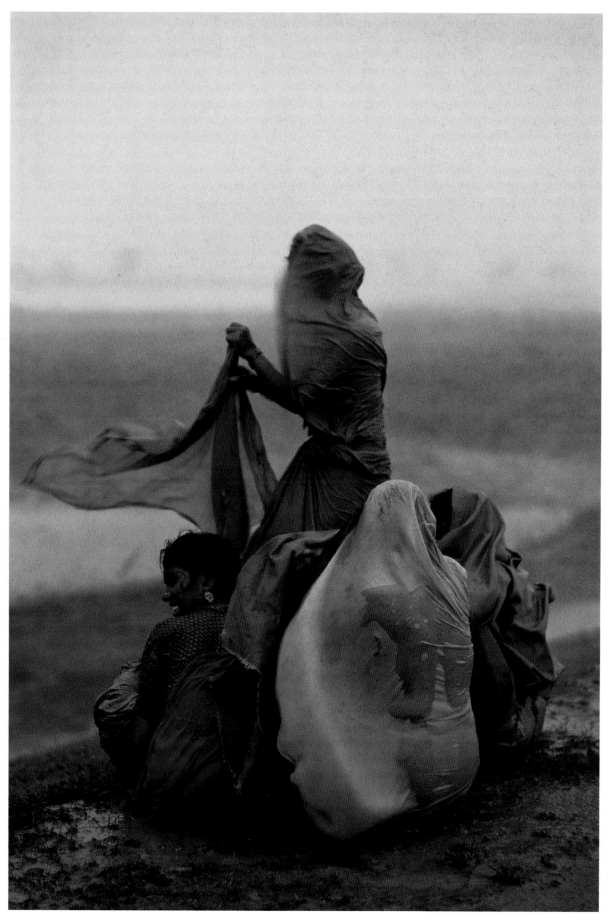

Raghubir Singh, Women caught in monsoon rains, Bahir, 1967; from *Aperture* 105, 1986.

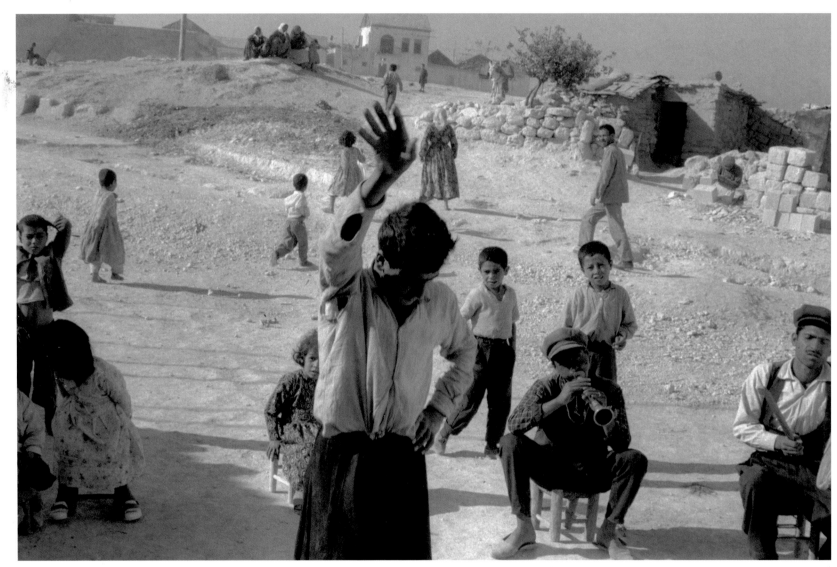

Henri Cartier-Bresson, *Turkey*, 1964; from *Aperture* vol. 13, no. 4, 1968.

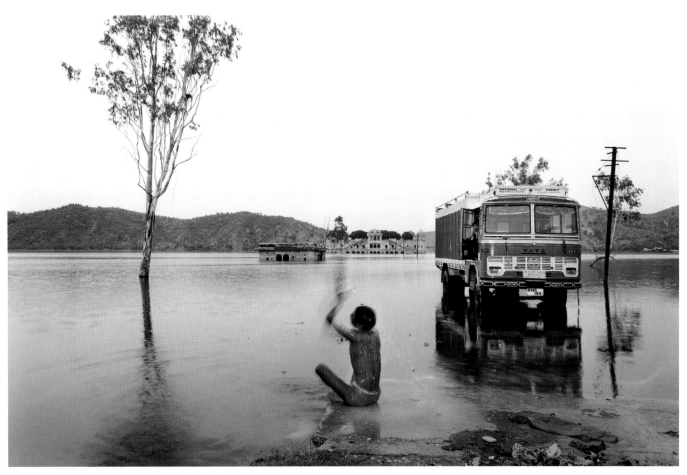

Mitch Epstein, *Monsoon*, Jalmahal, Jaipur, 1985; from *Aperture* 105, 1986.

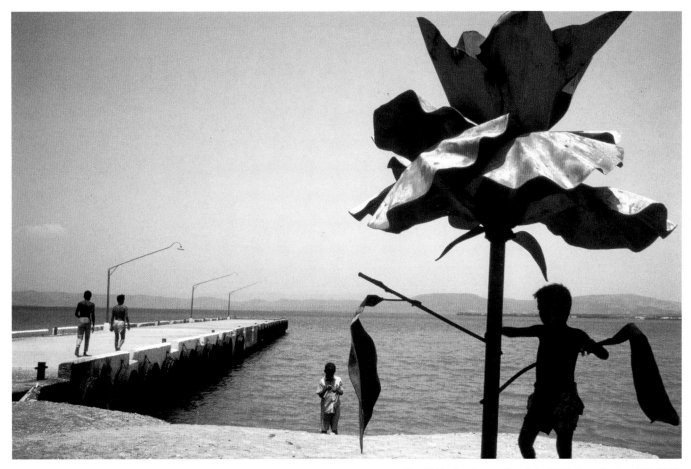

Alex Webb, *Guantanamo Bay, Cuba*, 1993; from *Aperture* 141, 1995.

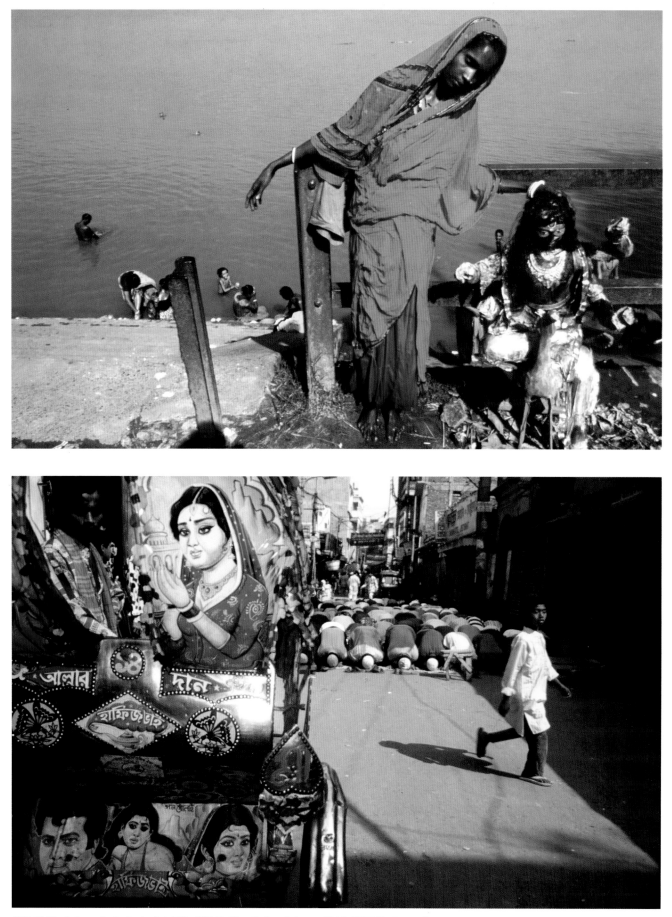

THIS PAGE: photographs by Raghu Rai. TOP: *With Goddess Kalima*, Calcutta, 2000. BOTTOM: *Prayer time*, Dhaka, 2000.

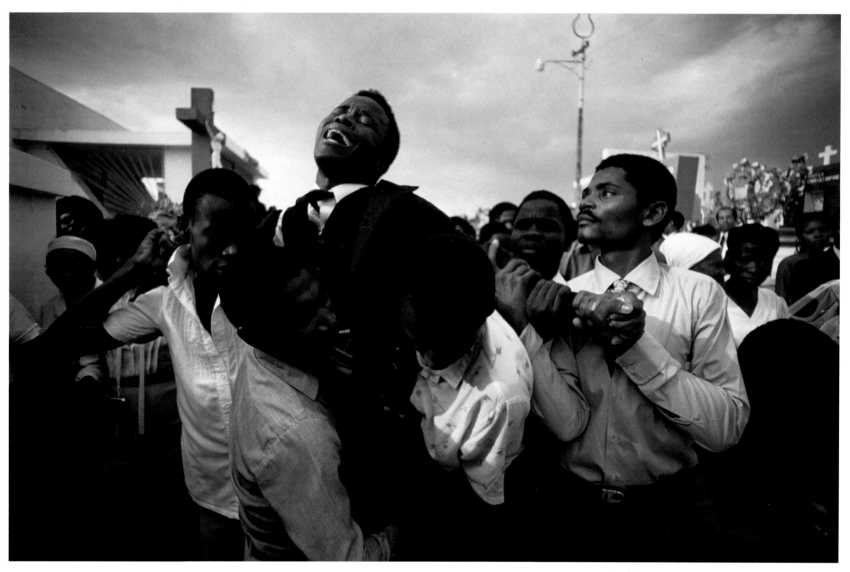

Maggie Steber, *Mother's Funeral*, 1987; from *Dancing on Fire: Photographs from Haiti* (Aperture, 1996).

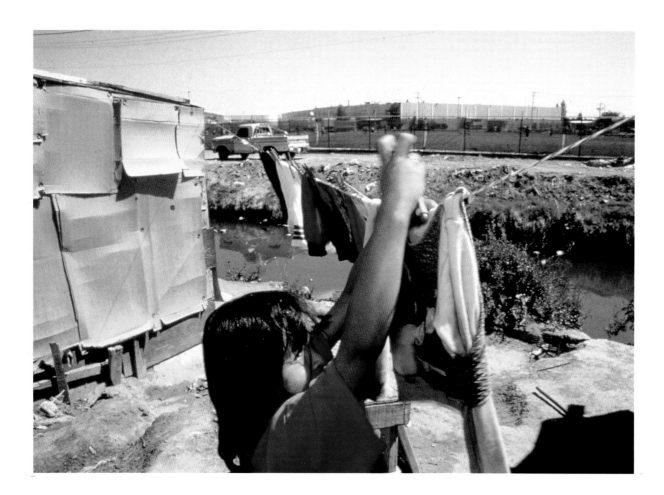

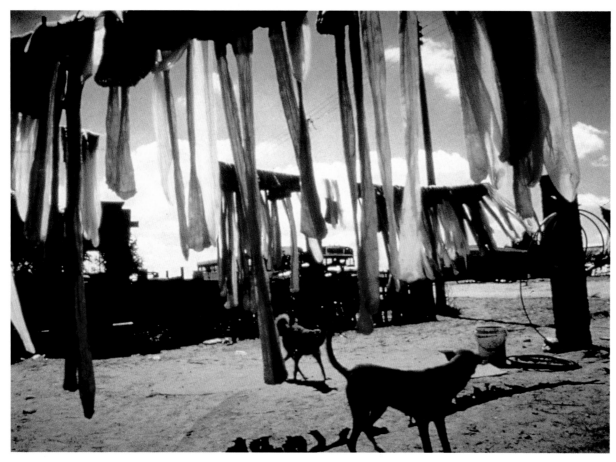

THIS PAGE: photographs by Julián Cardona; from *Juarez: The Laboratory of Our Future* (Aperture, 1998).
TOP: A canal of *aguas negras* (contaminated water, such as untreated sewage or waste water from the *maquiladoras*) separates one of the ca. 325 *maquiladoras* in Ciudad Juárez—this one in the Rio Bravo industrial park (in the background)—from the new home of seven-year-old Guadalupe Valenzuela Rosales, who lives with her parents, two sisters, and a brother in a cardboard-and-wood house, 1997.
BOTTOM: Hosiery discarded by El Paso shopkeepers is bought, mended, dyed, and dried in the sun by a Ciudad Juárez woman living in Colonia Puerto Anapra; she then resells the stockings for the equivalent of about a dollar, 1995.

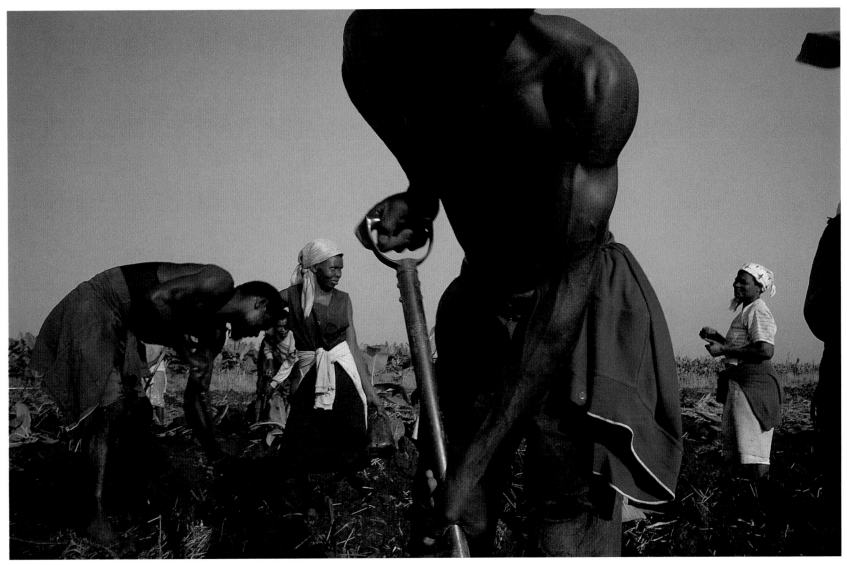

Pascal Maitre, *South Africa*, 1993; from *Mon Afrique: Photographs of Sub-Saharan Africa* (Aperture, 2000).

So what is familiar to one of us may very likely be familiar to another. Sweat in the eyes, sun on the back, cold in the heart—these things we all know. More important, we all know something of what they mean. Hard work, warm weather, pain, we all have enough in common to make most of our many worlds companion to each other. We eating, we sleeping, we mourning and rejoicing, we hating, we loving—it is the same with these. These we know; so knowing, these we see; and it is in these that a great photograph speaks, not of eating and sleeping, but of our-selves. Whether of a board fence, an eggshell, a mountain peak or a broken sharecropper, the great photograph first asks, then answers, two questions. "Is that my world? What, if not, has that world to do with mine?"

—Dorothea Lange and Daniel Dixon, from "Photographing the Familiar," *Aperture* vol. 1, no. 2, 1952

Castro reappeared. He had just spoken to a women's conference, and now spoke spontaneously for more than an hour and a half about photography, and about health care and baseball and video cassettes and other subjects, quickly moving back and forth from one to the other. During his talk, almost no one moved; a large group of photographers remained standing in the front of the hall.

At the end of his talk, Fidel Castro greeted Manuel Alvarez Bravo, considered Latin America's greatest photographer, who had not lectured but sat through the conference like any other delegate. For many delegates it was a major historical moment—Latin America's greatest photographer being presented to the man whom many consider its greatest politician.

The following text is an excerpt from Castro's speech. —Fred Ritchin

. . . But I have seen many books of Cuban photography containing nothing but pictures. There is a recently printed book called *Twenty-five Years Under Revolution*, designed with only photographs. It is wonderful, it has immense value for us. Even if it is difficult to picture an idea, a crowd that sustains its fight for an idea eventually achieves it.

We are very sorry that we didn't have a photographer with us during the revolutionary war or during the first years of struggle, while we were underground, or during the advance to Moncada. We should have taken some photographs but we didn't think about it. There are a few pictures of those days, but there should have been more. We would now be able to write the history of our revolution with those pictures alone.

Unbelievable as it may sound, we have no pictures from when we were on board the *Gramma*, not one. We would have loved it if only an amateur had photographed us. Even Che, who was an amateur photographer and liked to try almost everything, didn't have a camera with him at the time. If only we had a camera with us that day on the *Gramma*, maybe we would now have photographs of the *compañeros*, of the thrilling moments, of the disembarkment, and of all the revolutionary war. Now, after almost thirty years, you feel sadness and regret for not carrying a camera with which you could have taken the pictures that would now speak for themselves. On those occasions, as on so many others, it is only after time passes that people realize that they have been through historical moments that will never be repeated, and that the memory fades. We are not so pretentious as to think that people will talk about us sixty years from now, but at least our relatives and descendants will have some interest in knowing what really happened during those years. We must preserve these moments through photography.

Time passes so quickly and the world changes so much within a short time that we ought to be conscious of the things we do, to make them as good as possible, so future generations will not think badly of us. At least we have the duty to leave a testimony about how we spent our time. Sometimes one regrets that photography was such a recent invention. When was photography invented? 1839? What a delay for man to discover such an interesting activity!

. . . The point is that the role of photography is very important for the development of progressive ideas and for the struggle of the poor nations of the world.

—From the Colloquium on Latin American Photography, Havana (1984), *Aperture* **100, 1985**

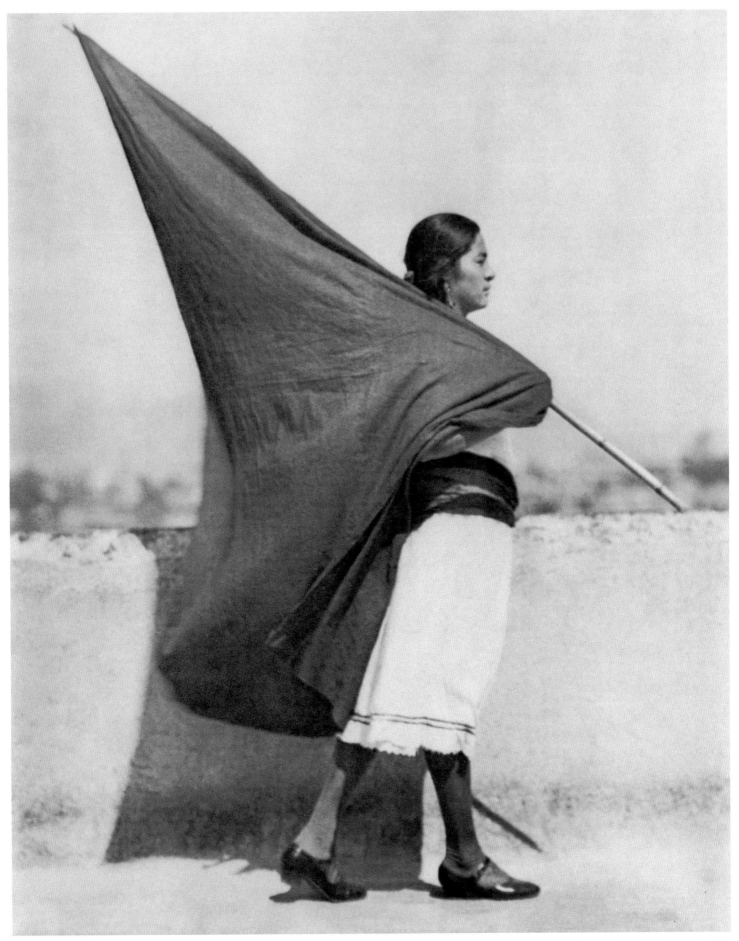

Tina Modotti, *Woman with Flag*, 1928.

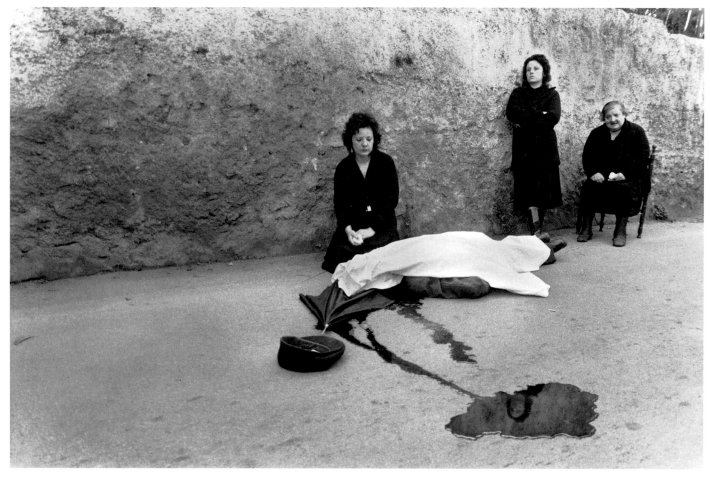

Franco Zecchin, The wife and daughters of Benedetto Grado at the site of his murder, Palermo, November 11, 1983; from *Aperture* 132, 1993.

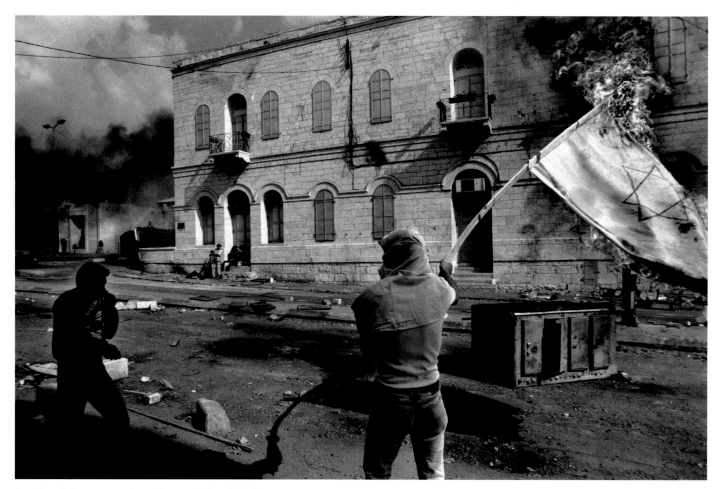

Larry Towell, Demonstrators burn a homemade Israeli flag in protest, Bethlehem, West Bank, 2000.

Gerhard Richter, *Beerdigung* (Funeral), 1988;
from *Aperture* 145, 1996.

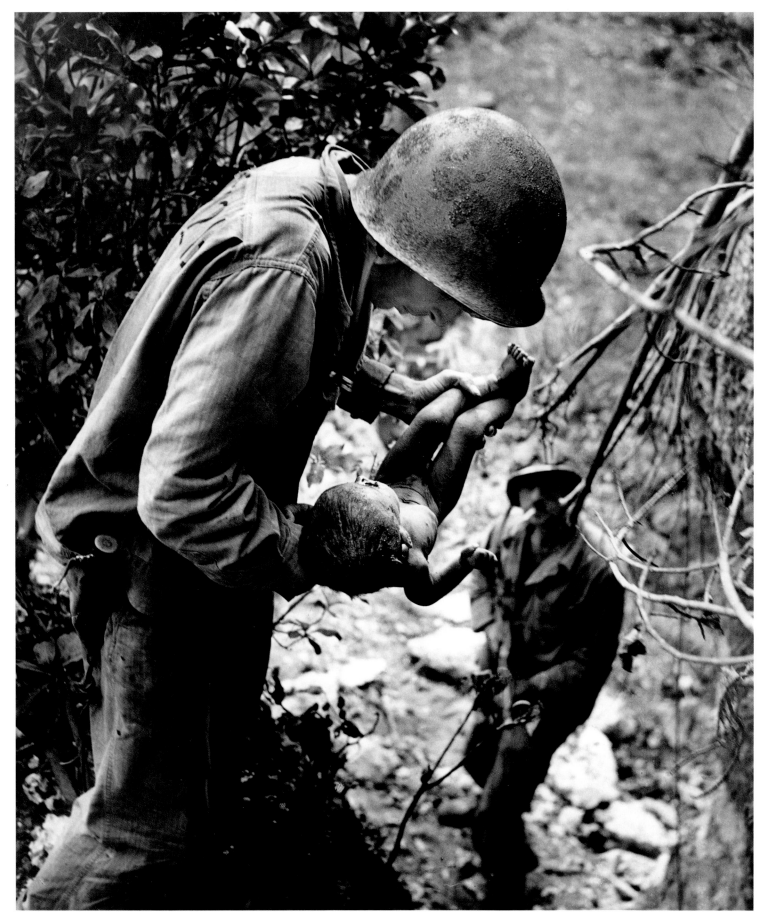

**W. Eugene Smith, Wounded, dying infant found by American soldier
in Saipan Mountains, June 1944; from *Aperture* vol. 14, nos. 3–4, 1969.**

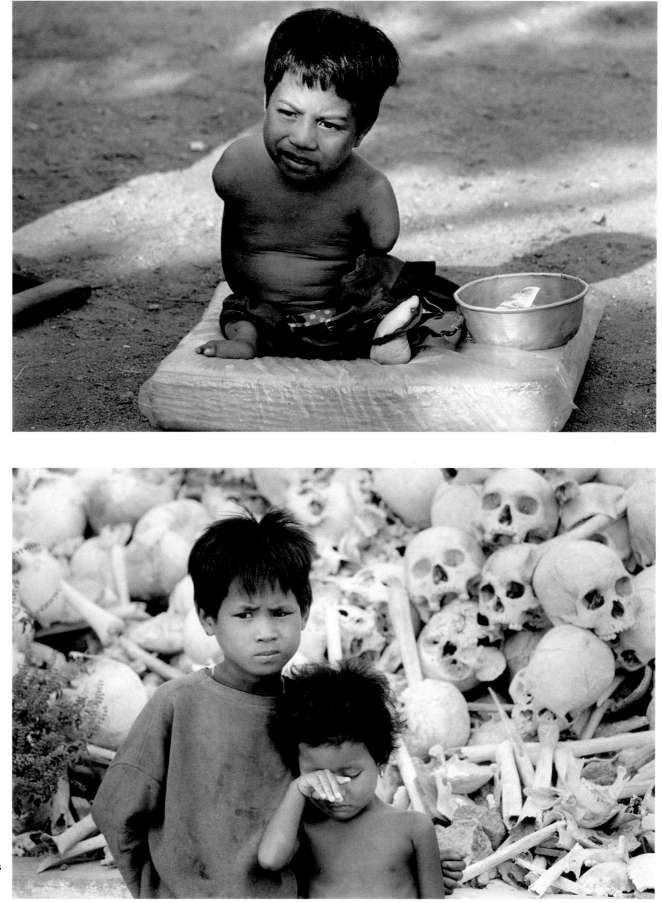

THIS PAGE: photographs by Philip Jones Griffiths.
TOP: A 12-year-old boy from Svay Rieng, a Cambodian province adjoining Vietnam that was widely sprayed with Agent Orange by American airplanes. Many of those who were exposed to this poison during the Vietnam war remain seemingly healthy, yet their offspring will bear the effects of American chemical warfare for generations to come. This boy was brought to Phnom Penh to beg—as are many others—because the money he collects in this center of Western tourism will help support his family trapped in the poverty of the countryside, 1995.
BOTTOM: Village children before one of the many mounds of skulls that are scattered around Cambodia, 1996.

Brian Weil, *Prince, Two-year-old with AIDS*, New York City, 1986; from
Every 17 Seconds: A Global Perspective on the AIDS Crisis (Aperture, 1992).

History is made by and for particular classes of people. A camera in some hands can preserve an alternate history.

—David Wojnarowicz, from "Close to the Knives," *Aperture* 137, 1994

Lee Miller, *Dead German S.S. Prison Guard*, Dachau, April 30, 1945; from *Aperture* 103, 1986.

THESE PAGES: photographs by Don McCullin, from a series on AIDS. Nkwazi compound in Ndola, Zambia, Justina Mkandawila with son Gift, five, and daughter Naomi, eighteen months old, February, 2001.

There are two courses open to the photographer. He can make the uncommon common. Or he can make uncommon the common.

The classic example of the photographer who aims to make the uncommon common is the news photographer. His goal is not to record the ordinary and the everyday, but the extraordinary and the unusual. Wherever there is disaster, the newsman is there. If he cannot find disaster, he searches for the odd and the peculiar, the exotic and the unfamiliar. His photographs, seen by millions, make momentary events and strange occurrences all over the world our common property. What more striking evidence could be offered of this power of photography than the atom bomb? The mushroom cloud, the very symbol of nuclear fission, has become known through photographs.

— Beaumont Newhall, from "Photographing the Reality of the Abstract," *Aperture* vol. 4, no. 1, 1956

At Cicetekeio Hospice, Ndola, Zambia, hospital patient Mildred Moyo, twenty, has her hair styled by a volunteer worker, February 2001.

PART III

The Indispensable Art: Survival

Director:

For art may need long years of true devotion
To bring perfection to the light of day.
The brilliant passes, like the dew at morn;
The true endures, for ages yet unborn.

 —Johann Wolfgang Goethe, *Faust*, Part One, Prelude

The old man lumbered down the stairs in a weathered bathrobe at eleven A.M., an unusually late hour for a photographer. But at age eighty-one, Paul Strand could rise at any hour he damned well pleased. What awaited him at the bottom of the stairs gave him a shock and sent him back up toward his bedroom in a very bad mood. He had seen a goodly portion of his life's work, hundreds of photographs including the very best of his one-of-a-kind masterpieces, spread out and covering nearly every square foot of the main room of his provincial French farmhouse. The early riser, twenty-eight-year-old Michael Hoffman, had been up since dawn placing, rearranging, and sequencing them.

"I had no choice," Michael recalled years later.

We were trying to get ready for the first major Strand retrospective in a quarter century. We'd gone through more than a thousand prints and were trying to get it down to around four hundred and fifty. But every time I'd suggest removing one, Paul would say, "What's wrong with that one? What don't you like about it?" And back it would go in the pile. I was getting desperate. But when Paul saw the ones I'd chosen all over his floor, he was very unhappy—at least, at first. Then, after a while, he came back down the stairs and stared and said, "I've never looked at them this way before. I've never seen the way they look in these kinds of relationships." And then he got more and more excited, and we made the final selection within the next day or so.

Only a few years in time, but an enormous passage of growth—of insight, experience, and breadth of ambition—had been traveled by Michael since his first encounter with Strand in 1966. Then, reluctantly, Strand and his wife Hazel had gone to Michael's and Misty's Brooklyn apartment for lunch. "Almost the first question I asked," Michael said, "was what did he think of Stieglitz's concept of 'Equivalents.' And Paul growled, 'Rubbish! Pure rubbish!' It wasn't an easy meeting, but Hazel and Misty—who had

far more social graces than either Paul or I—got on famously. Besides, I had something to offer." What Michael proposed was nothing short of revolutionary from Strand's perspective: republication of his critically acclaimed but seldom seen *Mexican Portfolio*. Strand didn't believe it could be done: an edition of fifty portfolios of twenty prints each. But Michael had come prepared with more than an idea. He set out, just as he had with Minor, to prove himself indispensable, and his timing was impeccable. Strand was concerned about his legacy and what would become of his oeuvre, encompassing a span from 1915 to Michael's Orgeval visit in 1971. His life's work could only be described as epic. And it had been peculiarly neglected.

The only child of hard-working, often financially pressed parents—his father sold French bric-a-brac, his mother taught kindergarten—Strand was born on Manhattan's Upper West Side in 1890. His parents sacrificed to send him to the progressive Ethical Culture School a few blocks away from their home; there he came under the influence of Lewis Hine, the great social documentarian who taught photography classes after school to a select group. Hine also took his young protégés to Stieglitz's 291 Gallery, where Strand first encountered the works of Steichen, Gertrude Käsebier, Clarence White, and the master himself. By age twelve, Strand had already decided that he wanted to be "an artist in photography." Ten years later, he had set up as a commercial photographer.

From the outset, Strand was an obsessive devotee of craftsmanship, and a continuous explorer. His early efforts imitated the soft-focus Pictorialist and Photo-Secession imagery, and abstractions and Cubist studies inspired by Picasso, Braque, and other artists whose work he had seen in Stieglitz's gallery and publications. Then, beginning in 1916, Strand made a few images, notably *Blind Woman*, *White Fence*, and *Wall Stree*t, which signaled the awakening of a vision that was purely his own. Stieglitz and Steichen were both enthusiastic about the new work. Stieglitz arranged for the emerging photographs to be exhibited and also published in *Camera Work*—even dedicating the last two issues of the journal to Strand's work.

For a livelihood, which his photography did not provide, Strand began working as a freelance filmmaker in 1920 and made a succession of documentaries, culminating in 1935 with *The Plow That Broke the Plains*, a documentary about the ecological disaster of

the Dust Bowl during the Depression. He continued his own photography throughout, and the *Mexican Portfolio* was made during his two-year stay in the country from 1932 to 1934. Strand finally gave up filmmaking in 1942, largely due to the generosity of his father, Jacob. He had been a lifelong supporter of his son's art and, finally achieving prosperity late in life, Jacob Strand helped make Paul frugally but comfortably independent.

Strand's reputation began entering Olympian realms with his 1945 retrospective at the Museum of Modern Art, curated by Nancy Newhall. At her suggestion, they collaborated on a major project, *Time in New England*, drawing upon the words of its most eloquent writers and images that Strand found in farmlands, villages, and along the sea. Strand's name also became attached to what political conservatives considered rabid Leftism (he was in fact a staunch Roosevelt New Dealer). He was appalled at the destructive McCarthyism that had overwhelmed his country. In 1950, he and Hazel Kingsbury, for several years assistant to fashion photographer Louise Dahl-Wolfe, moved to Europe. Hazel became Strand's third wife. They settled in France as permanent expatriates, and in the following years he undertook two more landmark collaborations, *La France de Profil*, with author Claude Roy, and *Un Paese: Portrait of an Italian Village*, with screenwriter Cesare Zavattini. Years later, Aperture would publish these books, along with other major Strand works, to still unmatched standards of photographic reproduction. Strand's travels expanded to Egypt, Morocco, and Ghana, but some of his greatest images were created in his own garden at Orgeval, a village twenty-three kilometers west of Paris, where he and Hazel had purchased a farmhouse in the early 1950s. Paul and Hazel periodically returned to the United States, and it was on one of these visits that Michael raised the possibility of rereleasing the *Mexican Portfolio*.

Michael had discovered in a small Brooklyn loft a nearly impoverished, eighty-four-year-old lithographer with an almost equally ancient press. Moreover, he had found another elderly man who created lacquers for religious objects, using the most authentic methods and materials. Strand was intrigued by the idea of these two anachronistic artisans and agreed to meet with them. Gradually, the prospect of reproducing the portfolio took hold. Handmade papers were ordered from Europe, then rejected because of miniscule flaws in the washing process, and remade. The portfolio—containing Strand's indelible portraits of villagers and village life—emerged over the course of the next two years. "It really was crazy," Michael said. "We were running all over Brooklyn, from printer to lacquer-maker, and Paul working one sheet at a time. Each print had to be perfect—one thousand of them! But it worked. The portfolio was finally released by Aperture and Da Capo Press in 1968."

During the two-year span of the Strand project, Michael was also engaged in frenzied, multidirectional sprints to keep *Aperture* alive. Patient, ever supportive, Shirley Burden continued picking up the basic bills for printing and mailing—whatever was not covered by subscriptions and the occasional advertisement. Michael received no salary, but he had his small army pension, his father helped out with the rent, and Misty worked for a nonprofit foundation. *Aperture*'s survival, Michael knew, depended upon repositioning it as a business—but a business fashioned uniquely in terms of its fundamental values and his own temperament and abilities.

The journal's values had been articulated by the Founders, finding expression in Minor White's editorship. First and foremost,

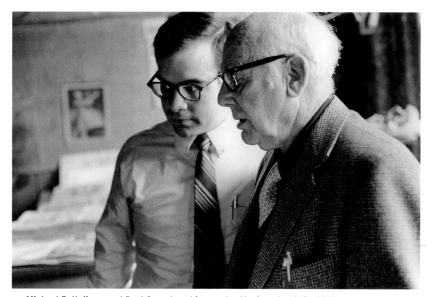

Michael E. Hoffman and Paul Strand working on the *Mexican Portfolio*, 1965. Photograph by Alen MacWeeney.

the journal existed for the benefit of the artist, to serve his or her intent. This meant that the publication was inherently antimercantilist—the profit motive must never dictate content. This freed the work from pressure upon selection of images and design, and further implied a challenge to all forms of censorship—challenges that would be met head-on in the ensuing years. Yet, even though the terms seem banal within the context, survival meant all the basics of business practice: product, supply, distribution, market, skilled labor, and infusions of capital. Such a mix of idealism and practicality was a tough sell.

Like many children of the well-to-do in the 1960s, Michael had an almost visceral resistance to working solely for money, or for pursuing any profession that his parents might regard as "normal." At the same time, he possessed—and delighted in—a prodigious skill for making a deal. This was in sharp contrast to Minor's way of working. Michael once tried to finagle a supply

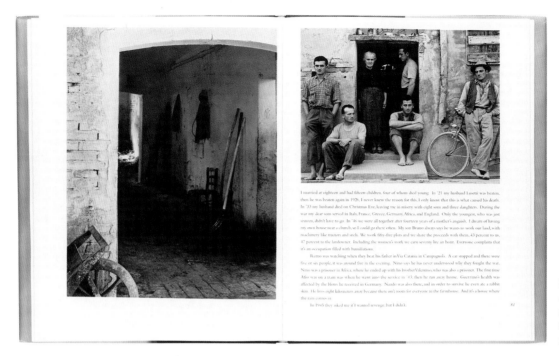

I married at eighteen and had fifteen children, four of whom died young. In '21 my husband Lisetti was beaten, then he was beaten again in 1926. I never knew the reason for this, I only know that this is what caused his death. In '33 my husband died on Christmas Eve, leaving me in misery with eight sons and three daughters. During the war my dear sons served in Italy, France, Greece, Germany, Africa, and England. Only the youngest, who was just sixteen, didn't have to go. In '46 we were all together after fourteen years of a mother's anguish. I dream of having my own house near a church, so I could go there often. My son Bruno always says he wants to work our land, with machinery like tractors and such. We work fifty-five plots and we share the proceeds with them, 43 percent to us, 47 percent to the landowner. Including the women's work we earn seventy lire an hour. Everyone complains that it's an occupation filled with humiliations.

Remo was watching when they beat his father in Via Catania in Campagnola. A car stopped and there were five or six people, it was around five in the evening. Nino says he has never understood why they fought the war. Nino was a prisoner in Africa, where he ended up with his brother Valentino, who was also a prisoner. The first time Alto was on a train was when he went into the service in '43, then he ran away home. Guerrino's health was affected by the blows he received in Germany. Nardo was also there, and in order to survive he even ate a rabbit skin. He lives eight kilometers away because there isn't room for everyone in the farmhouse. And it's a house where the rain comes in.

In 1945 they asked me if I wanted revenge, but I didn't.

Paul Strand's
Un Paese: Portrait
of an Italian Village
(Aperture, 1997),
pages 80–81.

The cornerstone of Michael's plan for Aperture was the publication of photography books to a standard either lost or never before attempted. . . . [He] needed higher-quality printing at less cost. He needed designers. He needed quality control. He needed the imagery of the very best practitioners, past and present. . . .

of high-quality paper from a supplier and suggested to Minor, "Maybe we can make a deal." Minor looked at him blankly: "What's a deal?"

Michael, on the other hand, was unabashed about asking for money wherever he thought he might find it. And in wooing artists he felt should appear in *Aperture*. And in seeking out free expert advice and services, legal and otherwise. He anxiously spent what seemed an extravagant amount of money for an electric typewriter. Working late into the night, he then wrote countless fund-raising, deal-making letters, placing false initials in the lower left-hand corner of each to give the impression that Aperture had a secretary.

An office was set up in a walk-up on East 91st Street, staffed primarily by Michael and a young man with what was then an utterly useless university degree in linguistics, Charles Simic. He hadn't been able to find a job anywhere else. Simic's first volume of verse was published while he was working at Aperture, and he would later be recognized as a major American poet. In the late 1960s, he was Aperture's man-of-all-work. "I was paid a miserable salary and did everything—answered telephones, handled mail, swept floors, cleaned the bathroom, proofread, ran errands, picked up people at the airport or train or bus station, My eventual title was 'business manager,'" Simic reminisced years later, adding, "The worst was when Michael set up a distribution company with a group of other small publishers."

The Book Organization, as it was called, was a sensible idea. Small presses, indispensable to the unmarketable underpinnings of cultural life, then as now found it difficult to get their poets, short-story writers, critics, artists, and others into bookstores. They offered little profit to the big mass-market publishers, nor could they afford sales representatives or glossy, eye-catching catalogs. In 1968, one of Michael's chief collaborators in forming a distribution cooperative of such presses was Jonathan Williams, whose Jargon Society had been founded in 1950 in North Carolina. Always pressed for (or simply without) cash, Williams nevertheless had succeeded in publishing the Appalachian photographs of Doris Ulmann, *Patagoni* by Paul Metcalf, and the work of an amazing array of poets, including himself, Charles Olson, Thomas Meyer, and James Broughton, to mention only a very few. Along with the Jargon Society and Aperture, the distribution group involved such presses as Corinth Books, Eakins Press, and Glide Publications. For the bookkeeping and accounting tasks, Michael volunteered Simic.

"It was horrible," Simic recalled. "These books would sell a copy here, two or three there, and each one had to be accounted for—the money and numbers and these tiny checks sent out, and picked over, and the copies and inventories controlled, accounts kept scrupulously." The small presses could fold as spontaneously as they had sprung up, even as the details delegated to Simic reached overwhelming proportions. (Of the original group, only

Aperture, Jargon, and Eakins continue to be active under their original rubrics.) Perhaps the Book Organization's most significant achievement was the beginning of a lifelong friendship between Michael and Williams; the poet/publisher would become one of Aperture's most original contributors.

The cornerstone of Michael's plan for Aperture was the publication of photography books to a standard either lost or never before attempted. This, he hoped, would provide growing revenues over a period of time—as opposed to the short shelf life of the journal. Its subscription base grew with aching slowness; receipts never kept pace with expenses. For his plan to succeed, Michael needed higher-quality printing at less cost. He needed designers. He needed quality control. He needed the imagery of the very best practitioners, past and present, who had ever worked in the medium. He needed writers with a critical sensitivity to the photographers and their creations. He needed cash. He needed help. And then came a series of desperately needed breakthroughs.

The first of these arrived in the person of Stevan Baron, an alumnus of Minor's workshops. Baron had gone to work at Random House in book production, and began volunteering his time to help get Aperture's quarterly and later the books out—a task he performed for years without pay until Michael managed to scrounge up a small, irregular salary. Together, Michael and Baron discovered a custom printer in lower Manhattan, Sidney Rapoport. He believed that both the periodical and the books could continue to be printed by letterpress, but with a less costly method. Doubtful at first, Michael and Baron worked with Rapoport to develop an improved process of two-color, duotone printing—running pages twice through the press with different densities of inking—to achieve heightened range and tone of black-and-white photographs. Though still costly, the process was cheaper than the previous one, and the quality improved.

Another development of incalculable importance came with the help of Dorothy Norman, Nancy Newhall, and Paul Strand. Norman had been negotiating with the Philadelphia Museum of Art to donate her private collection toward the creation of a new department of photography. It was an act of astonishing generosity: five hundred vintage and study prints by Stieglitz and other artists; Stieglitz memorabilia; and two complete sets of *Camera Work*, in themselves a Holy Grail for some collectors. Having worked with Michael on her evolving project *An American Seer*, Norman joined Nancy and Strand in promoting Michael as the first curator of the museum's new department. And so in 1968, at age twenty-six, Michael was heading a floundering publishing house, though he insisted that Minor always be listed as editor; and he was the first curator of the Alfred Stieglitz Center of Photography at one of America's most prestigious museums.

Soon after, there came another windfall, from a powerful influence in American photography who, according to Michael, "didn't like Aperture particularly." With Baron and Rapoport, the Weston *Flame of Recognition*—so disastrously printed in its first incarnation—was being redone, and Michael took the layout to Bruce Downs, editor of *Popular Photography*, a magazine with the medium's largest worldwide readership. As Michael remembered, "Downs said, 'I've never agreed with anything Minor White either did or said.' I thought I was dead in the water, until he added, 'But you know, when Weston died I did nothing, and the only publication that did anything was *Aperture*. That's been on my conscience.'"

"And then," Michael continued, "Downs did the most amazing thing. He personally did the most beautiful layouts on the Weston monograph, and wrote a lovely essay. He also put in a little squib about how people could subscribe to *Aperture*. That brought in two thousand new subscribers—more than the magazine had ever had. And that brought in money so we could pay the bills."

The year 1968 heralded an uncanny process of synergy for Aperture. Michael said, "The Philadelphia Museum association was extremely important because we could now attract new artists with the prospect of major exhibitions—artists who might not have wanted to take the time and trouble of publishing in a non-paying, small-circulation journal." Aperture augmented the museum's publishing capacity, as well as attracting its own participating artists, and with them came contributions to the museum collection. It was an enlarging capacity that reached out to other institutions, notably at first the Massachusetts Institute of Technology, where Minor had been installed as professor of pho-

Stevan A. Baron, *Nepal*, 1987.

tography. And *Aperture*, the journal, even if it could not maintain a quarterly schedule, provided the mechanism to create issues that served simultaneously as periodical, as museum catalog, and as hardcover monograph.

It was in the same year, at a Museum of Modern Art show, that a retired, fragile Edward Steichen came up to Michael and asked, "Could you do for me what you've done for Strand?" Steichen explained that most of his early negatives and glass plates had been lost during World War I, but he had a few left. He wanted them reproduced, like the *Mexican Portfolio*, in an edition of hand-pulled gravures. According to Michael, "Steichen said the most curious, unforgettable thing. He said, 'If I had it to do over I would do it Stieglitz's way.'" In spite of all of his great success, Steichen knew it was his early work that would survive. Aware that his aged lithographer would not be up to the task, Michael agreed to try, and launched a project that years later created Aperture's Photogravure Workshop. Steichen's masterpieces reemerged, though after the photographer's death, as the Workshop's first portfolio.

Also during 1968, Michael drew upon Norman's gift for his inaugural exhibition at Philadelphia, followed by "Light 7," the first of four innovative and controversial shows Minor had originally created at MIT's Hayden Gallery. Both were deemed successful, but Michael already had laid plans for two groundbreaking events: one offering well-deserved attention to a contemporary innovator, the other designed to throw light upon photography's early history.

The innovator was Robert Frank, a Swiss-born photographer and filmmaker who had accompanied Steichen as interpreter during his European forays in search of photographs for "The Family of Man." In the 1950s Frank traveled most of the lower forty-eight states on a Guggenheim grant. He retrieved indelible, penetrating moments in the lives of *The Americans*, as the monograph of his classic photographs would be named, with a perfectly timed text by Jack Kerouac writing at his best. Frank's monograph had been published in France, and in the United States by Grove Press, and was then quickly remaindered. He had a small group of admirers, Michael prominent among them. "I had traveled where he had been. I knew he had got it exactly right," Michael said. "And I thought his was one of the most powerful, original voices in photography in the past seventy years."

Michael determined upon a major Frank exhibition at Philadelphia, with Aperture republishing *The Americans*. Frank's only instruction to Michael about the photographs was: "Don't make them look too good." Michael responded by pasting the prints, unframed and unprotected by glass, to plain paper backdrops. "I had the sense to have two complete sets of prints made," Michael said, "so Philadelphia acquired a wonderful Frank addition for the collection."

Traveling on a shoestring, Michael and Misty made their first trip together to France. They visited the Strands at Orgeval, and Michael had his first of what would be many lively encounters with Henri Cartier-Bresson. The primary purpose of the trip, however, was Michael's hopes of securing the cooperation of André Jammes, a connoisseur, collector, and historian of early photography—known to his peers as "the impeccable eye." Jammes drew upon his own collection and loans from the French Photography Society, among other institutions, to assemble images spanning from 1850 to 1865. Jammes named the show "French Primitive Photography"; "primitive," he emphasized, in the sense of *primary*, a period of discovery, pioneering, and flowering at the dawn of the medium.

Back in Philadelphia with the prized images, Michael soon became desperate as to how they could be organized into a coherent exhibition. Here were pictures as diverse as Hippolyte Bayard's earliest still life, dated 1840, of replicas of classic statuary; boulevard and war-camp views of Second Empire luminaries; scenes from a lunatic asylum—it was a bewildering assortment. Michael called on Minor for help, and after some hesitation the mentor traveled to Philadelphia. Viewing the collection, laid out erratically on the floor in handsome frames, almost his first words were: "I don't see how you're going to do this." Michael replied, "Well something has to happen because in three days hundreds of people are going to walk through those doors to see what it's all about."

Suddenly, Michael recalled, "something took over. It was like magic." Minor started moving through the images, more than two hundred of them, shuffling, grouping them in squares and lines, and an entirely new dimension emerged. Minor later described the sequencing as putting the pictures "in the present because of all that time has done to them since." Minor also directed that the walls of the galleries be painted lime green. "It just seemed totally outrageous," Michael said. Meanwhile, Michael ruffled some curatorial feathers by demanding that pieces of Rodin sculpture from the Philadelphia Museum's collection be arranged around the exhibition space. "It was right for the period," Michael said, "and helped in the flow of visitors' movements and perceptions. The statues refreshed the eye."

"French Primitive Photography" was a resounding success. Aperture's accompanying catalog, published as a double issue of the periodical and as a monograph, received lavish critical acclaim. As for Michael, the experience of working with Minor on mounting the show was an illumination unto itself. "I understood it as something totally creative, something removed from the intellectual, linear approaches of curatorial convention. It was a completely new way of looking at pictures and offering them to the public."

PHOTOGRAPHS
ROBERT FRANK

Entry to the Robert Frank exhibition,
Philadelphia Museum of Art,1969.

"The Philadelphia Museum association was extremely important because we could now attract new artists with the prospect of major exhibitions—artists who might not have wanted to take the time and trouble of publishing in a nonpaying, small-circulation journal."

Installation view of "The Circle, Square, and Triangle" exhibition of Minor White's work, Philadelphia Museum of Art, 1969. The show was designed by White.

Katharine Carter Hoffman, Marie-Thérèse Jammes, André Jammes, and Michael E. Hoffman at the opening of "French Primitive Photography," Philadelphia Museum of Art, 1969.

These were halcyon days, passages from the late 1960s into the early 1970s. Michael seldom seemed to sleep, even when his schedule permitted. He and Misty were young and would often stay up through the night. Asked years later what sustained them, Michael always reverted to the same source: a sense of belonging and contributing to "a community of interest." It is a concept nearly impossible to identify with precision.

At the time, of course, the broadest popular sense of community was shaped by the anti–Vietnam War movement; by civil-rights protests; by gatherings of the young, with the inevitable associations of sex, drugs, and rock 'n' roll. These are the clichés now ensconced in mainstream memory. Yet within this generalized massing there were vital communities, constantly forming, subdividing, intersecting, and inspiring their various members—enough communities to baffle a herd of sociologists.

One source of these brachiating groupings was North Carolina's Black Mountain College. Opened in 1933, this pioneering experiment attracted select students and faculty over the course of its twenty-four-year life—including R. Buckminster Fuller, Willem de Kooning, Walter Gropius, John Cage, and Merce Cunningham (later the subject of a major Aperture monograph). Beaumont and Nancy Newhall joined the teaching staff for a few summers in the late 1940s. Black Mountain alumni were proponents and associates of the most crucial creative movements of the mid-twentieth century, from Fluxus to jazz to groundbreaking poetry to multimedia performance.

From Michael's perspective, the primary and enduring community had centered around Minor, and involved the core of Founders, gradually enlarging to the artists and audience Aperture engaged. Yet Minor's interests embraced an eclectic assortment, especially those he found of spiritual interest. Minor, a friend observed, could comfortably attend an early Catholic mass, move on to a Zen Buddhist meditation group in the afternoon, and round out the evening in a session with Gurdjieffians.

This last involvement was particularly important, because the teachings of the Greek-Armenian mystic George Ivanovitch Gurdjieff exerted a strong pull among artists, writers, and intellectuals. Michael and Misty became deeply involved, as did Steve Baron, Charles Simic, and a number of closely associated photographers, including Walter Chappell, Nathan Lyons, and Syl Labrot.

Despite a voluminous literature devoted to the life and work of Gurdjieff, who died in 1949, his influence is all but inaccessible to anyone not directly involved in the study-work groups of his successors. There are underlying precepts: that all of creation is filled with emanating energy; that this energy vibrates at differing, specified levels, broadly divided into what are called "octaves"; that an individual is a "psychophysical entity," affected by and

affecting these octaves; and that each act of creation, such as an artist's, reshapes the all-inclusive experience of life. The artist's task is to be "awake," to work toward attunement with all dimensions of reality, as opposed to the great masses of mankind who, in Gurdjieff's view, are "asleep."

There are intimations, admittedly tentative, of Gurdjieffian influence to be found among Aperture contributors—from Max Waldman's dynamic and chilling images of Peter Weiss's *The Persecution and Assassination of Jean-Paul Marat as Performed by the Inmates of the Asylum of Charenton Under the Direction of the Marquis de Sade*, as directed by Gurdjieff exponent Peter Brook, to Walter Chappell's extraordinary "Metaflora" series, in which, as the photographer described it, "avalanching electrons leap into light forms, precisely exposing the energy emanations occurring spontaneously . . . on negative film."

Other groups and their catalytic protagonists further attracted Michael. Julian Beck's Living Theater embodied the spirit of communal energy in the creation of works of art. Michael befriended Lincoln Kirstein, another sometime student of Gurdjieff's, whose influence redirected the course of dance history. Kirstein was also a brilliant writer and critic, whose essay on W. Eugene Smith for a 1969 Aperture monograph survives as one of the most incisive critical appreciations of the photographer. Within the vibrancy of the Pop Art movement, Michael found a valuable ally in Henry Geldzahler, then curator of Modern art at the Metropolitan Museum of Art.

Michael determined upon one of the most ambitious publishing ventures of Aperture's history: a massive volume, measuring one foot by one foot, of nearly two hundred Minor White images accompanied by the photographer's writings over a thirty-year period. Michael trundled the giant maquette of the book to every conceivable sponsor and copublisher, meeting generally with remarks such as "You're out of your mind," and "This will bankrupt you." Michael's will to publish remained undaunted, and ultimately it was Geldzahler who found the needed funds from the National Endowment of the Arts to publish in 1969 White's *Mirrors, Messages, Manifestations*.

One irony of Michael's involvement in the cultural flurry of innovation in the arts was that his stewardship of Aperture gained the reputation of being decidedly classical, even old-fashioned. While, for example, Julian Beck, Kenneth Anger, and others were breaking the boundaries of experimental theater and filmmaking, Michael was known for exhibiting Stieglitz, Strand, nineteenth-century Frenchmen, and Edward S. Curtis's historic photographs of North American Indians. There were new imagists appearing in the periodical, particularly the darkroom magician Jerry Uelsmann, keenly examined in essays by William Parker and Peter Bunnell. But by and large, during a period when

First and foremost, the journal existed for the benefit of the artist, to serve his or her intent. This meant that the publication was inherently anti-mercantilist— the profit motive must never dictate content. This freed the work from pressure upon selection of images and design, and further implied a challenge to all forms of censorship—challenges that would be met head-on in the ensuing years.

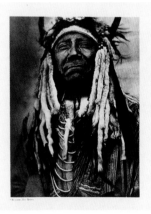

TOP: *Aperture* 81, 1978, pages 52–53: photographs by Eudora Welty.
MIDDLE: *Aperture* vol.16, no. 4, 1972, pages 34–35: photographs by Edward S. Curtis.
BOTTOM: *Aperture* 82, 1979, pages 8–9: photographs by Walter Chappell.

the prevailing creed was that nobody over thirty should be trusted, Michael, it was said, seldom published anyone under forty. The justification was unassailable. There was little point in purveying the avant-garde of a medium whose most significant *garde* had been so long neglected, unseen by a larger public. In a sense, the "community of interest" Michael served was still in its infant stage. And yet one of his most profound collaborations of the period involved an artist whose unique vision would be a defining influence in both photographic and art history.

Diane Arbus began to take photographs in the early 1940s, studied with Alexei Brodovitch and Lisette Model in the mid 1950s, and published her first photographs in 1960 in *Esquire*. John Szarkowski, who took over Steichen's position at the Museum of Modern Art in 1962, included her work on "American Rites, Manners, and Customs" in his 1967 exhibition "New Documents," along with the work of Lee Friedlander and Garry Winogrand. Viewers recognized Arbus's photographs as revolutionary. In 1971, she committed suicide. The following year, Szarkowski decided to mount a major Arbus exhibition.

Although photography books and exhibition catalogs were not nearly so common then as they are today, designer Marvin Israel and Arbus's daughter Doon had already designed and edited a publication to accompany the show. But six months before the exhibition was scheduled to open, there was still no publisher willing to take it on. The Museum of Modern Art was unable to publish the book, so in July, Szarkowski approached Michael and asked if he'd look at the project. Michael looked, and without a moment's hesitation said, "We're doing it."

Michael, Szarkowski, Israel, Doon Arbus, and Sidney Rapoport worked furiously and in less than four months—in time for the opening—the monograph was ready. "We printed 2,500 copies and expected to sell maybe 500," Michael said. The exhibition attracted a quarter-million people in New York before going on a North American tour. Still in print, sales of the Arbus monograph now approach 200,000.

"It was one of those times," Michael said later, "when the public was far ahead of the rest of us, far ahead of our expectations. It was another instance of the unpredictable boundaries of a 'community of interest.'" Of Michael's role, Szarkowski later said, "No one was a villain, but Michael was a hero."

Although financial problems persisted, Michael had also managed by the end of the year to put in place vital elements of Aperture's operations. Baron was proving to be a master of production of the most difficult books under the most difficult conditions. The nagging problem of design—the source of endless complaints from Minor—began to be resolved when a young artist named Peter Bradford went to work on mono-

graphs and issues. He was assisted by Wendy Byrne, who would from then on be involved with so many Aperture publications, up to the volume now in the reader's hands. "There are many great designers," Michael acknowledged, "but very few who work with photographs well." Michael also managed to attract the pro bono services of a distinguished, highly cultivated Manhattan lawyer, Arthur Bullowa. Donating countless hours, Bullowa managed to bring clarity and businesslike order to Aperture's increasingly intricate affairs. He also introduced a much-needed temperate tone to Michael's often mercurial negotiations with artists, writers, designers, printers, potential contributors . . . with just about everyone at one time or another. Not long after, another highly regarded attorney, Robert Anthoine, would augment, then assume the role of legal advisor, friend, and confidant. Both men would serve long tenures as heads of Aperture's Board of Trustees: Bullowa from 1966 to 1986; Anthoine from 1989 to 2001.

By 1972, at thirty years of age, Michael had provided Aperture with all but the financial means for survival and growth. He was acquiring an international reputation in his role as curator at the Philadelphia Museum of Art, and he was creating his own niche in the complex, vital relationships that are the living web of cultural life. He and Misty had also started a family: their son Matthew born in 1971, and daughter Sarah born in 1973. And they had found a weekend refuge away from the city, a four-hundred-acre farm at Shekomeko in the hills of Dutchess County, about a three-hour drive from New York. Here, in the study of his old farmhouse, Michael could catch up on paperwork. And in the nearby village of Millerton he established Aperture's warehouse, distribution, and archival operations.

Michael and Misty entertained artists, friends, and family at the farm. Michael found a passion for landscaping and organic gardening, and the house was soon bounded by rows of berry bushes, vegetable fields, and through the warm months a constant flowering. It was a good, creative, challenging life. But before Michael was thirty-one years of age, a series of losses would begin—the first was the hardest, the most indelible.

Michael had left the city early on Thursday, June 7, 1973. Misty was to follow. Late that afternoon a state trooper pulled up the drive. There had been a traffic accident. Misty, at age twenty-nine had died.

Michael's and Misty's families provided crucial support. Michael was glad, he admitted, that some of his closest colleagues weren't around him at the time—Norman, the Newhalls, a few others. A turning point came when he consulted a Freudian psy-

choanalyst. During the fifth session, Michael asked, "What are you trying to accomplish with me?" The analyst responded, "I want to help you live a normal life." "But I don't want a normal life," Michael said, and, terminating his own analysis, he walked out and went back to work.

A bizarre accident claimed Nancy Newhall's life the following summer. Her later years had been unkind to Nancy. Always a hard drinker she had, even in the eyes of those who most admired her, slipped over the edge and become literally a falling-down drunk. Then she decided to solve her own problems, went off by herself traveling in the West, and appeared to have beaten the alcoholism. She was sober, healthy, livelier than she had been in years, and looking forward to Beaumont's new appointment as professor of photography at the University of New Mexico in Albuquerque. They were white-water rafting on the Snake River in Grand Teton Park, Wyoming, when a large tree uprooted from the riverbank and struck Nancy, fracturing her skull. She died a week later.

In 1976, two years after Nancy's death, White and Strand died within months of each other. White's last years had been troubled by heart disease, which first became manifest in 1966 and led to a cardiac episode two years later. He undertook an intense period of new studies and meditation. As a tenured professor at MIT, he created four amazing exhibitions that found continued existence as Aperture issues/monographs—"Light 7," "Be-ing Without Clothes," "Octave of Prayer," and "Celebrations." Drawing upon photographers both famed and unknown, these projects embodied Minor's continuing sense of pure wonder, of innocence revisited and nourished and unafraid of exposure to the severity of critical intellect. In Michael's view, Minor's illness also cost him the strength and energy to resist those who would enshroud him with the guru mantle. His photography, including new works in color, continued. A deliberate clownish element entered his teaching, and his persona. Emaciated, grinning, and nude, he posed for a student, Abe Frajndlich, in a series of enacted roles called "Lives I've never lived"—as guru, gardener, philosopher, dancer, dying man, and others. But he also seriously worked with his final biographer, James Baker Hall, almost up to the moment of his death on June 24, 1976 at Massachusetts General Hospital.

Strand, whose death had occurred three months earlier, also worked up to the end in what had become the closest artistic collaboration of Michael's life. After the enormous success of his one-man show at Philadelphia in 1972 and the accompanying two-volume monograph, Strand had granted Michael his unreserved trust and loyalty. He had even insisted that Michael become his

agent for the sale of his photographs, with the proviso: "If Ansel gets a thousand dollars a print, I want ten thousand." As it turned out, the marketplace was ready.

The oddly neglected aspect of Strand's career was that almost no one had ever actually seen a Strand print—prints of great richness, dimension, and transfixing vision. The exceptions were those on view at the 1945 Museum of Modern Art and 1972 Philadelphia retrospectives, and a very few others. Otherwise, Strand didn't trust what he viewed as the likely barbarous handling of his rare prints by postal and museum staff. To meet requests from exhibitors and publishers, Strand tore pages from earlier rotogravure publi-

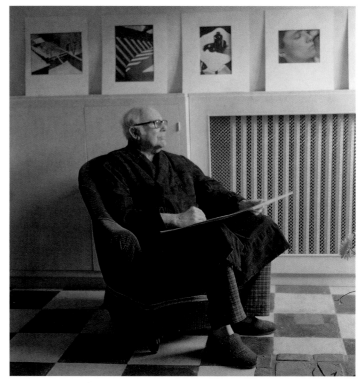

Richard Benson, Paul Strand, Orgeval, ca. 1975.

cations of his photographs, mounted, signed, and sent them off without comment. Once knowledgeable collectors actually viewed the originals, Strand prints easily went for his asking price and more. Within a few years of beginning to show and sell them, he was a millionaire.

Strand in his mid-eighties devoted himself to a book on his garden photographs in collaboration with writer Catherine Duncan. Even as the work progressed, Michael proposed the unthinkable: Strand, no longer able to work in the darkroom, should allow his prints to be made, and four portfolios created, with the assistance of a talented young craftsman, Richard Benson. Hazel's response was to the point; "Over my dead body!" Michael per-

sisted; Paul and Hazel, reluctant, allowed Benson a trial, which took place during a Strand visit to New York.

Benson was a young man who already had a reputation for conjuring pristine images from negatives, glass plates, and other media nearly lost to time and wear. With another craftsman, Jon Goodman, he had helped recreate the press, the inks, and the copper plates of hand-pulled gravure processes lost generations ago. The two were now able to realize photographic images of great texture, depth, and sensitivity at Aperture's newly established Photogravure Workshop.

Benson's gift was (and is) his technical transmutations faithful to spirit of the artist's original vision. In New York, Strand chose a negative for Benson to print—offering no instructions—and approved the results. Benson later said that he had not been able to make an exact duplicate of the Strand print. "But then, as Paul would readily admit, he couldn't make an exact duplicate of a Strand print either!" The Strands agreed to Benson's working under Strand's direction.

In the spartan darkroom setup, Benson discovered that Strand approached each print by increments, print by print closing in on his realization of the artwork. The equipment was almost rudimentary. "I had been used to the most advanced technical instruments; with the photograph once made, it was *made*," Benson told a gathering years later. "Strand crept upon on his images until they were exactly what he wanted." Back and forth Benson would go with each print, finally to Strand's bedroom in his last weeks for the master's approval. Strand signed each print until no longer able due to the bone cancer draining his life. Benson simply sat with him in the last few days, offering comfort.

After Strand's death, Michael and Benson discovered nearly four hundred Strand prints stored at his house: not even Hazel knew they existed. Hazel returned to New York and devoted the rest of her life to Aperture and the Strand Archive located in Millerton, where she bought a small house. Hazel's timely intervention helped save Aperture from extinction.

Aperture was in fact bankrupt in 1977. Michael—with his deeply felt losses of wife, friends, and mentors—had worked indefatigably to keep the enterprise afloat. But even in the best of economies it would have been difficult. In the late 1970s atmosphere of high inflation, high interest rates, and slow growth, it was impossible. Production costs had skyrocketed; the periodical and books were too expensive for a depressed market. Michael's primary article of faith was that there be no compromise in quality. To compromise would be an unredeemable betrayal of the Founders' intentions. Better that Aperture should cease.

At his home in Beverly Hills, Shirley Burden heard the news of Aperture's impending demise and immediately caught a plane to New York. Burden was far more than a conventional scion of inherited wealth: he was an artist of some accomplishment in his own right, and deeply admired the integrity of Aperture's vision. For Aperture, his wealth had been something of a problematic blessing. He had been involved with Minor from the beginning and everyone assumed, Michael said, that this Vanderbilt heir financed everything. In fact, his contributions up to that point were very modest—"rather nickel and dime," as another respectfully unnamed friend of Burden's put it. With Aperture's survival in doubt, Burden's role magnified.

After reviewing the balance sheets with Michael, Burden gathered Hazel into his limousine and the two agreed to guarantee funds from a matching NEA grant. Their administrators were sympathetic. At the eleventh hour, a total of $80,000 salvaged Aperture from a bankruptcy, which for a nonprofit foundation would have been terminal.

Aperture's silver anniversary passed unnoticed. Three times in its brief history, it had been brought back, phoenix-like, from the ashes. And like the phoenix, whose motto is "I am reborn," Michael was already envisioning new directions, even evolutionary changes in the Aperture commitment to an "ideal in photography."

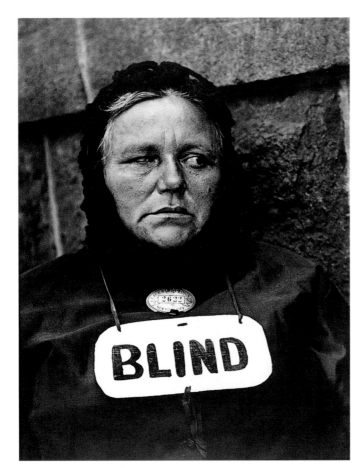

Paul Strand, *Blind Woman*, New York, 1916;
from *Paul Strand: An American Vision* (Aperture, 1990).

The persistent problem in photography is how to look at it. In 1916, at the age of twenty-six, Paul Strand went to Alfred Stieglitz, whom he had visited many times before, with a splendid new series of photographs that included a number of portraits of ordinary people. They had been taken by stealth on the streets of New York with a fake brass-bound lens attached to his reflex. They remain among the very greatest American photographs. But do we see them properly?

There is no doubt of Strand's social conscience; after all, he was a pupil of Lewis Hine's. But in this youthful series, he went beyond the assignments of Jacob Riis and Hine and penetrated to a deeper level. His work that year rivals even Rembrandt in its fearless insight. The *Blind Woman* is the most celebrated. . . . The woman, with a cast in one eye, is unique, powerful within herself, with a face as marked and enduring as a boulder facing the sea. "I like," said Strand, "to photograph people who have strength and dignity in their faces. Whatever life has done to them, it hasn't destroyed them."

But do we see this woman as Strand saw her? We are deceived because she wears a sign around her neck: BLIND, and we give her the automatic, easy pity that such a title—for that's what it really is—provokes. Tears rise agreeably to our eyes, and we respond with the clouded vision of our sentimentality. The fact is, she's not a beggar: she's a licensed newspaper vendor on Lexington Avenue at 34th Street. If we change that sign to a Chinese character or, better yet, put our hand over it, the woman changes, too. We see more directly into her spirit; she is obdurate and enduring, patient, and a bit unpleasant.

—Ben Maddow, from "Tears and Misunderstanding," *Aperture* 92, 1983

Sylvia Plachy, *Christmas card*, 2001.

THESE PAGES: photographs by Richard Avedon.
OPPOSITE: *Lew Alcindor, 61st Street and
Amsterdam Avenue*, New York City,
May 2, 1963; from *Aperture* 156, 1999.
ABOVE: *Penelope Tree*, New York studio,
June 1967; from *Aperture* 122, 1991.

Lucas Samaras, *Untitled (Self-Portrait)*, May 26, 1990.

Timothy Greenfield-Sanders, *Honey,*
Karen Finley, 2001.

Ralph Gibson, *Drag Queen*, 2000.

Ugo Mulas, *Marcel Duchamp*, New York, 1965;
from *Aperture* 132, 1993.

Marc Riboud, Shepherd during Christmas celebrations,
Provence, France, 1954; from *Aperture* vol. 18, no. 2, 1974.

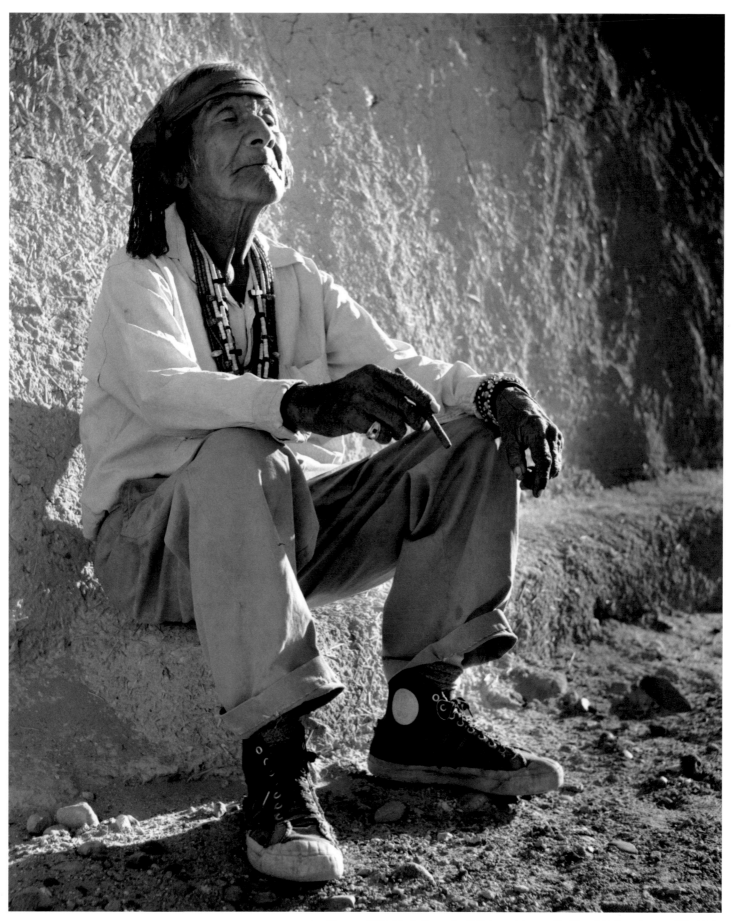

Lee Marmon, *White Man's Moccasins (Jeff Sousea)*, Laguno Pueblo, 1954; from *Aperture* 139, 1995.

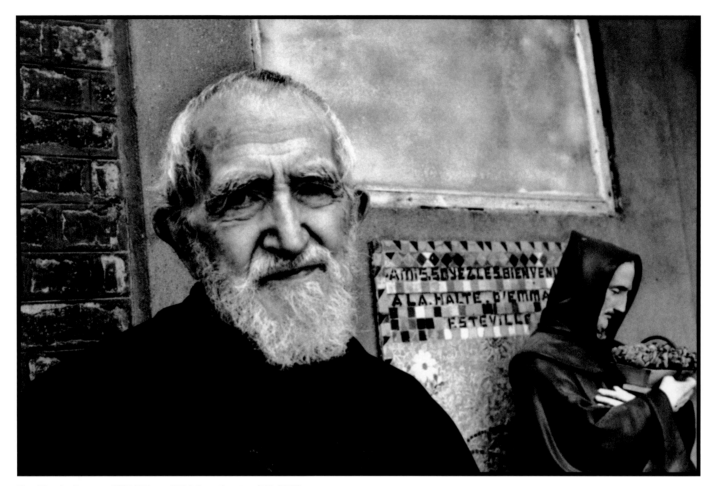

Henri Cartier-Bresson, *L'Abbé Pierre*, 1994; from *Aperture* 138, 1995.

The only thing about photography which interests me, he says, **is the aim, the taking aim.**

Like a marksman?

Do you know the Zen Buddhist treatise on archery? Georges Braque gave it to me in '43.

I'm afraid not.

It's a state of being, a question of openness, of forgetting yourself.

You don't aim blind?

No, there's the geometry. Change your position by a millimeter and the geometry changes.

What you call geometry is aesthetics?

Not at all. It's like what mathematicians and physicists call elegance, when they're discussing

a theory. If an approach is elegant it may be getting near to what's true.

. . . What counts in a photo is its plenitude and its simplicity. . . .

—John Berger, from "Henri Cartier-Bresson," *Aperture* 138, 1995

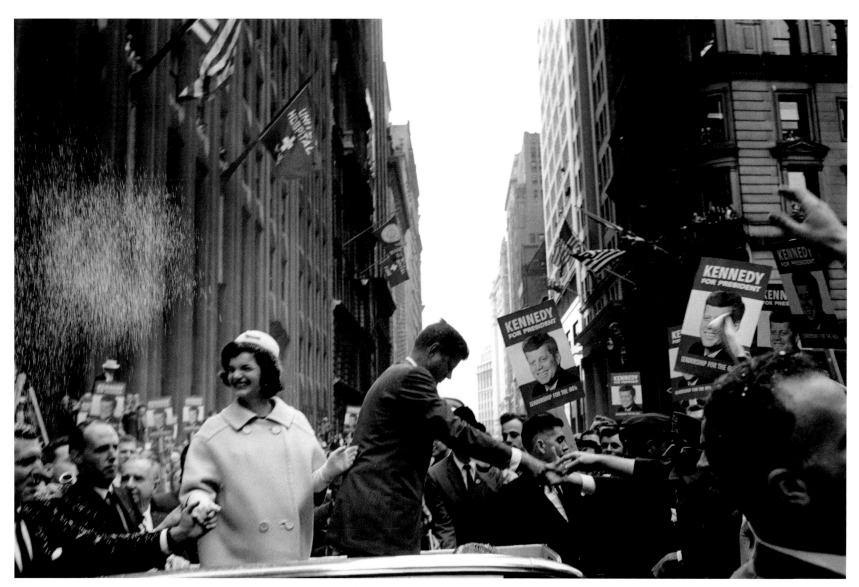

Cornell Capa, *JFK and Jackie*, New York, 1960.

Today, debates over censorship, reproductive rights, AIDS, and domestic violence are growing more and more heated. A powerful effort is underway to define and control expressions of sex and sexuality, and to reinstate the traditional family and institutionalized religious practice as ideals. One can recognize the support that such families and belief systems, at their best, can provide, and still feel that to impose any particular way of life as the American norm is to indulge a repressive impulse. What we are in fact threatened with is a drive toward a rigid social conformity, with the body as the pawn, or (as Barbara Kruger has termed it) the "battleground" in struggles between differing conceptions of public morality and individual freedoms.

"The Body in Question" unabashedly seeks to explore these issues, beginning with an examination of gender—the body created and recreated—and then moving through photographs and texts that consider, among other dynamics, the body abused, objectified, discovered, aroused, desired, censored, mythologized, manipulated, and celebrated. The images are corporeal, about the strengths and vulnerabilities of this most tangible manifestation of personal experience, ourselves, whether the body in question is a child, a person with AIDS, a victim of physical violence, or someone at the point of orgasm.

Conversely, many conservative political and religious leaders, nervous that certain presentations of the body, of difference, challenge their notion of public morality, seek to suppress these issues and have launched an attack on the arts in the United States in such a way as to undermine the First Amendment by attempting to have conditional (that is, limited) freedom of expression. Artists' studios are being raided and work confiscated: witness Jock Sturges. NEA grants are being revoked: witness Karen Finley. A museum and its director are being tried on obscenity charges: witness Cincinnati's Contemporary Arts Center—and more.

In light of these events, it is not surprising that some of the artists represented here, particularly those whose work focuses on children, feel threatened. Initially, a few of the photographers considered withdrawing their pictures from the issue—pictures to which they are committed, and which they, and we, believe to have integrity and merit. Although *Aperture* shared their concerns—having no desire to put the magazine and its contributors at risk—we feared succumbing to them, for what could be rationalized as an editing decision might really be an instance of self-censorship, one of the most subtle and insidious of the possible results of the ongoing assaults on literature and the arts.

Clearly, it is difficult to remain impervious to the demoralizing effects of assaults by those who so aggressively and manipulatively cast aspersions on others' convictions, motives, and choices: working through issues of quality (and what constitutes an "art" image), elitist attitudes, self-censorship, and even exploitation became an impassioned process as we considered the images for "The Body in Question." Some readers may think we have erred in our selection. But without the free play of images and words in magazines, books, exhibitions, and other public forums, it would be impossible to address and debate the vitally important ideas involved as fully and deeply as their seriousness demands. We hope that our audience will take this issue of *Aperture* to heart and mind at a moment when our right to our bodies— to represent, use, protect, enjoy, and view them—is increasingly questioned and menaced.

—**Melissa Harris, from "The Body in Question,"** *Aperture* **121, 1990**

I just couldn't wait to see
what it would look like
when they (the breasts)
were gone.
No grieving.
No sad good-byes.
I just want to be becoming
more visibly outside what
I feel like I am on the in-
side. Taking these steps
other people will see who
I have been all my life
and acknowledge

THIS IS WHO JAKE IS.

Clarissa Sligh, *I Just Couldn't Wait to See*, 2000.

Eugene Richards, Final
chemotherapy treatment,
Boston, 1979;
from *Exploding into Life*
(Aperture, 1986).

Christian Boltanski, *Jewish School of Gosse, Hamburgerstrasse in 1938*, 1994; from *Aperture* 142, 1996.

OPPOSITE TOP: *Aperture* 112, 1988, pages 66–67: photographs by Lorna Simpson.
BOTTOM: Lorna Simpson, *Guarded Conditions*, 1989; from *Aperture* 133, 1993.

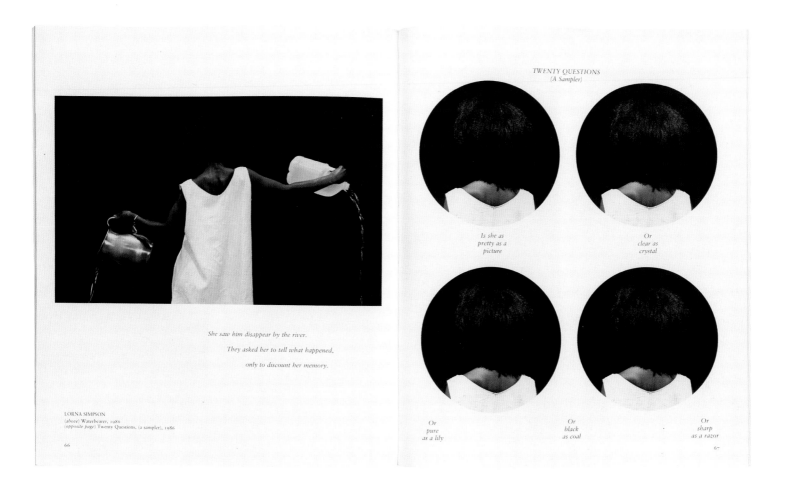

*Is she as
pretty as a
picture*

*Or
clear as
crystal*

*Or
pure
as a lily*

*Or
black
as coal*

*Or
sharp
as a razor*

She saw him disappear by the river.

They asked her to tell what happened,

only to discount her memory.

LORNA SIMPSON
(*above*) Waterbearer, 1986
(*opposite page*) Twenty Questions, (a sampler), 1986

66

67

GUARDED CONDITIONS

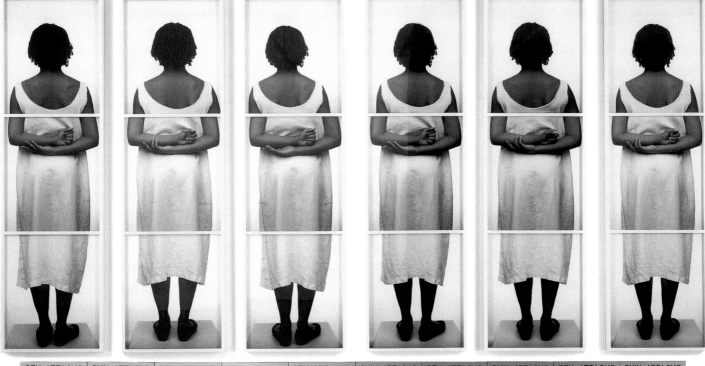

155

The most important reason for me to come to Genoa is to tell people on the radio what really happens here, because official media do not tell the truth. —**Man, Italy**

People are still dying in Bhopal. Over 20,000 have died and those born after the disaster have growth and menstrual problems.

Over 120,000 are still suffering from chronic diseases of the eyes, brain, reproductive and immune systems.

Five thousand metric tons of chemicals were dumped into the ground inside and outside the factory—it's gone into the drinking water, the only source of drinking water for ten communities.

Union Carbide evades justice and now it has sold itself to Dow Chemical. —**Man, India**

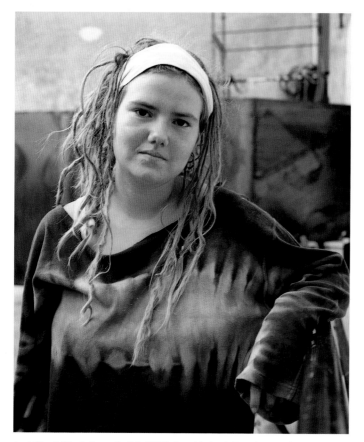

Joel Sternfeld, photographs July 2001, from his book *Treading on Kings: Protesting the G8 in Genoa.*

For me, ecology and equality of all peoples are the same subject.

If you have a factory and employ thousands of people under the lowest conditions or you are dumping chemicals it's the same—you have no respect for life.

The economy is ruling the world.

—**Declined to reveal nationality**

At present, even a piece of cloth given to one is torn into shreds and distributed; and no one individual becomes richer than another.

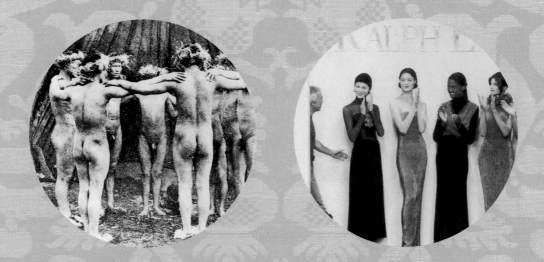

On the other hand, it is difficult to understand how a chief can arise till there is property of some sort by which he might manifest his superiority and increase his power.

Charles Darwin

Elaine Reichek, "Survival of the Fitting" (Ralph Lauren fall '94 collection), originally commissioned by and submitted to the *New York Times Magazine* as an artist's page for its fashion section. The *New York Times Magazine* rejected the work apparently because of the male frontal nudity in the photograph of the aboriginal peoples of Tierra del Fuego (left), from the late 1800s. The piece ran with another ethnographic photograph; from *Aperture* 138, 1995.

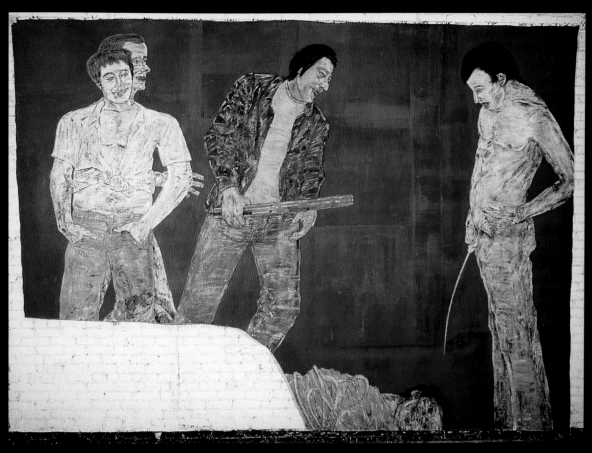

I have huge files of images and image fragments.
I virtually sense myself as made up of photos and imagistic fragments
jittering in my head
and onto the canvas.

On Tuesday, October 10, 1967, a photograph was transmitted to the world to prove that Guevara had been killed the previous Sunday in a clash between two companies of the Bolivian army and a guerrilla force on the north side of the Rio Grande river near a jungle village called Higueras. The photograph of the corpse was taken in a stable in the small town of Vallegrande. The body was placed on a stretcher and the stretcher was placed on top of a cement trough. . . .

The purpose of the radio photograph of October 10th was to put an end to a legend. Yet on many who saw it, its effect may have been very different. What is its meaning? What, precisely and unmysteriously, does this photograph mean now? I can do no more than cautiously analyze its impact on me.

There is a resemblance between the photograph and Rembrandt's painting of *The Anatomy Lesson of Professor Tulp*. The immaculately dressed Bolivian colonel has taken the Professor's place. Figures on his right stare at the cadaver with the same intense but impersonal interest as the doctors on the Professor's right. There are as many figures in the Rembrandt as in the stable at Vallegrande. The placing of the corpse in relation to the figures above it, and in the corpse the sense of global stillness—these, too, are very similar.

Nor should this be surprising, for the function of the two pictures is similar: both are showing a corpse being formally and objectively examined. More than that, both are intended to

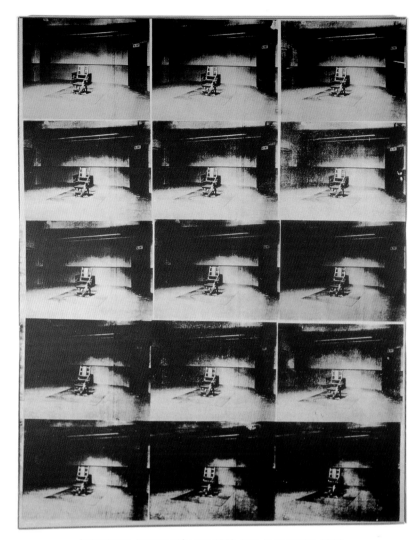

Andy Warhol, *Lavender Disaster*, 1963; from *Aperture* 136, 1994.

make an example of the dead: one for the advancement of medicine, the other as a political warning. Thousands of photographs are taken of the dead and the massacred. But the occasions are seldom ones of formal demonstration. . . .

I was also reminded of another image: Mantegna's painting of the dead Christ, now in the Brera at Milan. The body is seen from the same height. The hands are in identical positions, the fingers curving in the same gesture. The drapery over the lower part of the body is creased and formed in the same manner as the blood-sodden, unbuttoned, olive-green trousers on Guevara. The head is raised at the same angle. The mouth is slack of expression in the same way. Christ's eyes have been shut, for there are two mourners beside him. Guevara's eyes are open, for there are no mourners: only the colonel, a U.S. intelligence agent, a number of Bolivian soldiers, and thirty journalists. Once again, the similarity need not surprise. There are not so many ways of laying out the criminal dead.

Yet this time the similarity was more than gestural or functional. The emotions with which I came upon that photograph on the front page of the evening paper on Wednesday afternoon were very close to what, with the help of historical imagination, I had previously assumed the reaction of a contemporary believer might have been to Mantegna's painting. The power of a photograph is comparatively short-lived. When I look at the photograph now, I can only reconstruct my first incoherent emotions. . . .

—John Berger, from "Che Guevara Dead," *Aperture* vol. 13, no. 4, 1968

Andres Serrano, *Piss Christ*, 1987; from *Aperture* 138, 1995.

OPPOSITE: Michael Nichols, At a medical research facility
in New York, blood plasma separation is performed on one
of its chimps, n.d.; from *Brutal Kinship* (Aperture, 1999).

The camera is an unsophisticated mechanical instrument which, like a mirror, reflects passively without a conscience. The artist must supply the conscience.

—Ralph Eugene Meatyard, *Aperture* vol. 7, no. 4, 1959

THIS PAGE:
photographs by
Jerome Liebling,
Slaughterhouse,
South Saint Paul,
Minnesota, 1962;
from *The People, Yes*
(Aperture, 1995).

William Christenberry, from the series "The Klan Room," 1982;
from *Aperture* 115, 1989.

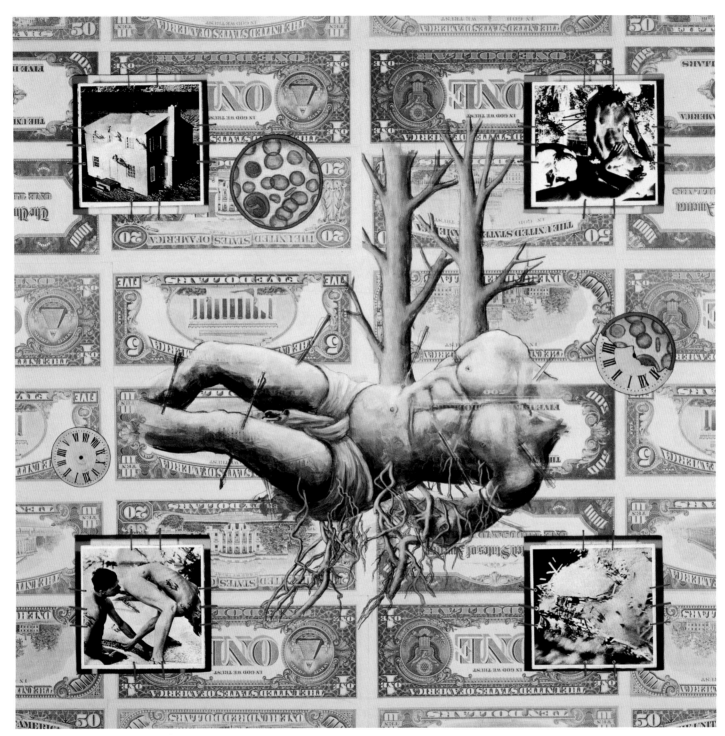

THESE PAGES: photographs by David
Wojnarowicz. *Bad Moon Rising*, 1989;
from *Aperture* 121, 1990.

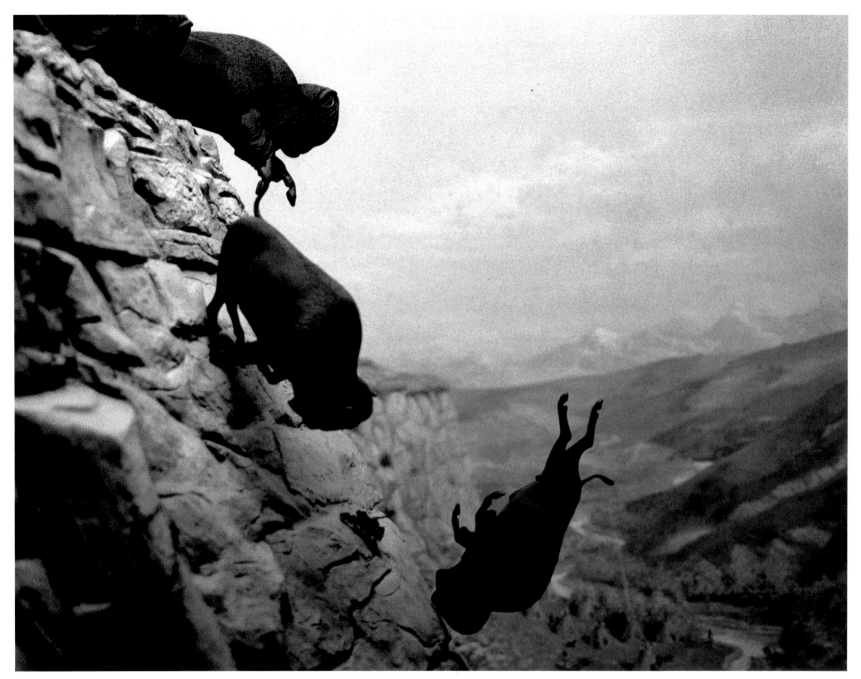

Untitled, 1988–89; from *Aperture* 137, 1994.

For work to be really alive to me, it has to engage with the world. I may talk about spiritual matters, I may talk about transcendental things. But to me, you don't have those qualities without engaging in heaven and hell, because you don't know one without the other. And I don't mean to get into a Calvinist dichotomy here, or even to suggest that I see things totally in terms of darkness and light. Not at all. It's only a metaphor for my concerns.

I think the greatest photographic work is that which has somehow engaged with the depths and the heights of the possibilities of our experience. . . .

—Michael E. Hoffman, from an interview with Robert Adams, *Aperture* 129, 1992

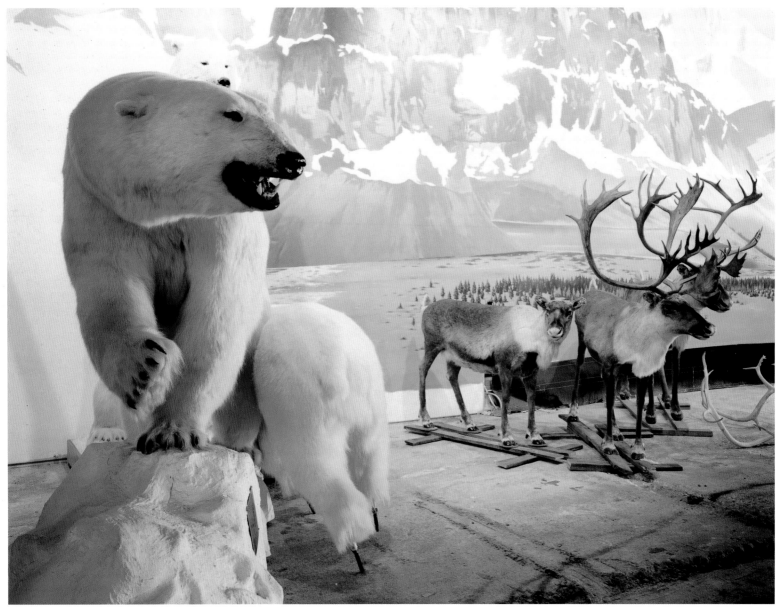

Virginia Beahan and Laura McPhee,
Spokane, WA, 2001.

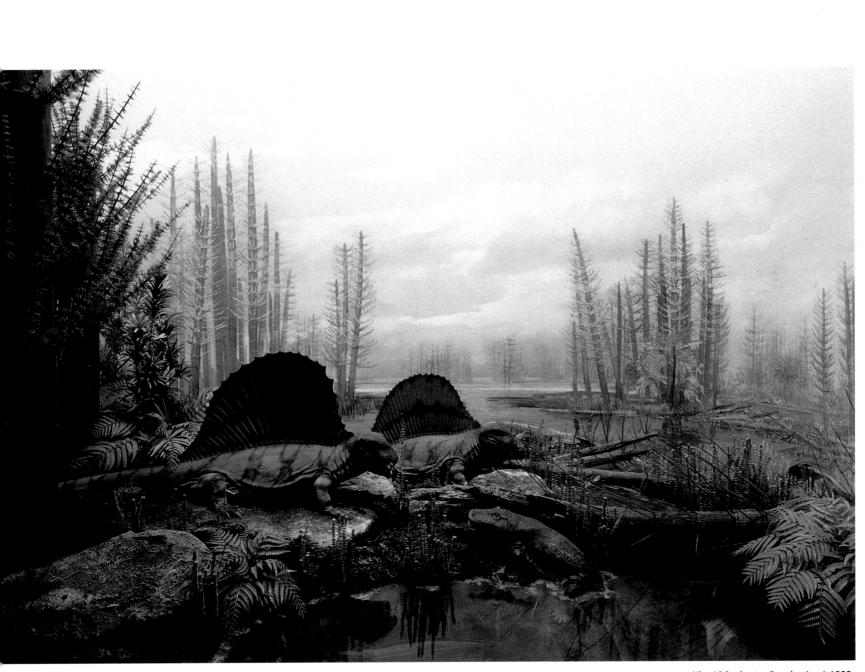

Hiroshi Sugimoto, *Permian-Land*, 1992.

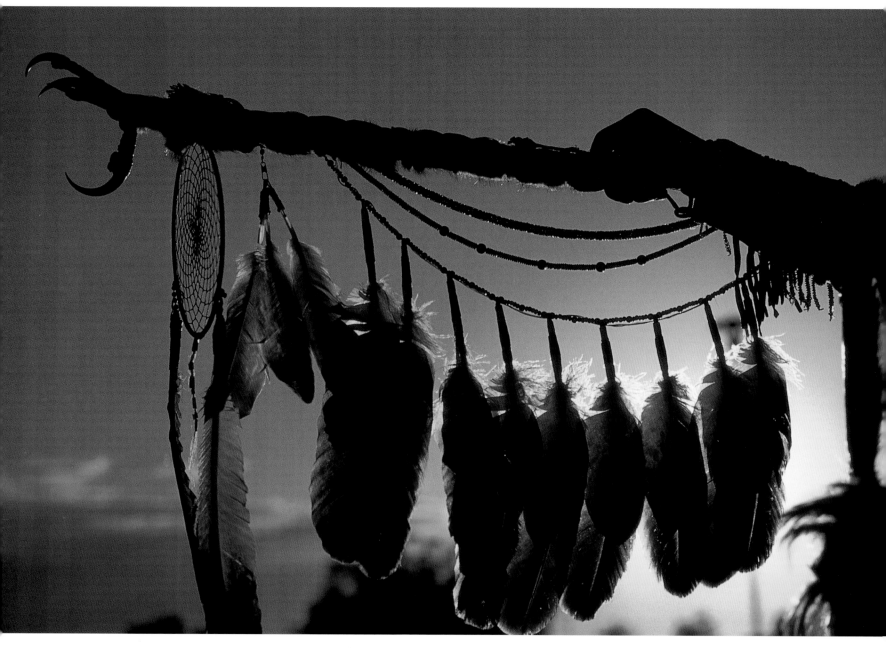

Ken Blackbird (Assiniboine), *Eaglestaff,*
Boise, Idaho, 1990; from *Aperture* 139, 1995.

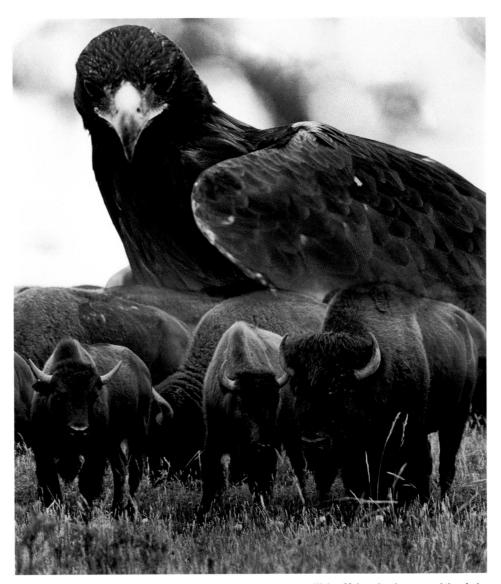

Walter Bigbee, *Lead me around the circle*,
1994; from *Aperture* 139, 1995.

Creating a visual history—and its representations—from Native memories or from Western myths: this is the question before Native image-makers and photographers today. The contest remains over who will image—and own—this history. Before too many assumptions are made, we must define history, define whose history it is, and define its purpose, as well as the tools used for the telling of it. The intent of history is to help us keep our bearings. That is, to know what is significant and, most importantly, to teach us *how* to recognize the significant. What happens when history is skewed, or when we no longer have the same skills of recognition? We as human beings become disabled by the inability to distinguish what is real from what is not. . . .

—Theresa Harlan, from "Creating a Visual History: A Question of Ownership," *Aperture* 139, 1995

What unites Dada, Surrealism, Pop, television, and, ultimately, the computer image, is their underlying relationship with the photographic. Although photography still constitutes one of the central conditions for the representation of experience, over the past fifteen years its legitimacy has been challenged on a number of points. Yet what seems so urgent about the relationship between the hegemony of the visual in Western culture, and the circumstances in which the photograph seemed to validate such spurious notions as "truth," or "fact," is that the process of dismantling the photograph's efficacy is paralleled by an intensification of the visual through digital technology.

—Timothy Druckrey, from "From Dada to Digital: Montage in the Twentieth Century," *Aperture* 136, 1994

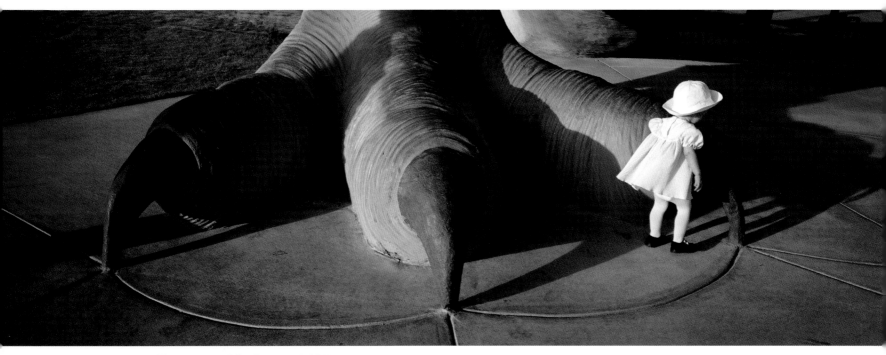

Pedro Meyer, *Niña con Monstruo* (Girl with monster), 2001.

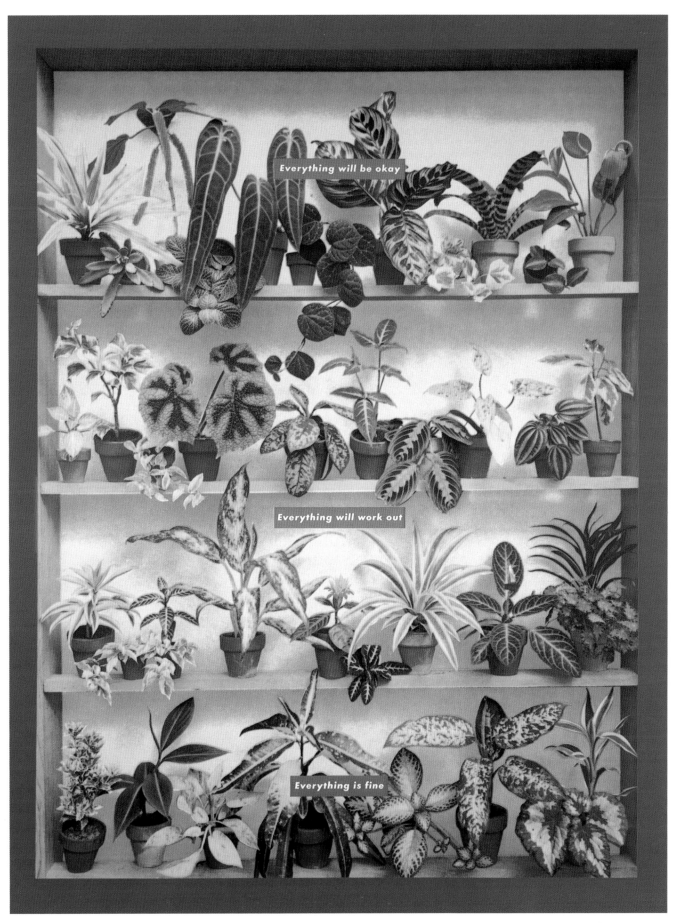

Barbara Kruger, *Untitled (Everything will be okay / Everything will work out / Everything is fine)*, 2001.

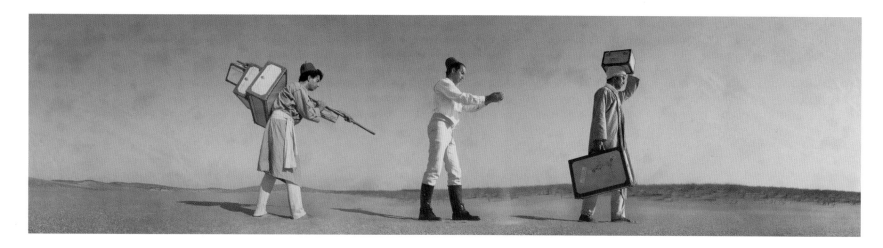

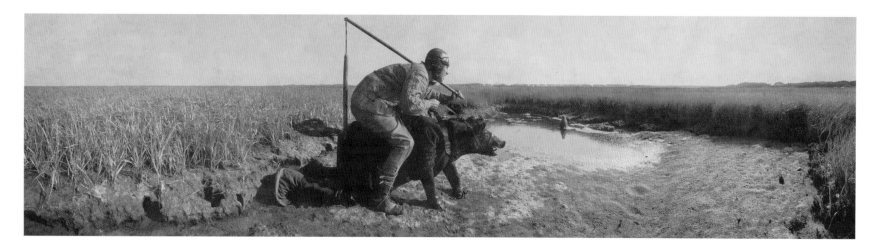

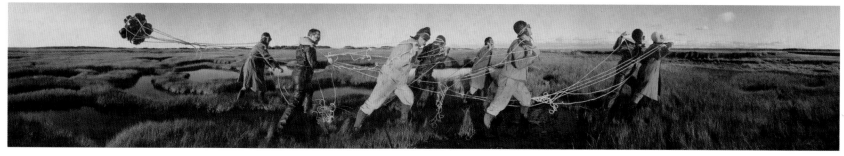

ABOVE: photographs by Nicholas K. Kahn and Richard S. Selesnick. TOP: *Luggage*, 2001. MIDDLE: *Rider*, 2001. BOTTOM: *The Black Sun*, 2001.

OPPOSITE: photographs by Mark Klett.
TOP: *Viewing Thomas Moran at the source*,
Artist's Point, Yellowstone, August 3, 2000.
BOTTOM: *Rebecca making coq au vin*
near the site of Smithson's Spiral Jetty,
Salt Lake, July 27, 2000.

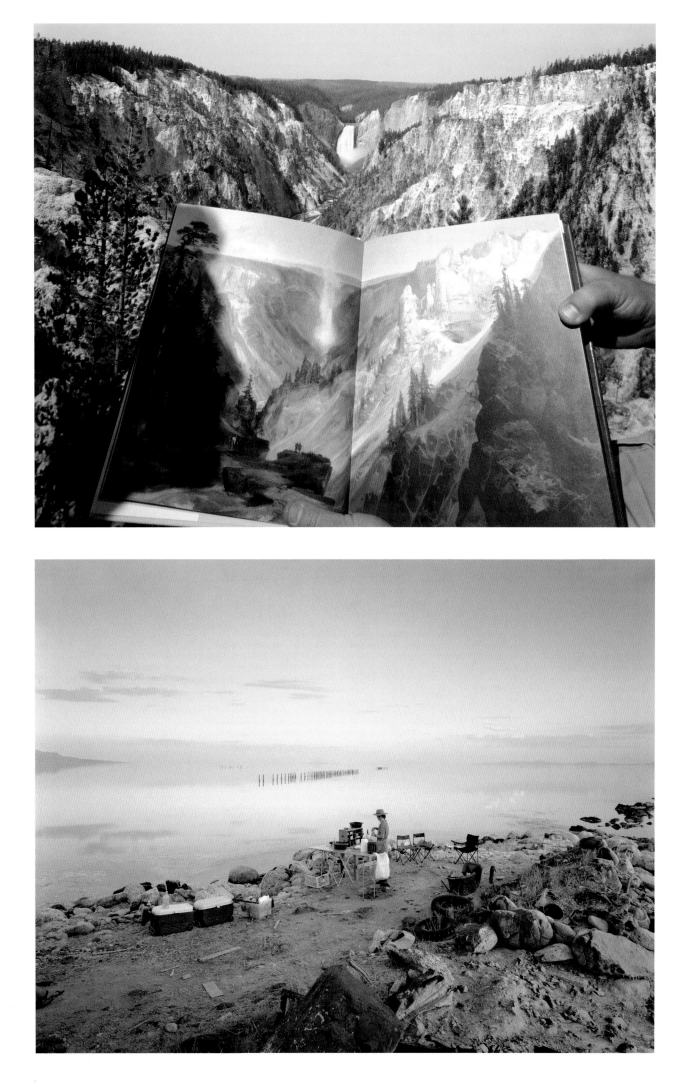

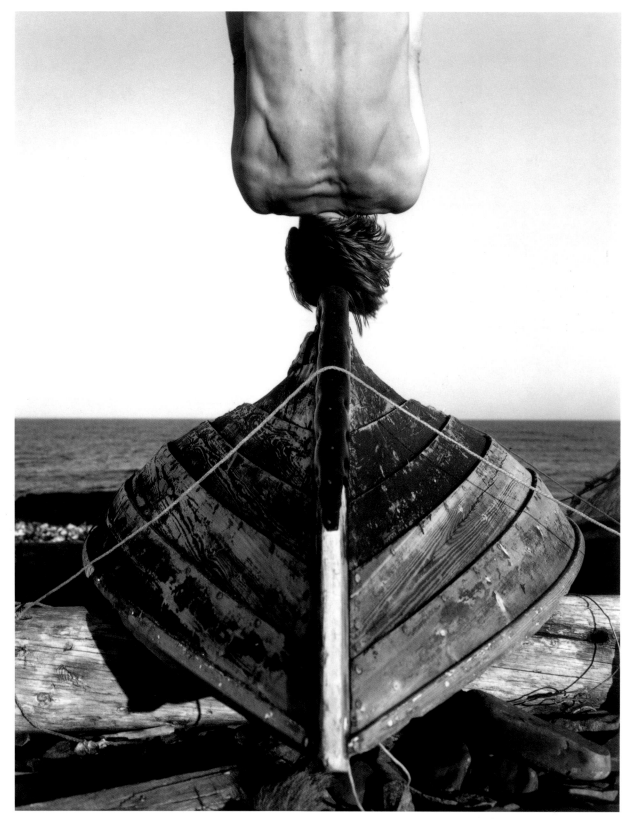

Arno Rafael Minkkinen, *Self-Portrait*,
Kilberg, Vardø, Norway, 1990;
from *Waterline* (Aperture, 1994).

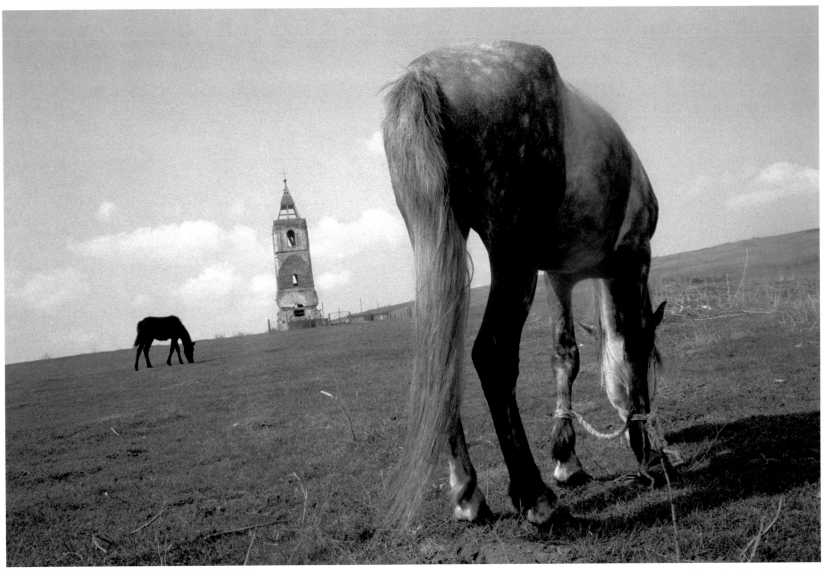

Josef Koudelka, *Transylvania*, 1999.

One view of photography is that it is a zen-like act which captures reality with its pants down—so that the vital click shows the anatomy bare. In this, the photographer is invisible but essential. A computer releasing the shutter would always miss the special moment that the human sensibility can register. For this work, the photographer's instinct is his aid, his personality a hindrance.

—Peter Brook, *Aperture* vol. 13, no. 2, 1967

Mimmo Jodice,
Solfatara Volcano,
Pozzuoli, Naples, Italy,
1990–1995;
from *Mediterranean*
(Aperture, 1995).

176

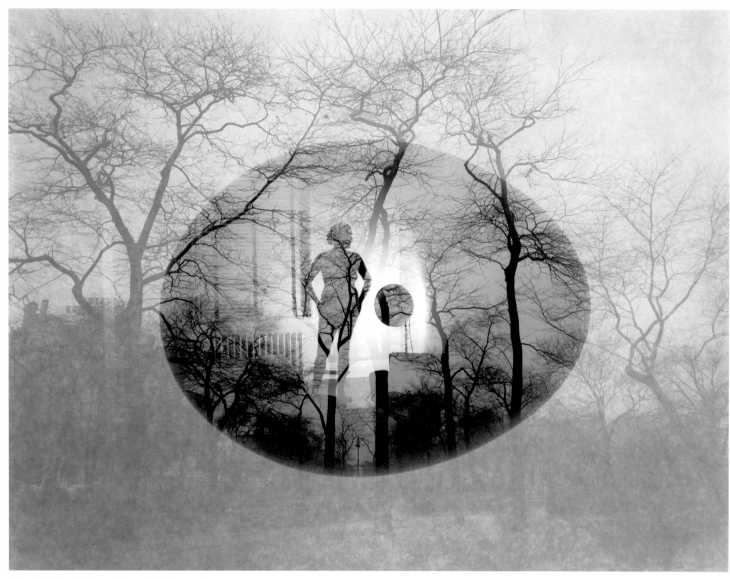

Harry Callahan, *Eleanor*, Chicago, 1953;
from *Aperture* vol. 13, no. 4, 1968.

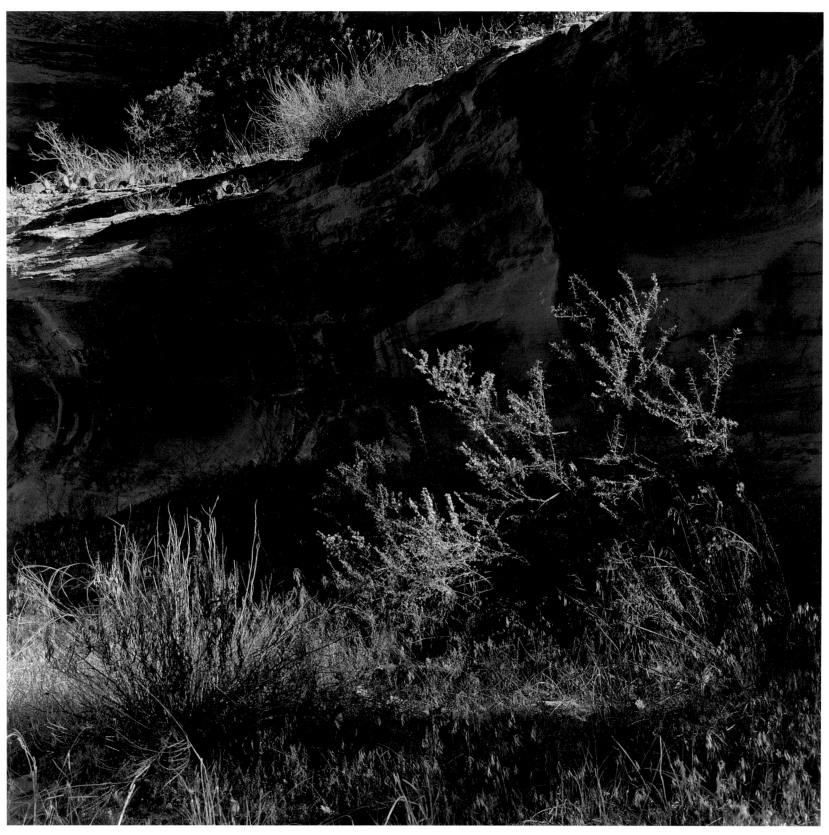

Ray K. Metzker, from the series "Moab II," 1997–98;
from *Ray K. Metzker: Landscapes* (Aperture, 2001).

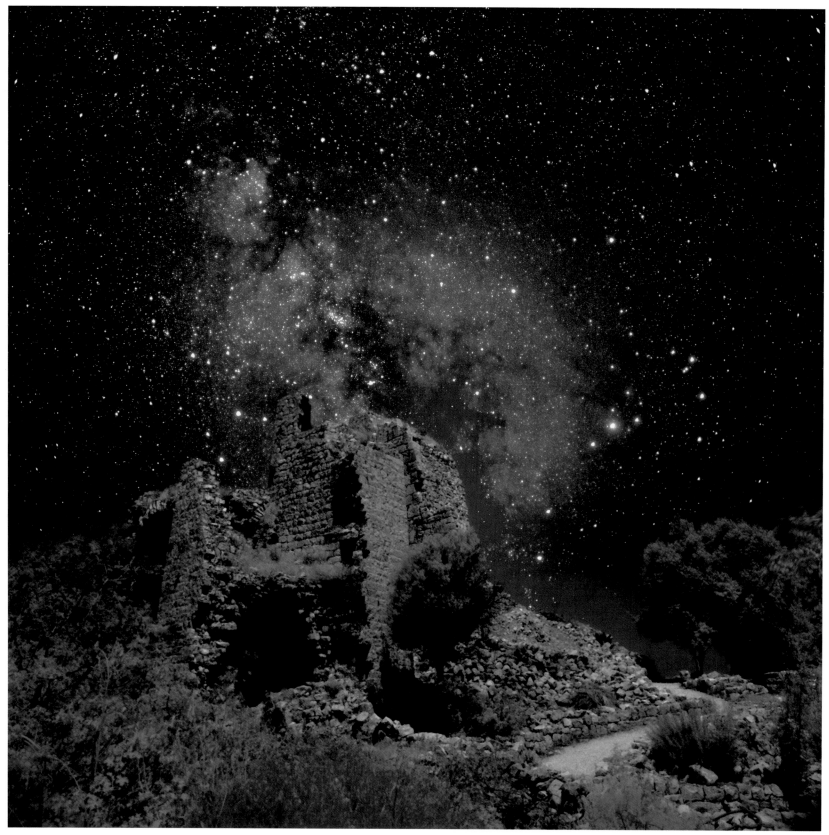

Neil Folberg, *Scorpius Milky Way Rising*, 1997; from *Aperture* 154, 1999.

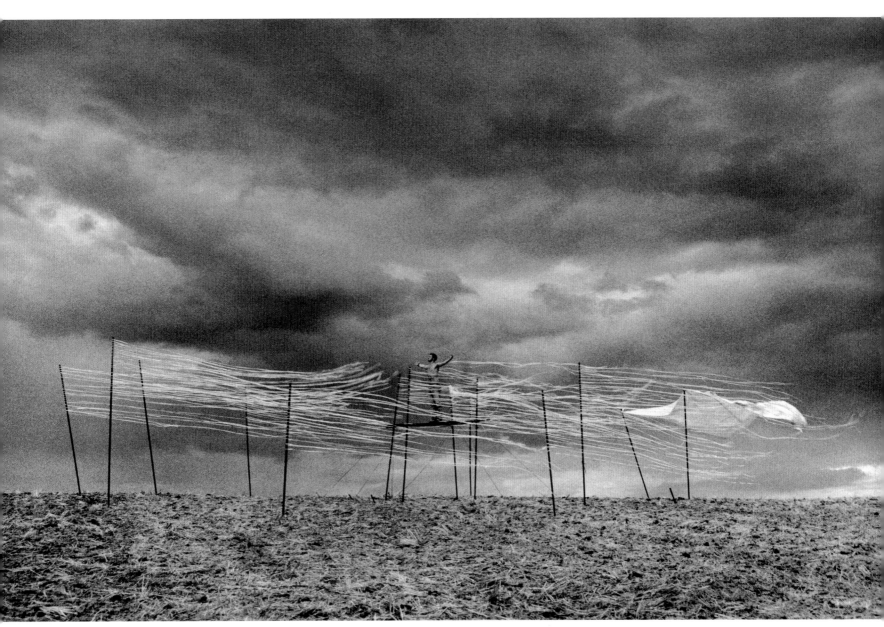

Pavel Pecha, from the series "My Intuitive Theater," 1990–1994; from *Aperture* 152, 1998.

"Understanding" of nature is another dimension than love of nature, or a delight or terror in Nature's spawning and spurning of mankind all at once. At least I prefer to use the word "understanding. . . ." When Nature is seen openly and objectively another force is occasionally glimpsed that is brilliant, clear, terrifying, compelling, brutal, magnificent, awesome, and anti-human. . . . It is not a comfortable experience. It is joyous.

—**Minor White, from "The Photographer and the American Landscape,"** *Aperture* **vol. 11, no. 2, 1964**

Robert Glenn Ketchum, *December 20, 1983 / 3:30 p.m.*;
from *The Hudson River & the Highlands* (Aperture, 1985).

Given the lack of public skills in reading photographs, given that photographic content is sometimes buried in beauty, contemporary landscape photographers are often condemned to making pretty pictures. Dramatic clouds and sifting light can overwhelm more mundane information. Yet who can resist beautiful landscape pictures of one kind or another? Not I. The role of aestheticization is the thorniest issue within the already difficult process of communicating not only how a landscape looks, or seems, but how it *is*, and, most significantly, how it became that way. . . .

—Lucy R. Lippard, from "Outside (But Not Necessarily Beyond) the Landscape," *Aperture* 150, 1998

Brett Weston, *Monterrey Pine and Fog*, 1962; from
Brett Weston: Voyage of the Eye (Aperture, 1975).

Richard Misrach, *Untitled #731–96*, from "Desert Canto" XXVI, 2001.

John Pfahl, *Relaxed Euphoria, Lotusland*,
Montecito, California, March, 2000.

THIS PAGE: photographs by David Goldblatt. TOP: The Colonial Mine with blue asbestos tailings, Wittenoom, Western Australia,1999. Blue asbestos was mined here from 1953 until 1966, when payable ore ran out. In 1994 it was estimated that some 65,000 tons of the substance were present in the mine's tailings dumps. With each rain some of this material gets washed into the creeks that surround the old workings. No safe level of inhalation of blue asbestos is known. In a susceptible person, one fiber could cause the fatal cancer, mesothelioma. Neither the government nor the mining company have so far indicated willingness to deal with this vast source of potential for harm.

BOTTOM: Children's swings at The Settlement, Colonial Mine, Wittenoom, Western Australia, 1999. The Settlement was close to mining operations and was home to the families of senior officials of the company. Only a caretaker lives on the property now.

THESE PAGES: photographs by Robert Adams.
Clearcut, Coos County, Oregon, 1999.

Photographers who can teach us to love even vacant lots will do so out of the same sense of whole-ness that inspired the wilderness photographers of the past twenty-five years (the deepest joy possible in wilderness is, most would agree, the mysterious realization of one's alliance with it). Beauty,

Clearcut, Columbia County, Oregon, 2001.

Coleridge wrote, is based in "the unity of the manifold, the coalescence of the diverse." In this large sense, beautiful photographs of contemporary America will lead us out into daily life by giving us a new understanding of and tolerance for what previously seemed only anarchic and threatening.

—Robert Adams, from "Inhabited Nature," *Aperture* 81, 1978

The Evolution of an Ideal

And sometime then there will be a history of how anything or everything comes out from every one, comes out from every one or any one from the beginning to the ending of the being in them.

—Gertrude Stein, *The Making of the Americans*

In 1936 Charis Wilson, at the age of twenty-two, posed for her fifty-year-old lover Edward Weston, in a series of photographs that might be grouped as the "dune nudes." The pictures were taken one morning near Oceano, California, and in a rare glimpse of a masterpiece from the subject's point of view, she described the moments of their creation:

> Altogether it was a magical place. The silence and emptiness, the beauty of the wind-sculptured forms, the absence of any living things beside ourselves—all these combined to give me an exhilarating sense of freedom. As soon as the sun warmed things up, I took off my clothes and went diving down a steep slope. . . . I was reminded of the childhood games of statues as I kept returning to the top of the bank to relaunch myself, and each slide down ended in a more abandoned position.

By one definition, art is what artists make. Therein lies the implication that the more that is known about the life of a great artist, the more that can be discovered about the nature of his or her work—about the creative process itself. In such a context, few artists have been better served than Weston.

Along with portfolios appearing from time to time in the journal, Aperture's contribution to the Weston iconography involves seven monographs. They are of course profoundly beautiful publications, but what most sets these monographs apart are the accompanying texts: writings that invoke the voices of Weston's admirers, friends, family, and lovers. These texts include Ben Maddow's classic biography of the photographer in *Edward Weston: His Life*; Charis Wilson's remembrances for *Edward Weston: Nudes* (excerpted above) and for *California and the West*; and a biographical essay by Susan Morgan in the 1995 monograph devoted to his portraits. Aperture's chief collaborator throughout has been Weston's youngest son, Cole, who recreated to perfection Edward's prints for publication, and who contributed his own recollections to the Weston saga.

And it was a saga, quintessentially American. No one told it better than Weston himself in his *Daybooks*. Although there are fragments from earlier and later in the photographer's life, these autobiographical writings span his most creative and productive years. In his huge, scrawling handwriting, Weston recounted his difficulties with money, marriage, conscience, and his devotion to his four sons. And there were rollicking accounts of life among artists, including those of the Mexican Renaissance such as José Orozco, Diego Rivera, and Tina Modotti—perhaps the greatest of Weston's many loves.

But it is in the moments of revelation arising from his work that Weston's journals rise to greatness. "I am not limiting myself to theories," he wrote. "Dare to be irrational—keep free from formulae, open to any fresh impulse, fluid." And elsewhere: "I have come to realize life as a coherent whole, and myself as a part, with rocks, trees, bones, cabbages, smokestacks, torsos, all interrelated, interdependent—each a symbol of the whole." Such fragments barely hint at the delights of the *Daybooks*, in which Nancy Newhall's editing in itself reached a level of brilliance. In the gathering of voices that have enriched Aperture publications, Nancy's insights offered prescient guideposts to future generations of editors.

Her essay in the debut issue of *Aperture*, "The Caption: The Mutual Relation of Words/Photographs," defined a new conception of the caption, which she called formally the *additive caption*. In contrast to the caption as title, miniature essay, or narrative, she wrote, the additive caption "leaps over facts and adds a new dimension. It combines its own connotations with those in the photograph to produce a new image in the mind of the spectator—sometimes an image totally unexpected and unforeseen, which exists in neither words nor photographs but only in their juxtaposition."

During his editorship, Minor White experimented with image/word possibilities through poetry, dialogues, and other devices. The technical essays of the early issues were quickly abandoned, as were the advisories on "how to look at" or "read" photographs. As Michael Hoffman's editorial tenure progressed, he continuously sought out writers, critics, poets, and especially the viewpoints and comments of contributing photographers.

Aperture's place in the critical canon is largely defined by its mission of being true to the "artist's intent." Thus the goal is to deepen the viewer's encounter with the images and their creators:

to provide, as Michael once put it, "an entry point into the work." The other dimensions of criticism—explication, analysis, and, automatically for some critics, abuse—are usually left to other venues.

In Aperture's history, the marriage of image and word has met with notable successes, often achieved with agonizing effort—none more successful, nor more agonizing, than with that master of architectural photography, Clarence John Laughlin.

Laughlin was born on a Louisiana plantation in 1905 and remained a resident of New Orleans throughout his life. His 1948 book *Ghosts Along the Mississippi*, a portrayal of architectural survivals and relics of the Old South, was extraordinarily successful, and caught the attention of both Minor and Michael. Letters these two exchanged in 1966 abound with descriptions of Laughlin's eccentricities, even as they pushed toward the creation of an exhibition and monograph devoted to the photographer.

On his first visit to Laughlin's apartment in a rundown building on New Orleans's Vieux Carré, Michael found himself in a gray room lit by a single yellow bulb, covered with dust, and surrounded by walls and stacks of books—more than fifteen thousand of them. Laughlin was, Michael said, "certainly one of the most well-read people in the entire universe." And he clearly had his own tastes. As Michael recalled, "His refrigerator was filled with cans of Spam, like some creation of Andy Warhol's. He had almost no money, and traveled by bus to work in a darkroom in the house of a wealthy friend, returning with the prints in a tray. He was an absolute master printer, although he used Sears & Roebuck varnish on them, which cracked horribly." The prints, which Michael was there to see, were brought out parsimoniously, because the artist wished to discuss each one—endlessly. The place, circumstances of the making, the atmosphere . . . Michael would leave the room for a break only to return and discover that Laughlin had gone on talking, oblivious to his absence. And so it went over several years, until finally the Laughlin exhibition was mounted in Philadelphia and the Aperture monograph appeared in 1973.

Clarence John Laughlin: The Personal Eye would remain one of Michael's favorite books not only because of the imagery, but also because of Jonathan Williams's accompanying text, which characterizes Laughlin as "all phantasmagoria and gumbo—Archimboldo, 'The Invasion of the Body Snatchers,' Grandville, Belle Grove Plantation, the Wizard of Oz, and skillet cornbread . . . *Bizarrerie*." The essay reads like a jukebox blaring a pastiche of jazz riffs, Cajun jigs, Eric Satie, and through it the rich, tempestuous sense of the artist emerges. Williams's text was that rarity of Newhall's ideal: merging word and image into a new medium.

Michael had embarked on a search for the images and artists, both past and present, that he believed needed to be brought before the public. There continued the endless pressure to raise funds and subventions, and to work with the myriad details and decisions of design and production. The Laughlin experience illustrates the enormous consumption of time each project required. Michael needed editorial help, and he also began to recognize that it was time for fresh perspectives. Although he chafed under the criticisms, Aperture was viewed by many as a publishing house limited to formal, classical, and above all "mystical" and "artistic" imagery deriving from the ascetic aesthetics of Stieglitz, Minor, and Michael himself. Aperture's most severe critics called it "cultish" and "incestuous."

Carole Kismaric had been one of the outstanding visual editors at Time-Life Books, involved with popular series on science, human behavior, and American history. She also was part of the editorial team that created the company's influential "Photography"

Participants of "Photography 1982," a symposium sponsored by Aperture at the Esalen Institute, Big Sur, California. Photograph by John Grimes.

series. Researched, written, edited, and designed to the highest standards, the publications of Time-Life Books nonetheless offered little creative scope to the individual, and when Michael invited her to work at Aperture, Carole was ready for a change.

"I had thought little about photography as art," Carole recalled years later. "I understood it as a powerful communicating device that had changed, and was continuing to change, our societies and our culture. But I thought, 'I've spent years communicating to millions of people with the books Time-Life was doing. Why not communicate to a few thousand about things of quality, of intellectual challenge?' I was supposed to stir things up."

She was also supposed to bring a much-needed degree of professionalism into the editorial process, which Michael freely admitted he lacked. One of her early tasks was sifting through the backlog of submissions, and one group of photographs in particular led to her own vision of what photography, and Aperture, could accomplish.

What I remember most profoundly is looking at this one portfolio of Jerome Liebling's photographs of cadavers and starting to cry. I was so *present* to the fragility of those cadavers; they were truly beautiful, and most people could not bear to look at beauty penetrating into this dimension of truth. . . . What I care about in photography is that it shows me something I've never seen before, that it documents our world and our experience of the world. But I've also been interested in the crossover—how the documentary experience extends in other dimensions of experience.

Aperture had never published anything like Liebling's cadavers. That singular experience enabled Kismaric and Hoffman, despite their differing approaches to the medium, to discover what Proust called the "consanguinity of spirit," which lets even the most opposite characters transcend differences. And Carole and Michael were indeed opposite characters, a study in complementary contrasts.

Michael was barely of medium height, with black hair and dark eyes, and rather stocky. He was extremely energetic and physically strong—ever burdened with tote bags and briefcases full of Aperture publications, maquettes of prospective books, and project proposals. He was always on the lookout for a deal. Carole was tall, slender, extremely elegant and gracious. They almost naturally fell into good cop/bad cop relationships with artists and writers. Michael could be a witty and utterly engaging conversationalist—but he also had a quicksilver temper and an amazing range of histrionic effects, from sweetly cheerful to full-fledged tantrum. Carole was invariably civil, simultaneously sympathetic and empathic. She could charm the birds down from the trees; Michael often sent them fleeing for cover.

Carole brought from Time-Life an extensive network of contacts among photographers and writers. She infused the journal with images and ideas relating to political and social issues that had been largely missing in *Aperture* since the death of Dorothea Lange in 1965. She also tapped into a new generation of documentarians with a grasp of deeper currents of the culture ranging from the exotic to the mundane: Danny Lyon's Hell's Angels and Texas convicts, Chauncey Hare's technologically alienated home life, Larry Fink's social gatherings, Garry Winogrand's and Tod Papageorge's street scenes found places alongside images by Atget, Strand, and Bullock.

From this point, at Carole's instigation, *Aperture* subscribers would begin to have an entirely new experience—and among their numbers were those who, accustomed to unperturbing images of classical and romantic beauty, were not pleased. The Liebling cadavers, the homoerotic interpretation of Yukio Mishima by the Japanese master Eikoh Hosoe, and in particular the searing war

images by Don McCullin brought storms of protests and subscription cancellations. Unexpectedly, the numbers of cancellations were balanced by a newly awakened interest among a more venturesome audience. The journal continued, slowly, to grow.

Confident in Carole's stewardship of the journal and book projects, Michael was free to pursue his dream of transforming Aperture into a community of like-minded souls who would share his quest for "life beyond the ordinary." Naming it the Silver Mountain Foundation, he envisioned a residential environment where individual creativity would be nurtured by communal living. His intangible hopes for Silver Mountain never materialized, but his expanded vision led to tangible results. It was during these few years in the early 1980s that Aperture created the Paul Strand Archive, the Photogravure Workshop, the Internship Program, and a gallery to exhibit the prints of published photographers. And Aperture, now officially a foundation, finally found a permanent home.

Housed in the five-story building that Shirley Burden had purchased for Aperture at 20 East 23rd Street in Manhattan, the new headquarters brought to an end Aperture's thirty-year wanderings. The second-floor gallery was a long-cherished dream of Burden's, but it wasn't the only legacy of this member of a collateral branch of the legendary Vanderbilts. He was an accomplished artist in his own right. Following a brief career as a filmmaker in Hollywood, Burden had devoted himself to photography after World War II. He was a deeply religious man who brought a gentle vision to his subjects. He was also shy and unassertive, and his books were published with Aperture only at Michael's insistence.

The late 1970s and early 1980s were a crucial period because the long struggle to have the medium recognized as an art form was being resolved. This was only in part due to the accomplishments of the artists. Collectors, connoisseurs, galleries, and museums were creating a new market. Prices were rising for the works of dead masters, in particular, but also for critically recognized members of the new generation. "Art photography" was beginning to be profitable. Still, a new art form—and photography had existed for only a few generations—remains a novelty until it is firmly placed within a tradition. It needs a history.

In this connection, Michael was undertaking seminal monographs of the medium's past. One of the most triumphant resulted from a visit to New York in 1980 by Mark Haworth-Booth, then at the beginning of his long career as curator of photographs at the Victoria & Albert Museum in London. He brought with him a proposal for an ambitious project, *The Golden Age of British Photography: 1839–1900*. Haworth-Booth's selection for the book ranged from Chauncey Hare Townshend, William Fox Talbot, and Roger Fenton through the early artistic ventures of Oscar Rejlander; the Victorian portraiture of Julia Margaret Cameron and Lewis Carroll, down to the early struggle for photography as an art waged

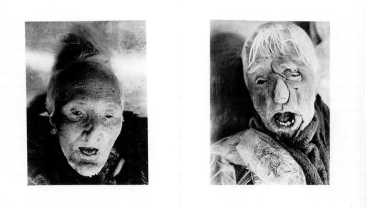

The Liebling cadavers, Eikoh Hosoe's homoerotic work, and in particular the war images by Don McCullin brought storms of protest and subscription cancellations. Unexpectedly, the numbers of cancellations were balanced by a newly awakened interest among a more venturesome audience.

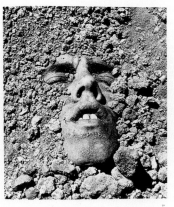

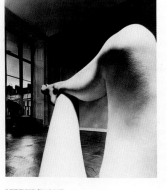

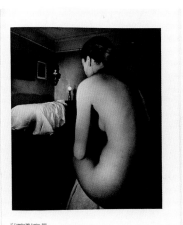

TOP: *Aperture* 79, 1977, pages 72–73: photographs by Jerome Liebling.
MIDDLE: *Aperture* 137, 1994, pages 28–29: photographs by David Wojnarowicz.
BOTTOM: *Aperture* 99, 1985, pages 66–67: photographs by Bill Brandt.

by P. H. Emerson. *The Golden Age* was more than a revelation of overlooked photographers; it was also a major addition to critical history. Haworth-Booth, who also wrote the book's introductory essay, would go on to become one of Aperture's most prolific contributors.

Michael's understanding of the need for a historic tradition also found expression in elegant monographs devoted to the studies of cathedrals by Frederick Evans; to the portraiture of North American Indians by Edward Curtis; and to the largely neglected, and perhaps greatest, twentieth-century portraitist, August Sander.

Equally important to Michael was bringing the medium's artists to a wider public through inexpensive, small-format books. A selection of Henri Cartier-Bresson's acclaimed photographs introduced the Aperture "History of Photography" series in 1976, later retitled "Masters of Photography." For the first time, audiences unable to afford Aperture's more costly monographs had access to well-rendered images by Stieglitz, Strand, Weston, Eugène Atget, André Kertész, Man Ray, and others—a total to date of eighteen volumes in the series.

In the 1970s, Aperture also made its early ventures into what had been a prohibitively expensive domain of publishing: color photography. Stephen Shore's vision of mainstream America—its seldom appreciated highways, byways, gas stations, small towns—was one of the early color efforts. This volume, *Uncommon Places*, was followed by Shore's magnificent *Gardens at Giverny: A View of Monet's World*. The search for printers capable of reproducing high-quality color, at a nonbankrupting price, had Aperture's production expert Steve Baron journeying from Hong Kong to Italy, with numerous stops in between.

Meanwhile, Kismaric's efforts with the journal led to discoveries of photographers with that most subtle of qualities: the literary sensibility. British photographer Bill Brandt revealed a gift for the *genius loci* in his studies for *Literary Britain*. And America's literary heartland, the Deep South, inspired two artists whose photography came to light almost simultaneously in Aperture publications.

One of the best-loved storytellers of the twentieth century, Eudora Welty had at the beginning of her writing career carried a camera into the homes, churches, and neighborhoods of her black friends and acquaintances in Mississippi. The subjects in Welty's photographs were treated with the same encompassing sense of kinship and warmth as they are in her short stories and novels.

William Christenberry was born in Hale County, Alabama, and his grandparents' farm bordered that of the pseudonymous "Ricketts" family, the subject of Walker Evans's and James Agee's Depression-era collaboration, *Let Us Now Praise Famous Men*. Christenberry was a lifelong fan of Agee, inspired by the author's famous supplication: "If I could do it, I would do no writing at all

here. It would be photographs; the rest would be fragments of cloth, bits of cotton, lumps of earth, records of speech, pieces of wood and iron, phials of odors, plates of food and of excrement." And indeed, the photographer Christenberry made use of painting, found objects, and sculpture in his large, mysterious, sinister environmental work, "The Klan Room." The expressive range of Christenberry's talents, as well as his deep-seated dread of Klan influence in the South, were represented in resonant color reproductions in an Aperture monograph and in the journal.

The photographer whose literary gifts have most decisively influenced Aperture over the years was based in the West, near Colorado Springs. A former professor of literature, Robert Adams, and his wife Kerstin, were ardent conservationists, peace activists, and supporters of animal rights in an area where some of the most transcendent vistas of American nature were blighted by some of the worst excesses of American culture. Near his home were both a plutonium-producing nuclear-bomb factory and a nuclear power-plant; the landscape was disfigured by urban sprawl. Adams documented these blights upon land and lives. He also possessed a true landsman's poetic instinct in his photographs of pristine prairies and grasslands, and scenes evoking universally felt moments in a series called "Summer Nights." Adams's perfectly composed images demand pause and considered attention. Michael was to become one of Adams's most devoted supporters; Aperture has published no fewer than six monographs of his work, as well as portfolios in the journal. Adams also brought to the medium his gifts as a critic with two volumes of essays: *Beauty in Photography: Essays in Defense of Traditional Values* and *Why People Photograph*.

Michael once remarked, "When you look backward too much, you get turned into a pillar of salt." By 1980, he felt a need for personal renewal. Inspired in part by Dorothy Norman—who had had close personal relationships with Mahatma Gandhi and Prime Ministers Jawaharlal Nehru and Indira Gandhi—Michael set out for a prolonged pilgrimage to India. His only companion was the Temple edition of Dante's *Divine Comedy*. His travels and the poem worked their wonders, each with rippling implications for Aperture in the ensuing years.

The most significant event in Michael's Indian journey was the first of many encounters with the Dalai Lama, beginning a close association that would subsequently lead to Aperture's publications *Tibet: The Sacred Realm, Photographs 1880–1950* and *Tibet Since 1950: Silence, Prison, or Exile*, two historic monographs documenting life before and after the Chinese invasion and occupation. *Journey to Enlightenment*, with photographs and narrative by Matthieu Ricard, celebrates the life and teachings of the Tibetan spiritual master Khyentse Rinpoche. Other volumes devoted to the photographers and imagery of India became staples of the

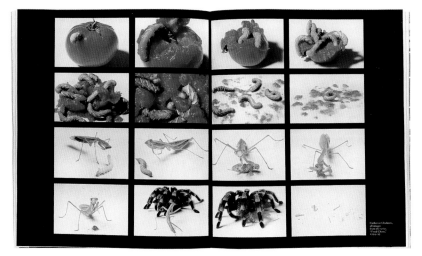

"I've felt almost a sense of obeisance to these ghosts, these spirits that I've had the privilege of being related to, a responsibility in my act of service to provide for a continuation of their qualities, of their ideas."

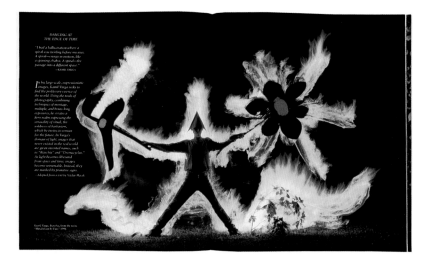

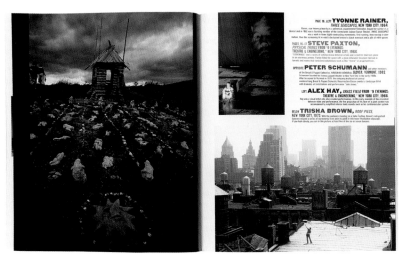

TOP: *Aperture* 143, 1996, pages 32–33: photographs by Catherine Chalmers.
MIDDLE: *Aperture* 152, 1998, pages 50–51: photograph by Kamil Varga.
BOTTOM: *Aperture* 164, 2001, pages 18–19: photographs by Peter Moore.

Aperture library. Michael, who felt he had found a second home on the subcontinent, seldom let a year pass without visiting it.

Michael had read Dante at college, but the long hours spent in the poet's company during his first Indian journey led to a life-long study. New interns at Aperture to whom he gave copies were shocked to find that reading the epic seemed to be a prerequisite for a successful apprenticeship (in later years, Michael would add the gargantuan *Mahabharata* to the list of required reading). As he once remarked to Robert Adams, "I go back to Dante because he seems to offer a key in the search from darkness to light."

His own energies refreshed, Michael felt that Aperture, too, was ready for revitalization. He and Kismaric believed that there was a need for more meaningful dialogue among the arts, and together they organized an extraordinary conference of poets, performance artists, graphic artists, curators, writers, and critics, along with photographers William Christenberry, Ray Metzker, Linda O'Connor, Frank Gohlke, Sigfried Halus, and Raymond Depardon. The group convened at the Esalen Institute on California's Big Sur coast in November 1982. In an ensuing manifesto, they recognized a "growing climate of public restraint, the complexities and dangers of the age, the prevalence of mechanization and dehumanizing technique, [which] encroach upon the individual, the society, and the human adventure itself." Within this context, the group statement continued, "an artist is an awakener: to the surrounding world, to dimensions of the human spirit, and, when necessary, to the need for action."

In subtle ways, the conference guided Aperture's direction during the remainder of the decade and beyond. After Kismaric left Aperture in 1984 to pursue new creative challenges, a soft-spoken, dynamic young Englishman, Mark Holborn, was named editor. Michael enabled Holborn to pursue his passion for Japanese art and photography in three unprecedented publications, *Black Sun: The Eyes of Four*, featuring the photographs of Masahisa Fukase, Eikoh Hosoe, Daido Moriyama, and Shomei Tomatsu; *BA.RA.KEI.: Ordeal by Roses*, Hosoe's controversial tribute to Mishima; and a volume devoted to the fantastic theater of Butoh. Marilyn Bridges's amazing aerial studies of ancient earthworks were featured in the monograph *Markings*. Holborn also helped shepherd Nan Goldin's *The Ballad of Sexual Dependency* through publication even as she brought its source, an uproarious, emotional slide show, with commentary, into Aperture's Burden Gallery.

After Kismaric and Holborn, there was a considerable turnover of Aperture editors and guest editors: a succession of highly talented individuals, each of whom left their mark. These included Charles Hagen, Steve Dietz, Nan Richardson, Lawrence Frascella, Rebecca Busselle, Peggy Roalf, Michael Sand, and Andrew Wilkes. Under their helms through most of the 1980s, and then into the 1990s, the journal shifted to thematic approaches. These issues were devoted to such subjects as the relationship of photography and drawing, including a number of rapid-fire sketches by Cartier-Bresson; to technology and transformation; to connoisseurs and collecting; to fashion photography; and to varieties and experiments in communal living.

It was during this period that *Aperture* also became a truly international journal of photography. Michael's powers of persuasion had reached new heights when he wrested from the Communist bureaucracy in Czechoslovakia the masterpieces by a long-overlooked genius, Josef Sudek, for the exhibition and monograph *Poet of Prague*. The most influential and innovative photographers would be represented in issues of the journal devoted to France, Italy, Germany, Japan, Cuba, and Spain. India was a continuing subject of Aperture monographs, including the mammoth volume in tribute to the country's golden anniversary of freedom from colonial rule, *India: A Celebration of Independence*.

Editorial stability was achieved—and editorial content grew yet more adventurous—when Melissa Harris, who had first joined Aperture in 1989, took over the journal, as well as selected book projects, in 1992. Melissa brought to the work a unique background that ranged from teaching multimedia collaboration at Yale University (her alma mater) to her editing job at *Artforum* magazine. Along with her breadth of interests in the arts, she also brought to Aperture deeply felt concerns about political, social, and moral issues. Harris challenged complacency and sanctimony as no previous editor had done. Early on, censorial objections were raised—and dismissed—by her fearless compilation issue/monograph "The Body in Question." Later, Melissa brought to publication Eugene Richards's dark yet compassionate chronicle of drug addition; Sally Mann's poignant portrayals of childhood; Mary Ellen Marks's edgy photo-essays; Donna Ferrato's exposé of domestic violence; Letizia Battaglia's probing of mafioso evil rife in Sicily; the chaotic dynamism of bordertown life in *Juárez: The Laboratory of Our Future*, a photographic anthology with texts by Charles Bowden, Eduardo Galeano, and Noam Chomsky; and an issue and monograph devoted to the life, work, and terrible affliction from AIDS of the artist David Wojnarowicz. A champion of the dauntless eye, Harris also fostered definitive monographs on geniuses of other media, including dancer-choreographer Merce Cunningham and the controversial, worthy heir of Italian *commedia dell'arte*, Nobel laureate Dario Fo.

For editors, curators, and spectators, the power of fine photography is in large measure the power of surprise: "What I have never seen before," as Carole Kismaric put it. This has nothing to do with the pursuit of faddish "newness" or of shock value for its own sake—all too often the purview of "art biz" in modish gal-

leries. Surprise, as John Szarkowski has pointed out, is primarily about enlargement of vision and experience.

Space allows mention of only a few instances of such surprises in recent Aperture history. Among them: Young British photographer Nick Waplington, whose color profiles of working-class families in Nottingham unveiled a new dimension of intimate theater in documentary photography. Robert Glenn Ketchum's color landscapes of the Tongass helped save the last North American rainforest from untrammeled development. Michiko Kon's constructions from the wares of fishmongers of Japan brought new wit to still lifes. Mimmo Jodice's lens refocused the mythical impressions of ancient Mediterranean civilization and the romance of present-day Paris. Joel-Peter Witkin's comic-grotesque tableaux, which have been featured in the magazine, transmogrified studio photography. Graciela Iturbide unveiled dreamlike encounters with the commonplaces of Mexican life. And Neil Folberg, in *Celestial Nights*, created new thresholds of mystical contemplation.

And of the wordsmiths' contributions. . . . Arthur Miller on his wife Inge Morath's photography; Czeslaw Milosz on Czech photographer Josef Koudelka; Larry McMurtry on the rodeo scenarios of Louise Serpa; Adam Gopnik on Parisian life and times. There were the self-scripted playlets of Duane Michals, the self-captioned album of Allen Ginsberg. Writers who expanded the encounter with photographic experience notably included Szarkowski, John Berger, Susan Sontag, and Andy Grundberg. Insights from kindred media were offered up by David Byrne, Karen Finley, and John Waters. Acclaimed literary figures include E. Annie Proulx, Paul Bowles, Reynolds Price, Marguerite Duras, and V. S. Naipaul. And finally, there popped up surprising contributors across a spectrum from Muhammad Ali to Aung San Suu Kyi.

Aperture's list of artists and writers is as varied and distinguished as contemporary world culture has to offer. These brief mentions are a fraction of the hundreds who have appeared in the journal and monographs. Such a plethora of omissions!

With the fiftieth anniversary approaching, Michael reflected on his own experience with Aperture as what he called the "evolution of an ideal." It is an ideal never articulated to anyone's intellectual satisfaction, but manifests in the artists and their work.

Evolution is a process of increase: of numbers, of complexity, of diversity. Evolution, in a word, is about *more*. To understand its workings, especially in terms of something as ambiguous as an ideal, it may be helpful to trace a lineage: in this instance, from the photo-reportage of Aperture's activist-founder Dorothea Lange, to photography's preeminent turn-of-the-twenty-first-century chronicler, Brazilian Sebastião Salgado.

The parallels are obvious. Both Lange and Salgado have recorded the lives of workers, their families, and displacing forces beyond their control. Both are artists of the highest order, even as they

FROM TOP: Aperture's Burden Gallery; Honeyboy Edwards and Michael E. Hoffman at the Blues Benefit at the Supper Club, 1999; Bruce Davidson, Michael E. Hoffman, and Emily Davidson at the Cotton Mary benefit, 2000; Marilyn, Elvis, Michael E. Hoffman, Liz, and David Graham at the "Land of the Free" opening at Aperture's Burden Gallery, 2000; Michael E. Hoffman presents Cornell Capa with an ICP Lifetime Achievement Award in Photography at the Supper Club, 1999.

have wedded their imagery to social science; both have worked in close partnership with their spouses (for Lange, the social scientist Paul Taylor; for Salgado, the designer and manager of his projects, Lelia Wanick Salgado). Lange ranged across the United States during the peak years of the Depression; her subjects included the urban unemployed, tenant farmers, and families driven from farmlands by ecological disaster. Salgado has ranged the globe. If his subjects, like Lange's, are workers and migrants, they are far more than victims of temporary circumstance. They have been irresistibly swept up in Tolstoyan shifts of history.

For *Workers: An Archaeology of the Industrial Age*, Salgado took his cameras into the plantations, factories, fishing villages, mines, slaughterhouses, oil fields, and shipyards in nearly a score of countries. His camera vision ranged from panoramas of tens of thousands of antlike miners in the gold-ore pits of Brazil to candid eye contact with young women on the tea plantations of Central Africa. *Workers* occupied Salgado for nearly seven years. He devoted the next six years to *Migrations*, traveling to forty countries where humanity by the tens of millions has been forced into the life of refugee, exile, and migrant by war, repression, poverty, and environmental catastrophe.

Migrations was published at the beginning of the new millennium, and it was also in 2000 that Melissa Harris undertook an evolutionary leap in the content of the journal. It was in response, she wrote in an editorial, "to the shifting boundaries between media, and to the remarkable range of cross-cultural experiences that photography now addresses." With a bold transformation in design by Yolanda Cuomo, the new *Aperture* was to be increasingly diverse, with the "potential to motivate, to incite, to infuriate, to enrapture, to change minds, to change lives."

Even as Michael was reflecting upon "the evolution of an ideal," he was grumbling about his own personal evolution. Now in his fifties, he complained that he was becoming a curmudgeon. In fact, as old friends such as Haworth-Booth observed, quite the opposite was happening. Although his temper could still be mercurial, Michael was in fact becoming . . . well, almost mellowed. In 1998, Michael and Melissa were married. Two years later, Michael's first grandchild, Isabel Katharine, the daughter of Michael's son Matthew and his wife, was born in December 2000.

With the beginning of 2001, momentum gathered for the publications, exhibition, and other events marking Aperture's fiftieth anniversary. Michael and Melissa were determined that the occasion should be focused upon the future. Melissa and her staff sent out requests for new work to more than one hundred artists. The Burden Gallery was closed to make space for laying out, selecting, and sequencing images. At the Millerton complex, long-time archivist and master conservator Anthony Montoya oversaw printing and framing of selected images. Wendy Byrne was at work designing and re-designing journal issues devoted to the occasion. And throughout the New York headquarters, staff and interns were involved in fund-raising, publicity, scheduling, and the endless details of finance and bookkeeping. Meanwhile, the Foundation's trustees were keeping watch, appropriately trustful but not without some anxiety: they, too, had reputations at stake. Michael, as ever, was involved in every single detail.

Then, in mid August of 2001, Michael was taken seriously ill and admitted to New York Hospital. Throughout the following weeks, including the horrible September of the terrorist attacks on Manhattan's World Trade Center, he fought the illness. Still, at Aperture, the work continued, always awaiting Michael's approval or changes. For nearly four decades, he had decided upon the selection and sequencing of photographs, the design, the printing, the hanging of exhibitions. It was inconceivable that Michael would not be back. But on November 23, the meningitis diagnosed exhausted even his seemingly invincible life force. Michael died of complications from the disease at age fifty-nine.

It seemed unbelievable, unthinkable, then and it still does months later, at the time of this writing. That Michael died. More than the passing of a single man, it was as if a roomful of animated, irreplaceable, utterly alive people had suddenly vanished, never to return. The shock, of course, was felt deeply at Aperture, but the work went on. The fiftieth anniversary took on special meaning as a tribute to the man who had made it possible.

On a personal note, I began the interviews with Michael which were to be the basis for this essay in February 2001 at Esalen. The next sessions took place at his Shekomeko farm in late July. On our final day of discussions, relaxing in the late afternoon with Leonard Cohen's music in the background, I put to him a question I had raised often during our twenty-five years of collaboration and friendship: "Michael, why did you do this, devote your life to Aperture?" In the past, he'd shrugged it off, usually with: "I was unemployable anywhere else." On this occasion, he did answer, and spoke of Stieglitz, Minor, Ansel, Nancy, Weston, and the other Founders and shaping artists of Aperture's beginnings. He spoke carefully, as if he had been thinking about it for some time:

I've felt almost a sense of obeisance to these ghosts, these spirits that I've had the privilege of being related to, a responsibility in my act of service to provide for a continuation of their qualities, of their ideals.

And that was what he intended for Aperture's fiftieth anniversary, to be a celebration of trust, of continuity, and above all of service to those artists who will make photography's future.

Anna Gaskell, *Untitled #5 (wonder series)*, 1996; from *Aperture* 156, 1999.

David Graham, *Xina,* Tyler State Park, Richboro, PA, 1994.

Belief is something with many sides to it. Believing in pictures is like believing in God—or believing in pictures in a practical sense, at a time when painting is rather out of favor. . . . We're always creating pictures; take fashion, for example. We put something on because we believe in it, and we thereby offer a picture of ourselves that tells other people who we are and what we're like. The same happens in other ways—we're always creating pictures for other people to understand if they can.

—Gerhard Richter, *Aperture* 145, 1996

William Wegman, *Hot Fudge,* 1994; from *Aperture* 143, 1996.

Sandy Skoglund, *The Wedding*, 1994;
from *Aperture* 143, 1996.

© Sandy Skoglund, 1994

Elliott Erwitt, *A Nudist Wedding*, Kent, England, 1984;
from *Aperture* 159, 2000.

Raymond Depardon, *Fainting Bride, Bois de Boulogne, Paris, France*, 1956; from *Aperture* 148, 1997.

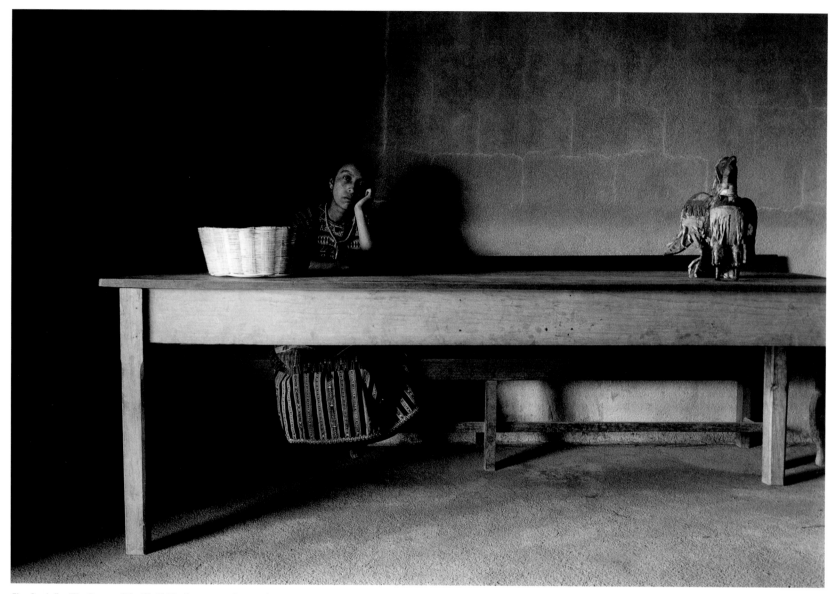

Flor Garduño, *The Owner of the Big Table*, Sumpango, Guatemala, 1989; from *Witnesses of Time* (Aperture, 2000).

With singular dedication, the complete artist lives to assuage his desire for fresh insight and for new force and quality of being. Structuring the substance of his medium, he gives it an order that, however familiar it may be in some of its components, will be in its total character new to experience, never before seen, fresh in the world and therefore an enormous refreshment of the world.

—Brewster Ghiselin, from "The Silence of Stones: The Photographer as Artist," *Aperture* 79, 1977

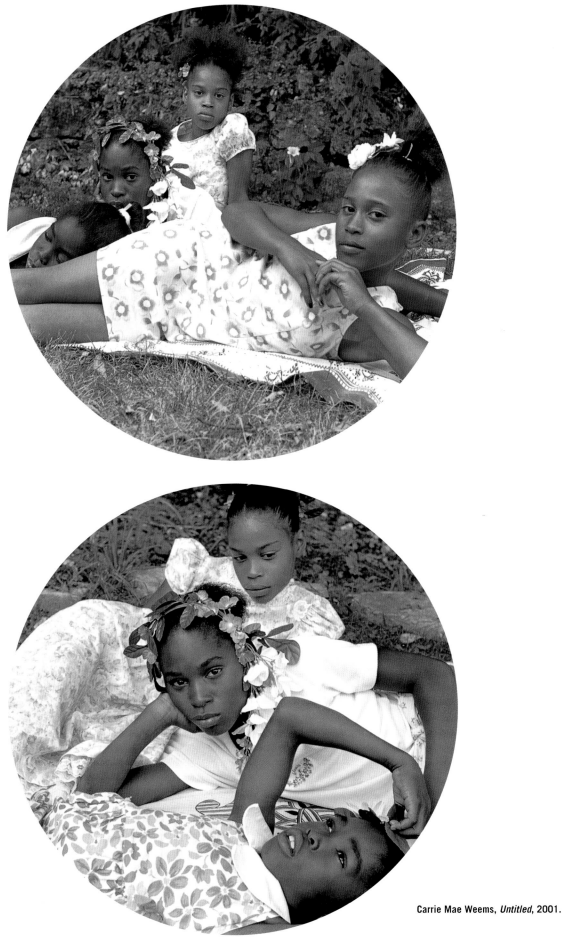

Carrie Mae Weems, *Untitled*, 2001.

205

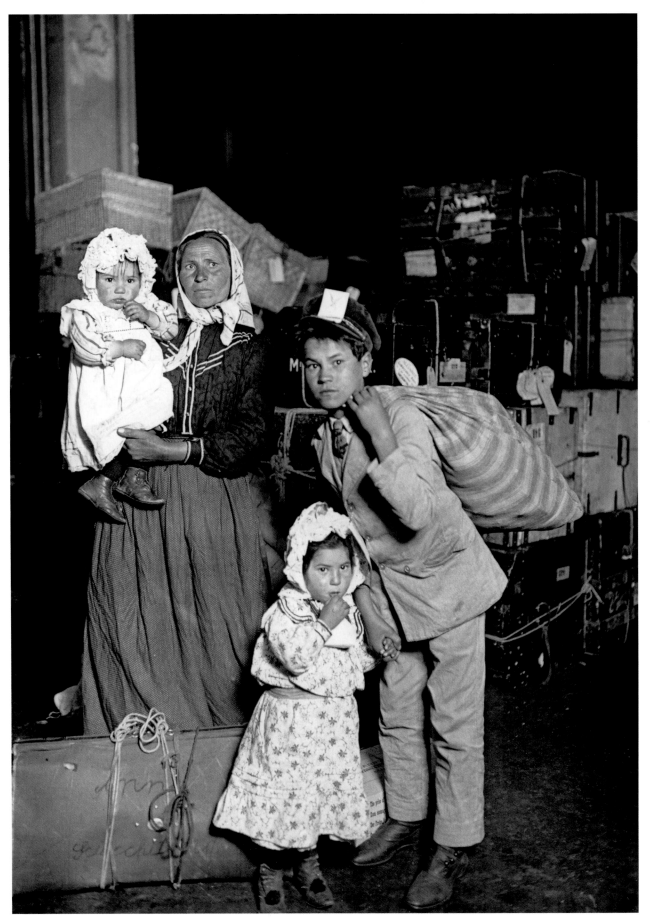

Lewis Hine, *Looking for lost baggage, Ellis Island*,
1905; from *Aperture* vol. 5, no. 1, 1957.

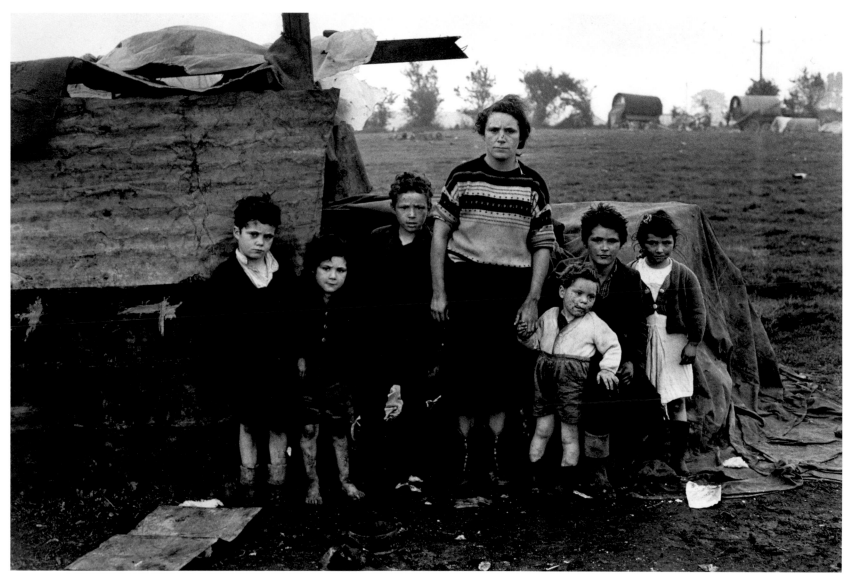

Alen MacWeeney, *The Ward Family*, from the series
"Travelers," 1965; from *Aperture* 82, 1979.

Danny Lyon, *Nancy*, 1981;
from his book
Knave of Hearts, 1999.

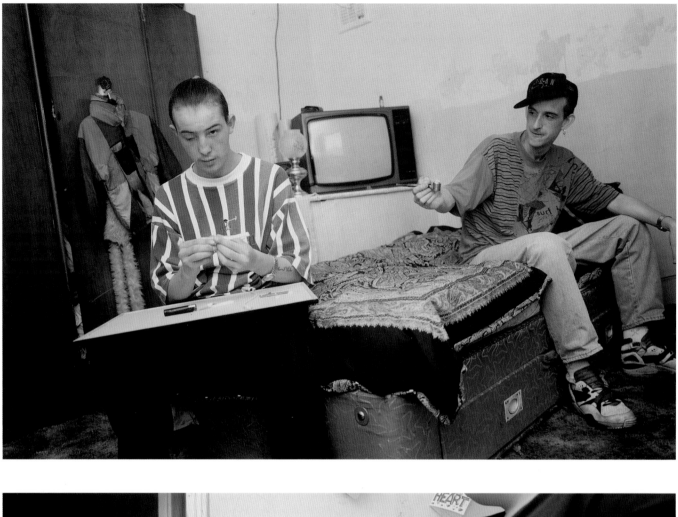

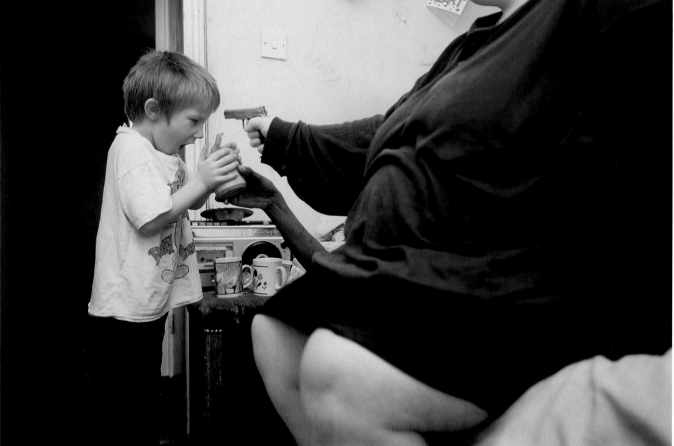

THIS PAGE: photographs by Nick Waplington, from the series "Living Room," 1996–97.

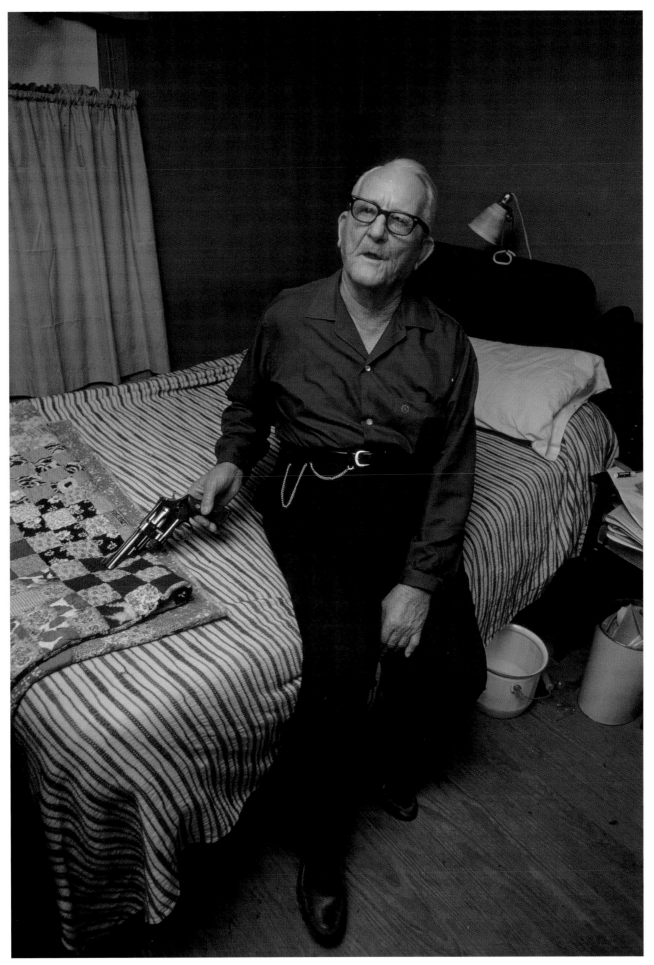

William Eggleston, *Untitled (Morton, Mississippi)*, 1969–70.

The combination of sexual content and photography makes for a particularly explosive mix, and not just for members of fundamentalist groups. The reasons for their disapproval are clear; images that depict sexuality outside of marriage and procreation encourage immorality (or so we are to believe), and thereby subvert the traditional social arrangements conservatives would like to reinstate. But for the average citizen, sexual imagery can be difficult and disturbing too. Heirs to a Victorian cultural tradition that regarded sexual pleasure with profound suspicion, we greet explicit images of sexuality with anxiety and an underdeveloped history of looking. Distinctions that viewers are accustomed to making—between fantasy and behavior, image and reality—become curiously evanescent when it comes to sex. Our unease often increases if the sexual acts depicted are unfamiliar or unconventional. . . .

—Carole S. Vance, from "Photography, Pornography and Sexual Politics," *Aperture* 121, 1990

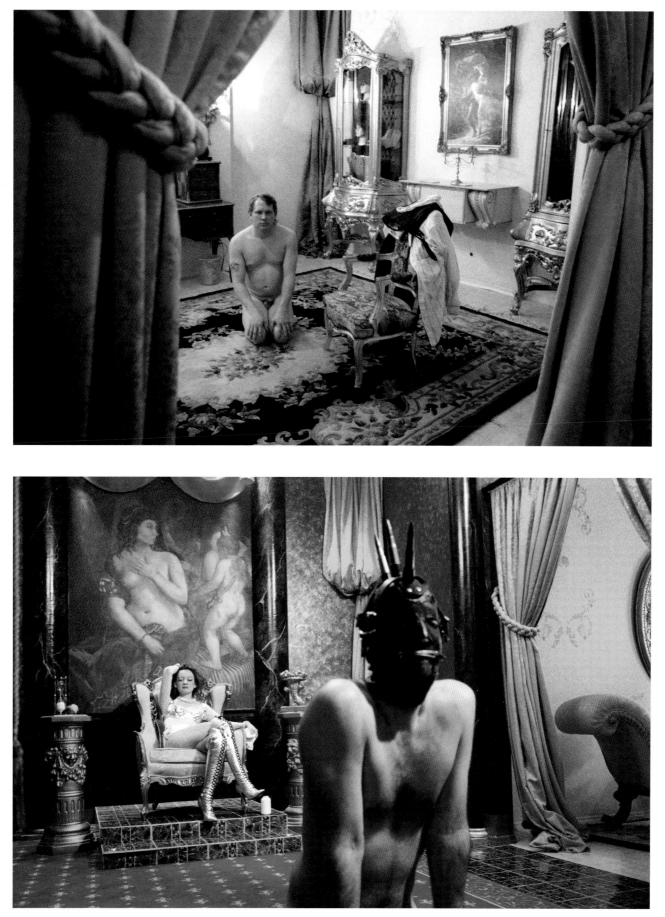

THIS PAGE: photographs by Susan Meiselas. TOP: *Pandora's Box, Awaiting Mistress Natasha, The Versailles Room, New York City*, 1995. BOTTOM: *Pandora's Box, Mistress Catherine After the Whipping I, The Versailles Room, New York City*, 1995.

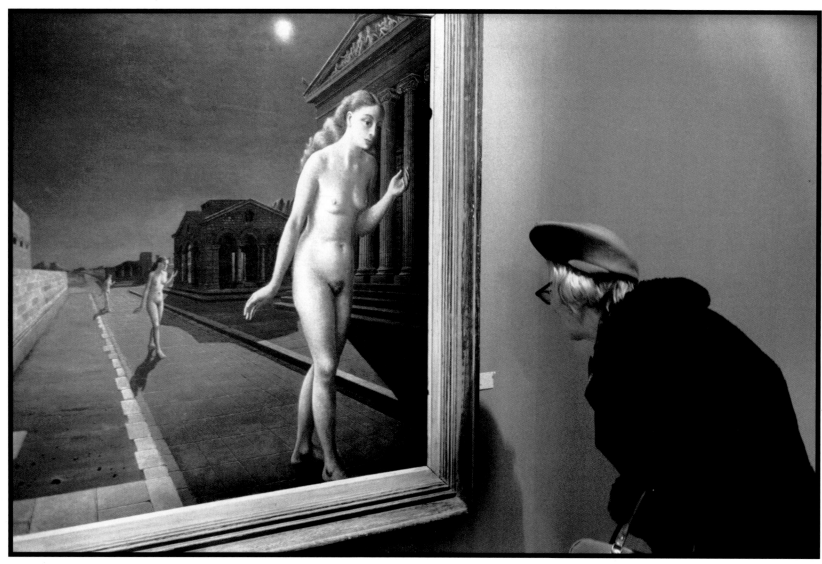

Martine Franck, *Exhibition, Pompidou Center,* Paris,
France, 1977; from *Aperture* 151, 1998.

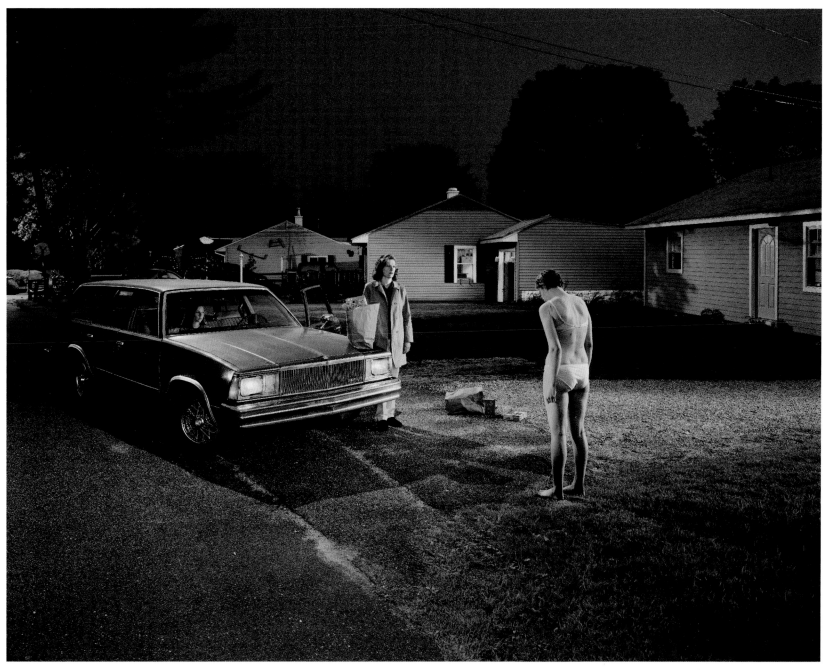

Gregory Crewdson, *Untitled (penitent girl)*, 2001–02.

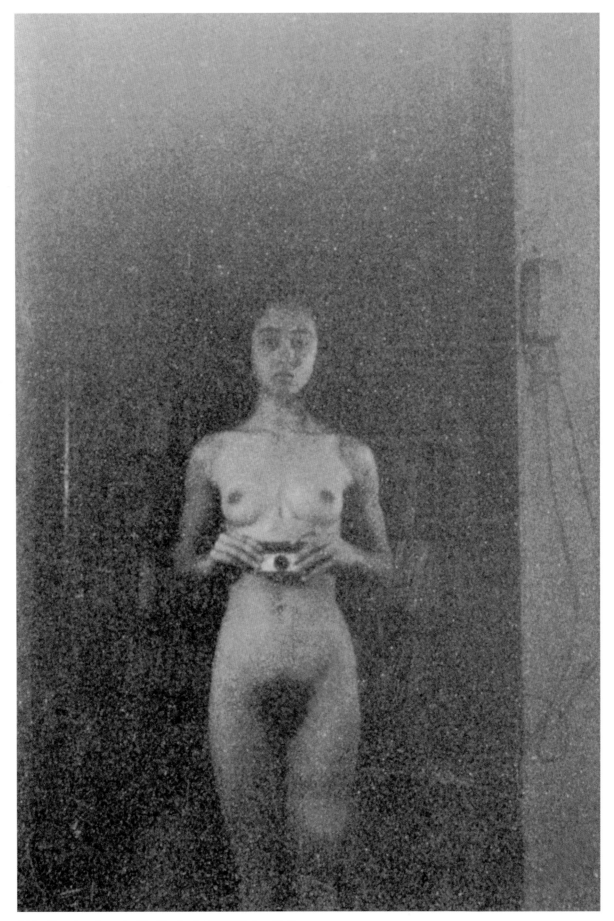

Adrian Piper, from the series "Food for the Spirit," 1971; from *Master
Breasts: Objectified, Aestheticized, Fantasized, Eroticized, Feminized
by Photography's Most Titillating Masters . . .* (Aperture, 1998).

Robert Capa, *Carnival,* Zürs, Austria, February, 1950; from
Robert Capa: Photographs (Aperture, 1996).

THIS PAGE: photographs by Donna Ferrato. TOP: *Katherine Cronin, Lakewood, Ohio*, 2001. BOTTOM: *Eve finds her g-spot*, 2000.

Keri Pickett, *Touch*, 1996; from *Faeries: Visions,
Voices & Pretty Dresses* (Aperture, 2000).

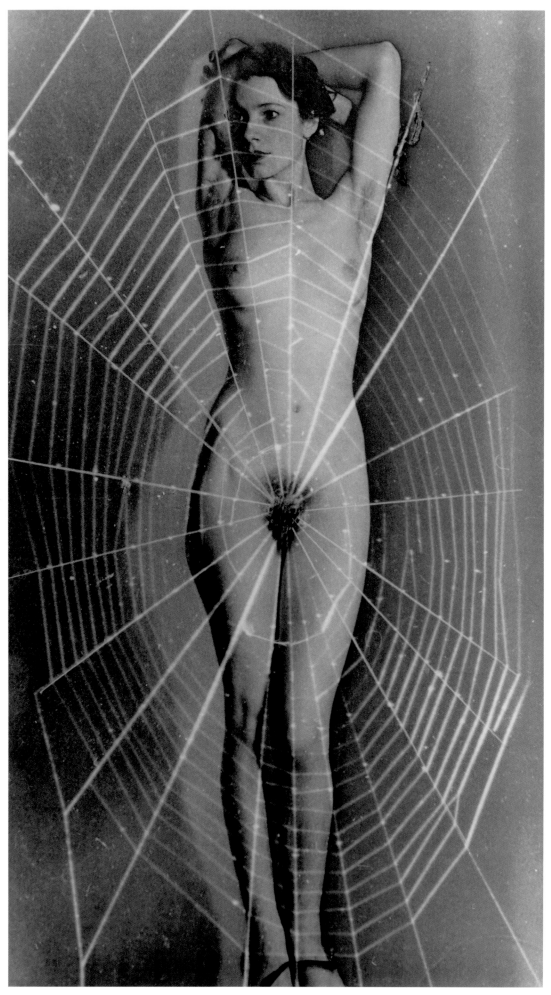

Man Ray, *Spider Lady*, ca. 1930;
from *Aperture* 103, 1986.

Left and above: James Turrell, Detail of Crater Bowl with survey net and contour lines, 1985

59

Aperture 157, 1999, pages 58–59: photographs by James Turrell.

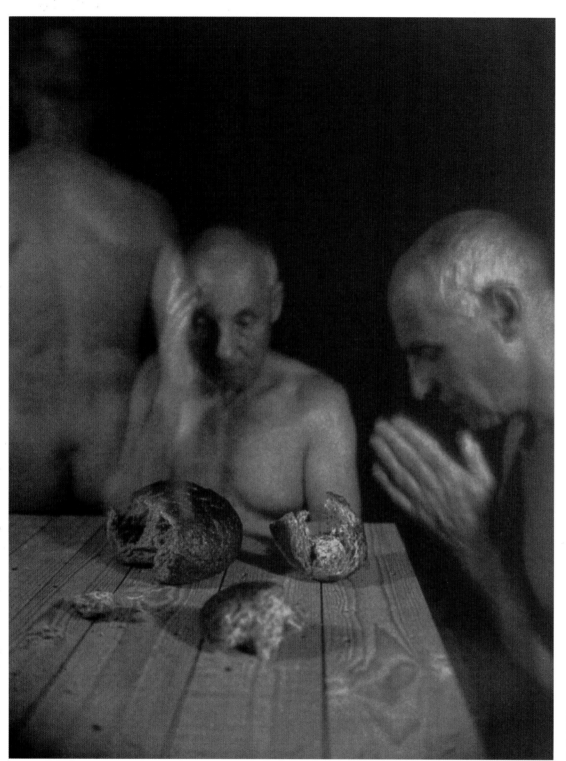

Jan Van Leeuwen, Based on
the painting *The Meal at
Emmaus* by Jan Steen, n.d.;
from *Aperture* 154, 1999.

It's fictitious to think that ideas in art
don't exist in reality.

There is no imagination, no flight of fancy
that is not grounded in reality.

A superlative photograph, in its cohesion,
is a reintroduction to nature.

For verification, no matter how abstract the work of art,
the artist goes back to the world.

The fulfillment of a work of art
is to find itself again in nature.

Some speak of a return to nature,
I wonder where they could have been.

—**Frederick Sommer,** *Aperture* **98, 1985**

OPPOSITE TOP: *Aperture* 102, pages 70–71: photographs by Daido Moriyama. **BOTTOM:** *Aperture* 143, pages 10–11: photographs by Horst P. Horst.

70

71

11

Opposite: Horst P. Horst, *Duck,* New York, 1946. *Above:* Horst P. Horst, *Bread,* New York, 1959.

THIS PAGE: photographs by Paul Thorel. TOP: *Deserti* (Deserts), 2000.
BOTTOM: *Doppia Onda a Donnini* (Double wave at Donnini), 2000.

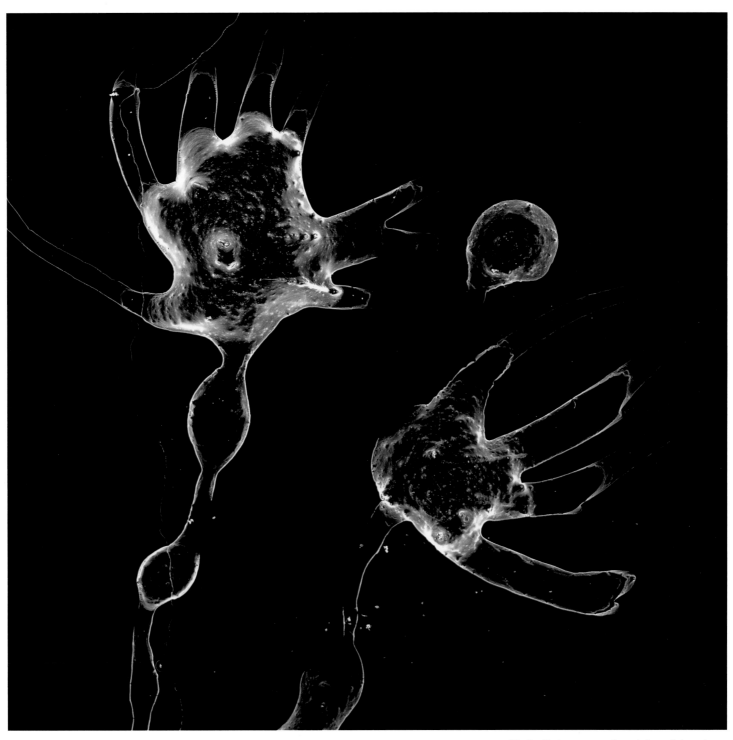

Charles Lindsay, camera-less photograph from drawn
negative, from the "Science Fiction Project," 2001.

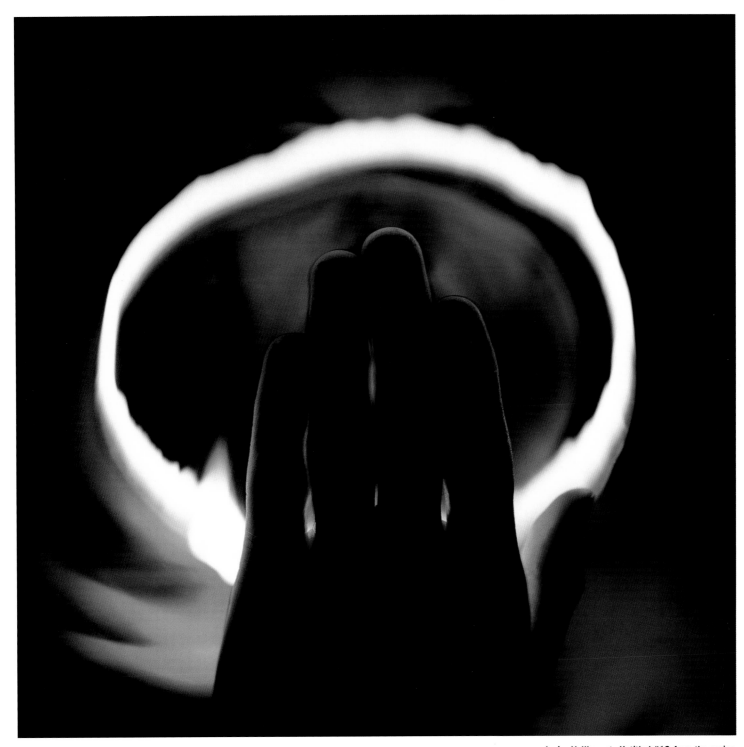

Javier Vallhonrat, *Untitled #18,* from the series
"Autograms," 1991; from *Aperture* 155, 1999.

OPPOSITE: Miguel Rio Branco, *Door into Darkness*, 2001.

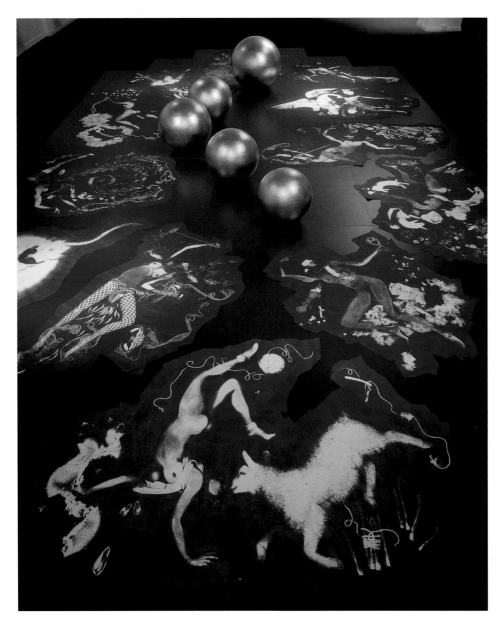

Helen Chadwick,
The Oval Court (detail),
from *Aperture* 113, 1988.

We should consider the evidence of revolution through imagery at some length because the great-grandsons of the Photo-Secessionists are again using the medium for revolt. While their great-grandfathers pitted an ideal form against Philistinism in photography, the current revolt looks like a dismissal of the both the Philistine and the ideal form.

Although carelessness is the order of the day among the great-grandsons, now and then we see work among the inherently creative twenty-year-olds that evokes the sense of personal authenticity that has always been the watermark of art. Many students are discovering that when the uniquely photographic print fails, some derivation from the original negative may evoke the very feeling that inspired them to expose in the first place. With such experiences repeated often enough, who wouldn't begin to doubt the supremacy of the pure photography tradition?

—Minor White, *Aperture* vol. 15, no. 3, 1970

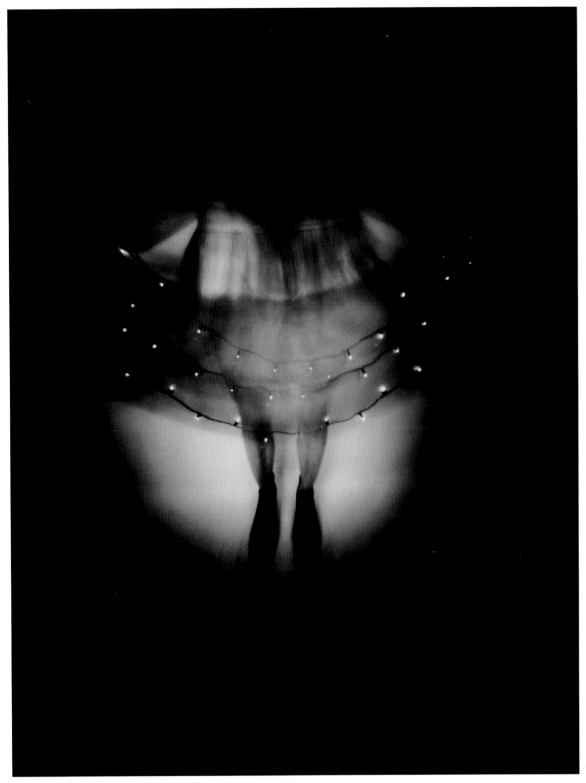

Barbara Ess, *No Title*, 1997–98; from
*I Am Not This Body: Photographs
by Barbara Ess* (Aperture, 2001).

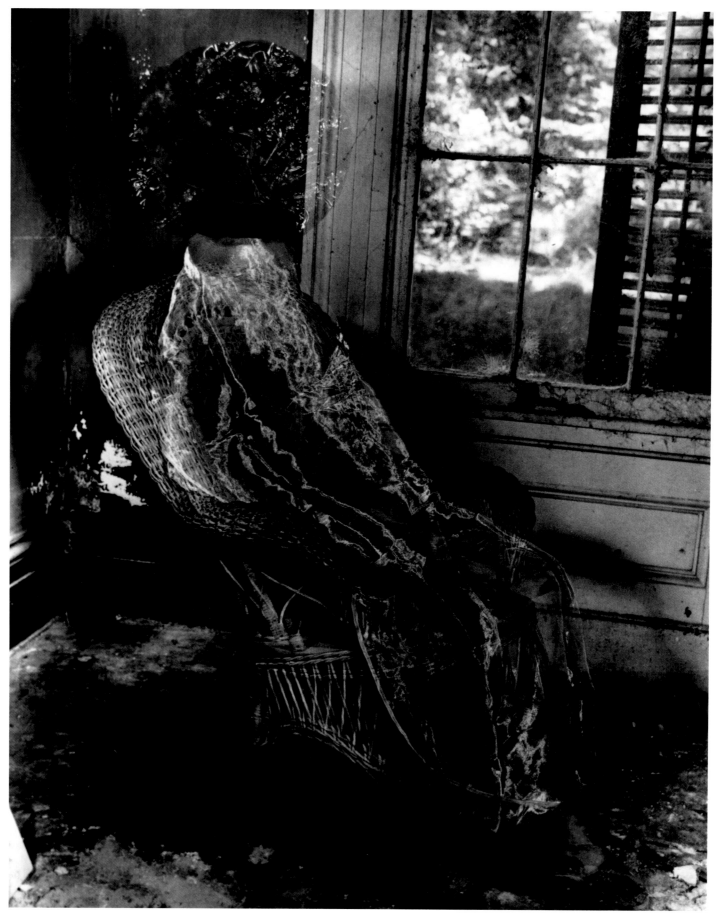

Clarence John Laughlin, *The House of the Past*, 1948; from *Aperture* vol. 9, no. 3, 1961.

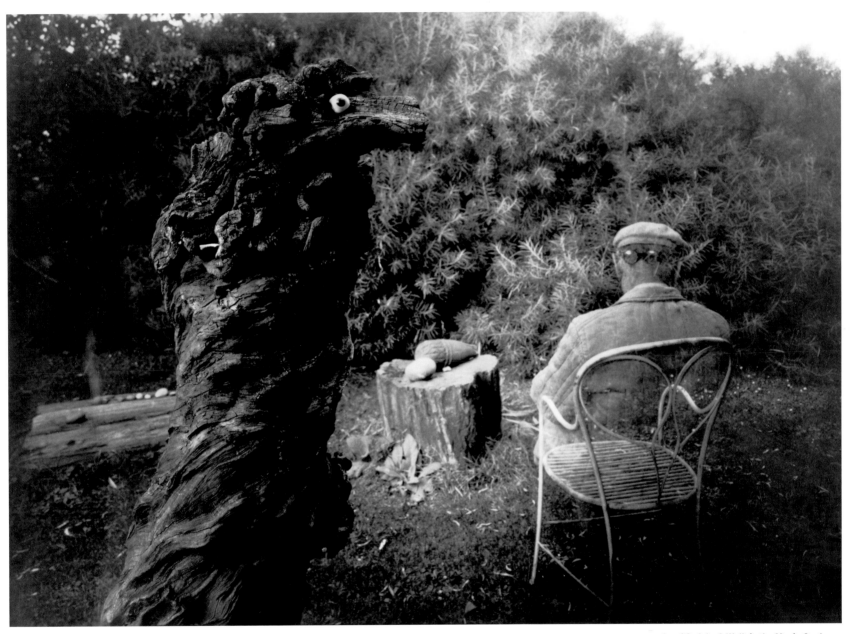

Josef Sudek, *A Walk in the Magic Garden—Rothmayer's Garden*, 1959; from *Josef Sudek: Poet of Prague, A Photographer's Life* (Aperture, 1990).

THESE PAGES: photographs by Mike and Doug Starn. OPPOSITE TOP: *Attracted to Light #D*, 1996–2001. THIS PAGE TOP: *Attracted to Light #G*, 1996–2001. BOTTOM: *Structure of Thought #7*, 2001.

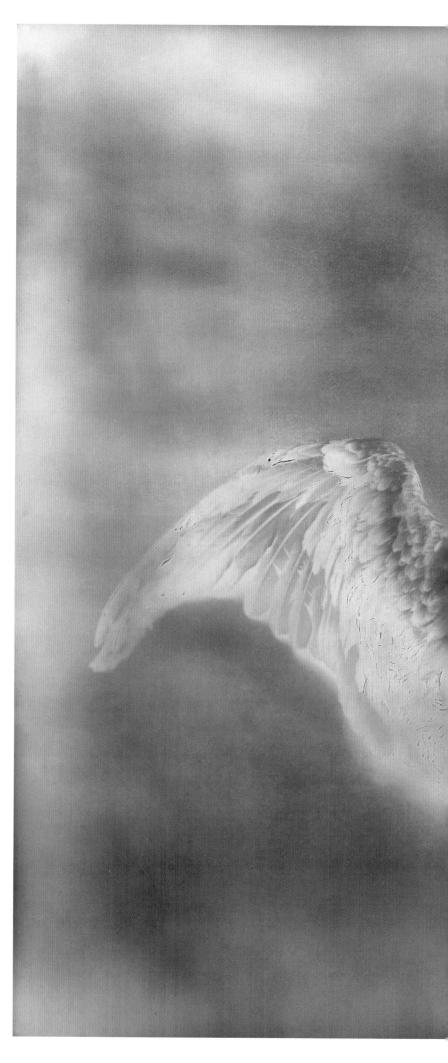

Warning: If experiencing a photograph can not be done with some of the abandon of a boy riding a bicycle, or children wading in the gutters after a rain, there is no reason to experience photographs.

—**Minor White and Walter Chappell, from "Some Methods for Experiencing Photographs,"** *Aperture* **vol. 5, no. 4, 1957**

Adam Fuss, from the series "My Ghost," daguerreotype, 1999.

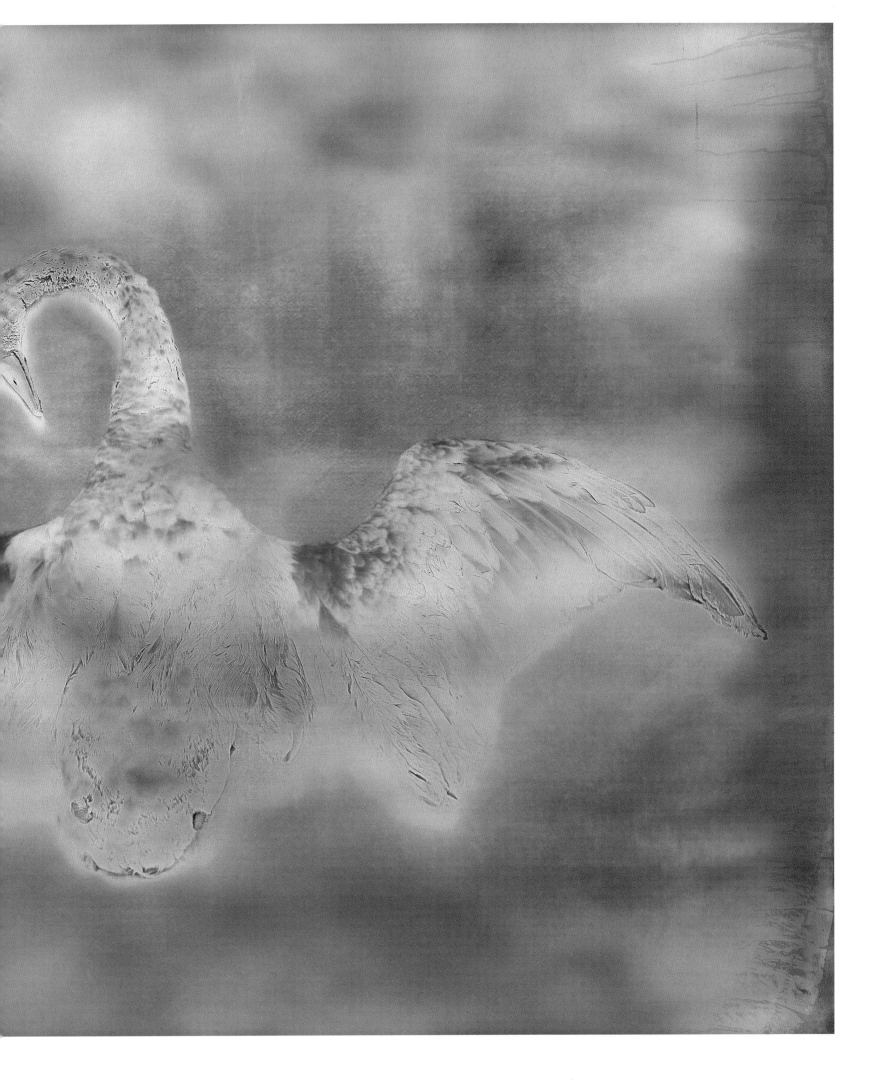

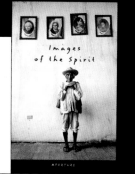
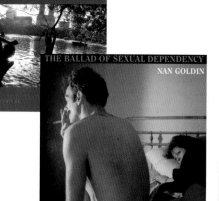
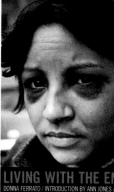

TEXT CREDITS

Unless otherwise indicated, all excerpted texts are from issues of *Aperture* magazine and are copyright © Aperture Foundation, Inc.

Founder's statement on front jacket flap, reprinted courtesy the Minor White Archive, Princeton University, copyright © 1952 by Minor White, renewed by the Trustees of Princeton University, all rights reserved; cover quotation and excerpt on page 16, reprinted from the *PSA Journal* vol. 29, no. 7, copyright © 1963 Photographic Society of America; p. 18, excerpt by Barbara Morgan, reprinted courtesy the Minor White Archive, Princeton University, copyright © 1953 by Minor White, renewed by The Trustees of Princeton University, all rights reserved; p. 23, excerpt by Richard Neutra, reprinted courtesy the Minor White Archive, Princeton University, copyright © 1958 by Minor White, renewed by The Trustees of Princeton University, all rights reserved; pp. 41 and 117, excerpts by Dorothea Lange and Daniel Dixon, reprinted courtesy the Minor White Archive, Princeton University, copyright © 1952 by Minor White, renewed by The Trustees of Princeton University, all rights reserved; p. 42, excerpt by Henry Miller, from *Plexus, The Rosy Crucifixion, Book Two,* New York: Grove Press, 1965; p. 59, excerpt by Nancy Newhall, reprinted courtesy the Minor White Archive, Princeton University, copyright © 1952 by Minor White, renewed by The Trustees of Princeton University, all rights reserved; p. 72, excerpt by Ansel Adams, reprinted courtesy the Minor White Archive, Princeton University, copyright © 1952 by Minor White, renewed by The Trustees of Princeton University, all rights reserved; p. 75, excerpt by Yukio Mishima, from *The Temple of the Golden Pavilion,* translated by Ivan Morris, New York: Alfred A. Knopf, Inc., 1994; p. 89, excerpt by Minor White, reprinted courtesy the Minor White Archive, Princeton University, copyright © 1959 by Minor White, renewed by The Trustees of Princeton University, all rights reserved; p. 126, excerpt by Beaumont Newhall, reprinted courtesy the Minor White Archive, Princeton University, copyright © 1956 by Minor White, renewed by The Trustees of Princeton University, all rights reserved; p. 199, excerpt from *The Daily Practice of Painting: Writings and Interviews 1962–1993,* by Gerhard Richter, New York, MIT Press, 1995; pp. 224 and 236, excerpts by Minor White and Walter Chappell, reprinted courtesy the Minor White Archive, Princeton University, copyright © 1957 by Minor White, renewed by The Trustees of Princeton University, all rights reserved.

IMAGE CREDITS

All photographs are courtesy and copyright © the artist unless otherwise indicated.

Front cover and page 17, photograph by Minor White, reproduction courtesy the Minor White Archive, Princeton University, copyright © 1982 by The Trustees of Princeton University, all rights reserved; p. 14, photograph by Walter Chappell, courtesy Walter Chappell Estate, all rights reserved; p. 18, photograph by O. Winston Link, courtesy and copyright © 2001 O. Winston Link Trust; p. 19, photograph by Bernd and Hilla Becher, courtesy Sonnabend Gallery, New York; p. 20 and back cover, photographs by Lynn Davis, courtesy Edwynn Houk Gallery, New York; p. 21, photograph by Ansel Adams, courtesy Ansel Adams Archive, Center for Creative Photography, copyright © Trustees of the Ansel Adams Publishing Rights Trust; p. 23, photograph by Frederick Evans, courtesy The Metropolitan Museum of Art, Purchase, David Hunter Malpin Fund, 1968, copyright © 1996 The Metropolitan Museum of Art; p. 24, photograph by Charles Sheeler, cour-

tesy Gilman Paper Company Collection; pp. 26–27, photograph by Thomas Struth, courtesy the artist and Marian Goodman Gallery; pp. 30–31, photographs by Bruce Davidson, courtesy and copyright © Bruce Davidson/Magnum Photos, Inc; p. 32, photographs by Chuck Close, courtesy the artist and Pace/MacGill Gallery, New York; p. 33, photograph by Cindy Sherman, courtesy the artist and Metro Pictures; p. 34, photograph by Shirin Neshat, courtesy Barbara Gladstone Gallery, New York; p. 35 and back cover, photograph by Edward Weston, courtesy Collection Center for Creative Photography, The University of Arizona, Tuscon, copyright © 1981 Center for Creative Photography, Arizona Board of Regents; p. 36, photograph by Annie Leibovitz, courtesy Annie Leibovitz/Contact Press Images; p. 37, photographs by Allen Ginsberg, courtesy and copyright © Allen Ginsberg Trust; p. 39, photograph by Charles Nègre, courtesy Sotheby's, London; p. 42, photograph by Gianni Berengo Gardin, courtesy and copyright © Gianni Berengo Gardin—Contrasto/Matrix; p. 43, photograph by Dorothea Lange, courtesy and copyright © the Dorothea Lange Collection, Oakland Museum of California, City of Oakland. Gift of Paul S. Taylor; p. 44, photograph by Josef Breitenbach, courtesy Collection Center for Creative Photography, The University of Arizona, Tuscon, copyright © The Josef Breitenbach Trust; p. 45, photograph by Emmet Gowin, courtesy Pace/MacGill Gallery, New York; p. 49 and back cover, photograph by Leonard Freed, courtesy and copyright © Magnum Distributions/Magnum Photos, Inc; p. 50, photograph by Garry Winogrand, courtesy Fraenkel Gallery, San Francisco and Collection Center for Creative Photography, The University of Arizona, Tuscon, copyright © The Estate of Garry Winogrand; p. 51, photograph by Ferdinando Scianna, courtesy and copyright © Magnum Distributions/Magnum Photos; p. 52, photograph by Jacques Henri Lartigue, courtesy and copyright © Association des Amis de Jacques Henri Lartigue; p. 53, photograph by Giorgia Fiorio, courtesy Contact Press Images; p. 54, photograph by Tracey Moffatt, courtesy Matthew Marks Gallery, New York; p. 57, photograph by Martin Munkacsi, courtesy Howard Greenberg Gallery, copyright © Joan Munkacsi; p. 61 and back cover, photograph by Barbara Morgan, courtesy and copyright © Barbara Morgan Archive; p. 69, photograph by Jonathan Saadah, courtesy the collection of Arlette and Gus Kayafas; p.72, photographs by Pierre et Gilles, courtesy Galerie Jérôme de Noirmont, Paris; p. 73, photograph by Nam June Paik, courtesy the artist and Holly Solomon Gallery; p. 74, photograph by Salvador Dalí and Horst P. Horst, courtesy Staley-Wise Gallery, New York, copyright © Horst Archive; p. 76, photograph by Walter Chappell, courtesy Walter Chappell Estate, all rights reserved; p. 77, photograph by Ralph Eugene Meatyard, courtesy Fraenkel Gallery, San Francisco, copyright © the Estate of Ralph Eugene Meatyard; p. 78, photograph by August Sander, courtesy and copyright © 2002 Die Photographische Sammlung/SK Stiftung Kultur–August Sander Archive, Cologne/Artists Rights Society (ARS), New York; p. 79, photograph by Brassaï, courtesy the Metropolitan Museum of Art, Purchase, Warner Communications Inc. Purchase Fund, 1980, copyright © Gilberte Brassaï; p. 80, photograph by Alfred Eisenstaedt, courtesy Alfred Eisenstaedt/TimePix; p. 81, photograph by Lisette Model, courtesy J. Paul Getty Museum, Los Angeles, copyright © Estate of Lisette Model; p. 82, photograph by David McDermott and Peter McGough, courtesy Galerie Jérôme de Noirmont, Paris; p. 83, photograph by W. Eugene Smith, courtesy Collection Center for Creative Photography, The University of Arizona, Tuscon, copyright © The Heirs of W. Eugene Smith, courtesy Black Star, Inc., New York; p. 84, pho-

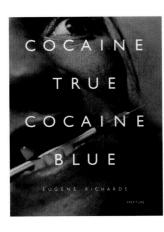
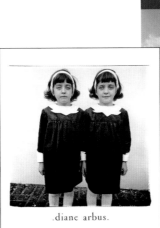

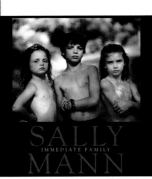
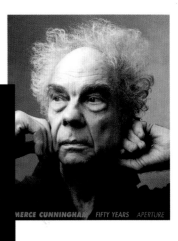

tograph by Inge Morath, courtesy Magnum Photos, Inc.; p. 86, work by Robert Rauschenberg, courtesy the artist and Untitled Press, Inc; p. 87, photograph by Robert Mapplethorpe, courtesy the Robert Mapplethorpe Foundation, Inc, copyright © The Estate of Robert Mapplethorpe; p. 88, photograph by Peter Hujar, courtesy Matthew Marks Gallery, New York, copyright © The Estate of Peter Hujar; pp. 90–91, photographs by Diane Arbus, courtesy Robert Miller Gallery, New York, copyright © Estate of Diane Arbus, 1971; p. 94, photograph by Max Waldman, courtesy and copyright © Max Waldman Archive; p. 95, photograph by Imogen Cunningham, courtesy and copyright © The Imogen Cunningham Trust; pp. 96–97, photographs by Sally Mann, courtesy the artist and Edwynn Houk Gallery, New York; p. 99, photograph by Peter Hujar, courtesy Matthew Marks Gallery, copyright © The Estate of Peter Hujar; p. 100, photograph by Jan Groover, courtesy Janet Borden, Inc.; p. 101, photograph by Sigmar Polke, courtesy Michael Werner Gallery, New York and Cologne; p. 102, photographs by Mario Giacomelli, courtesy Howard Greenberg Gallery, New York, copyright © Photology, Milan; p. 103, photograph by Masahisa Fukase, courtesy Robert Mann Gallery, New York; p. 104, photograph by Shomei Tomatsu, courtesy Tepper Takayama Fine Arts; p. 105, photograph by Paul Caponigro, courtesy the artist and Schmidt Bingham Gallery; p. 107 photograph by László Moholy-Nagy, courtesy Bauhaus-Archiv Berlin, copyright © VG Bild Kunst Bonn; pp. 108–109, photographs by Sebastião Salgado, courtesy Amazonas Images; p. 110, photograph by Chris Steele-Perkins, courtesy Magnum Photos, Inc.; p. 111, photograph by Raghubir Singh, copyright © 1974 by Raghubir Singh; p. 112, photograph by Henri Cartier-Bresson, courtesy Magnum Photos, Inc.; p. 113 (bottom), photograph by Alex Webb, courtesy Magnum Photos, Inc.; p. 114 and back cover, photographs by Raghu Rai, courtesy Magnum Photos, Inc.; p. 119, photograph by Tina Modotti, courtesy Throckmorton Fine Art, New York; p. 120 (bottom), photograph by Larry Towell, courtesy Magnum Photos, Inc.; p. 121, painting by Gerhard Richter, courtesy Marian Goodman Gallery; p. 122, photograph by W. Eugene Smith, courtesy Collection Center for Creative Photography, The University of Arizona, Tuscon, copyright © The Heirs of W. Eugene Smith, courtesy Black Star, Inc., New York; p. 124, photograph by Brian Weil, courtesy Collection Center for Creative Photography, The University of Arizona, copyright © 2001 Brian Weil Estate; p. 125, photograph by Lee Miller, courtesy and copyright © Lee Miller Archives; pp. 126–127, photographs by Don McCullin, courtesy Contact Press Images; p. 138, photograph by Paul Strand, copyright © Aperture Foundation Inc., Paul Strand Archive; pp. 140–141, photographs by Richard Avedon, copyright © 1963/1967; p. 142, photograph by Lucas Samaras, courtesy Pace/MacGill Gallery, New York; p. 145, photograph by Ugo Mulas, courtesy Archivio Ugo Mulas; p. 146, photograph by Marc Riboud, courtesy Magnum Photos, Inc; p. 148, photograph by Henri-Cartier Bresson, courtesy Magnum Photos, Inc; p. 154, work by Christian Boltanski, courtesy Marian Goodman Gallery; p. 155 (bottom), photograph by Lorna Simpson, courtesy Collection Museum of Contemporary Art, San Diego, Museum purchase, Contemporary Collectors Fund; p. 156, photographs by Joel Sternfeld, courtesy the artist and Pace/MacGill Gallery, New York; p. 159 work by Andy Warhol, courtesy the Andy Warhol Foundation, Inc./Art Resource, New York; p. 160, photograph by Andres Serrano, courtesy Paula Cooper Gallery, New York; pp. 164–165 and back cover, photographs by David Wojnarowicz, courtesy P.P.O.W. Gallery, New York; p. 167, photograph by Hiroshi Sugimoto, courtesy Sonnabend Gallery, New York; p. 171 and back cover, photograph by Barbara Kruger, courtesy Mary Boone Gallery, New York; p. 175, photograph by Josef Koudelka, courtesy Magnum Photos, Inc; p. 178, photograph by Harry Callahan, courtesy Pace/MacGill Gallery, New York; p. 183, photograph by Brett Weston, courtesy and copyright © Brett Weston Archive; p. 198, photograph by Anna Gaskell, courtesy Casey Kaplan 10-6, New York; p. 202, photograph by Elliott Erwitt, courtesy Magnum Photos, Inc; p. 203, photograph by Raymond Depardon, courtesy Magnum Photos, Inc; p. 205, photographs by Carrie Mae Weems, courtesy P.P.O.W Gallery, New York; p. 206, photograph by Lewis Hine, courtesy George Eastman House; pp. 208–209, photograph by Danny Lyon, courtesy Edwynn Houk Gallery and bleakbeauty.com; p. 211, photograph by William Eggleston, courtesy the artist and Cheim & Read Gallery, New York; p. 214, photograph by Martine Franck, courtesy Magnum Photos, Inc; p. 215, photograph by Gregory Crewdson, courtesy Luhring Augustine Gallery; p. 216, photograph by Adrian Piper, courtesy Paula Cooper Gallery, New York; p. 217, photograph by Robert Capa, courtesy the Estate of Robert Capa, copyright © 2000 Cornell Capa; p. 220, photograph by Man Ray, courtesy and copyright © 2002 Man Ray Trust/Artists Rights Society (ARS), NY/ADAGP, Paris; p. 222, photograph by Jan Van Leeuwen, courtesy Photos Do Not Bend Gallery; p. 224, photograph by Joel-Peter Witkin, courtesy the artist and Fraenkel Gallery, San Francisco; p. 225, photograph by Frederick Sommer, courtesy J. Paul Getty Museum, Los Angeles, copyright © Frederick and Frances Sommer; p. 230, work by Helen Chadwick, courtesy and copyright © V & A Picture Library; p. 231, photograph by Barbara Ess, courtesy the artist and Curt Marcus Gallery; p. 232, photograph by Clarence John Laughlin, courtesy and copyright © The Historic New Orleans Collection; p. 233, photograph by Josef Sudek, courtesy Philadelphia Museum of Art: Alice Newton Osborn Fund and funds contributed by Peter A. Benoliel, Lynne and Harold Honickman, the J.J. Medveckis Foundation, Harvey S. Shipley Miller and J. Randall Plummer, Marion Stroud Swingle and D. Robert Yarnall Jr., 1989; pp. 236–237, daguerreotype by Adam Fuss, courtesy the artist and Cheim & Read Gallery, New York.

All spreads from issues of *Aperture* are copyright © Aperture Foundation, Inc., except for the following: page 8, (top), *Aperture* vol. 1, no. 1, 1952, pages 4–5, reproduction courtesy the Minor White Archive, Princeton University, copyright © 1952 by Minor White, renewed by The Trustees of Princeton University, all rights reserved; p. 11, (top), *Aperture* vol. 2, no. 4, 1953, pp. 30–31, reproduction courtesy the Minor White Archive, Princeton University, copyright © 1953 by Minor White, renewed by The Trustees of Princeton University, all rights reserved; p. 14, *Aperture* vol. 3, no. 4, 1955, pp. 20–21, reproduction courtesy the Minor White Archive, Princeton University, copyright © 1955 by Minor White, renewed by The Trustees of Princeton University, all rights reserved; p. 22 (top) *Aperture* vol. 6, no.4, 1958, pp. 174–175, reproduction courtesy the Minor White Archive, Princeton University, copyright © 1958 by Minor White, renewed by The Trustees of Princeton University, all rights reserved; p. 64 (top), *Aperture* vol. 1, no. 4, 1953, pp. 28–29, reproduction courtesy the Minor White Archive, Princeton University, copyright © 1953 by Minor White, renewed by The Trustees of Princeton University, all rights reserved; p. 67, *Aperture* vol. 6, no. 1, 1958, pp. 40–41, reproduction courtesy the Minor White Archive, Princeton University, copyright © 1958 by Minor White, renewed by The Trustees of Princeton University, all rights reserved.

ACKNOWLEDGMENTS

Aperture gratefully acknowledges Getty Images for their generous grant, which accompanied the Lifetime Achievement Award given to Michael E. Hoffman by the International Center of Photography, in conjunction with ICP's 2002 Infinity Awards.

This book's title, *PastFORWARD*, was initially conceived by Baryshnikov Productions for White Oak Dance Project's marvelous revival of the Judson Dance Theater. That production, done in collaboration with many of the original Judson choreographers, was a tribute to their past work in a new context, as well as a celebration of their evolution since the Judson days in the 1960s. Similarly, Aperture's fiftieth anniversary publication honors and celebrates our history and role in the evolution of the medium—and looks toward our future with great anticipation for all of the extraordinary work we have yet to publish. Aperture is very grateful to Mikhail Baryshnikov and Baryshnikov Productions for agreeing to let us borrow this dynamic and apt title for our publication and exhibition.

We are deeply thankful to the photographers, artists, writers, editors, scholars, curators, and patient factotums who have been the lifeblood of Aperture over the past five decades. Without them, as the saying goes, all this would not have been possible.

R. H. Cravens is grateful to Peter Bunnell, Carole Kismaric, Susan Pakulis, Charles Simic, Jill and Lanny Shore, John Szarkowski, Jonathan Williams, and the staff of Aperture, especially Diana Stoll, for their help in compiling this book's essay. In particular, throughout this project, Assistant Editor Michael Famighetti has rendered invaluable support and research assistance. With the exceptions of the chapter epigraphs and the passage from Sinclair Lewis's *Babbitt*, all citations in the text were culled from personal interviews or from Aperture publications. Research for the essay was also aided by Penelope Niven's *Steichen: A Biography* (New York: Clarkson Potter, 1997); and Beaumont Newhall's *History of Photography* (New York: Museum of Modern Art, 1964) and *Focus: Memoirs of a Life in Photography* (Boston: Bulfinch, 1993).

Library of Congress Control Number: 2002107716
Hardcover ISBN: 0-89381-996-4

Printed by Sing Cheong Printing Co. Ltd., Hong Kong.
Duotone separations by Martin Senn.
Color separations by Bright Arts (H.K.), Ltd., China.

The staff at Aperture for *Photography PastForward: Aperture at 50*:
Melissa Harris, *Editor*
Diana C. Stoll, *Text Editor*
Wendy Byrne, *Designer*
Stevan A. Baron, *Vice President, Production*
Lisa A. Farmer, *Production Director*
Andrew Hiller, *Associate Editor*
Michael Famighetti, *Assistant Editor*
Bryonie Wise, *Production Assistant*
Justin Meade, Charles Stotler, and Alyssa Worsham, *Work-Scholars*

This project was originally conceived in collaboration with Michael E. Hoffman, Publisher and Executive Director (1964–2001)

Janice B. Stanton, *Interim Executive Director*

Aperture Foundation publishes a magazine, books, and portfolios of fine photography and presents world-class exhibitions to communicate with serious photographers and creative people everywhere. A complete catalog is available upon request.

Aperture Customer Service: 20 East 23rd Street, New York, New York 10010. Phone: (212) 598-4205. Fax: (212) 598-4015. Toll-free: (800) 929-2323. E-mail: customerservice@aperture.org

Aperture Foundation, including Book Center and Burden Gallery: 20 East 23rd Street, New York, New York 10010. Phone: (212) 505-5555, ext. 300. Fax: (212) 979-7759. E-mail: info@aperture.org

Aperture Millerton Book Center: Route 22 North, Millerton, New York, 12546. Phone: (518) 789-9003.

Visit Aperture's website: www.aperture.org

Aperture Foundation books are distributed internationally through:

UNITED KINGDOM, EIRE, SOUTH AFRICA: Aperture c/o Robert Hale, Ltd., Clerkenwell House, 45-47 Clerkenwell Green, London EC1R OHT, United Kingdom. Fax: +44 (207) 490-4958. E-mail: enquire@hale-books.com

WESTERN EUROPE, SCANDINAVIA: Nilsson & Lamm, BV, Pampuslaan 212-214, P.O. Box 195, 1382 JS Weesp, Netherlands. Fax: +31 (29) 441-5054. E-mail: info@nilsson-lamm.nl

AUSTRALIA: Tower Books Pty. Ltd., Unit 9/19 Rodborough Road, Frenchs Forest, Sydney, New South Wales, Australia. Fax: +61 (29) 975-5599. E-mail: towerbks@zipworld.com.au

NEW ZEALAND: Southern Publishers Group, 22 Burleigh Street, Grafton, Auckland, New Zealand. Fax: +64 (9) 309-6170. E-mail: hub@spg.co.nz

INDIA: TBI Publishers, 46 Housing Society, South Extension Part-I, New Delhi 110049, India. Fax: +91 (11) 461-0576. E-mail: tbi@del3vsmp.net.in

To subscribe to *Aperture* magazine write Aperture, P.O. Box 3000, Denville, New Jersey 07834, or call toll-free: (866) 457-4603. One year: $40.00. Two years: $66.00. International subscriptions: (973) 627-2427. Add $20.00 per year.

First Edition
10 9 8 7 6 5 4 3 2 1